Wayfarers of the Thai Forest
The Akha

by Frederic V. Grunfeld
and the Editors of Time-Life Books
Photographs by Michael Freeman

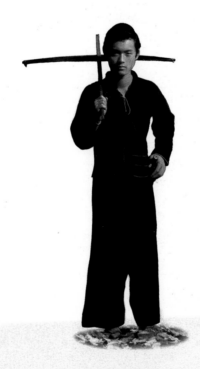

PEOPLES OF THE WILD · TIME-LIFE BOOKS · AMSTERDAM

TIME-LIFE BOOKS

European Editor: Kit van Tulleken
Design Director: Louis Klein
Photography Director: Pamela Marke
Chief of Research: Vanessa Kramer
Planning Director: Alan Lothian
Chief Sub-Editor: Ilse Gray

PEOPLES OF THE WILD
Series Editor: Gillian Boucher
Head Researcher: Jackie Matthews
Picture Editor: Jeanne Griffiths
Series Designer: Rick Bowring
Series Co-ordinator: Belinda Stewart Cox

Editorial Staff for *Wayfarers of the Thai Forest*
Text Editors: John Gaisford, Deborah Thompson
Staff Writer: Louise Earwaker
Researcher: Mark Karras
Sub-Editor: Sally Rowland
Editorial Assistant: Elizabeth Jones
Proofreader: Judith Heaton
Design Assistant: Paul Reeves

Editorial Production
Chief: Ellen Brush
Quality Control: Douglas Whitworth
Traffic Co-ordinators: Linda Mallett, Helen Whitehorn
Picture Co-ordinator: Philip Garner
Art Department: Julia West
Editorial Department: Theresa John, Debra Lelliott, Rebecca Read,
Sylvia Wilson

Published by Time-Life Books B.V., Ottho Heldringstraat 5, 1066 AZ Amsterdam.

ISBN 7054 0703 9

TIME-LIFE is a trademark of Time Incorporated U.S.A.

Cover: A young Akha girl's face is framed by her headdress—a blue cotton bonnet that she has lavishly decorated with silver, beads and tassels. In the background photograph, an Akha village of thatched bamboo houses clings to the steep, forested hill-slopes.

Front end-paper: The circle on this outline map of the world marks the area where groups of the Akha people are scattered among the wooded mountains of Thailand, Burma, Laos and the Chinese province of Yunnan.

Peoples of the Wild Series

This volume is one in a series that undertakes to record the unique lifestyles of remote peoples who have not yet yielded to the encroaching pressures of the modern world.

PEOPLES OF THE WILD
THE EPIC OF FLIGHT
THE SEAFARERS
WORLD WAR II
THE GOOD COOK
THE TIME-LIFE ENCYCLOPAEDIA
OF GARDENING
HUMAN BEHAVIOUR
THE GREAT CITIES
THE ART OF SEWING
THE OLD WEST
THE WORLD'S WILD PLACES
THE EMERGENCE OF MAN
LIFE LIBRARY OF PHOTOGRAPHY
THIS FABULOUS CENTURY
TIME-LIFE LIBRARY OF ART
FOODS OF THE WORLD
GREAT AGES OF MAN
LIFE SCIENCE LIBRARY
LIFE NATURE LIBRARY
YOUNG READERS LIBRARY
LIFE WORLD LIBRARY
THE TIME-LIFE BOOK OF BOATING
TECHNIQUES OF PHOTOGRAPHY
LIFE AT WAR
LIFE GOES TO THE MOVIES
BEST OF LIFE

Contents

The Author

Frederic V. Grunfeld is an American writer and cultural historian who has published many articles on tribal art. He was a roving editor of *Horizon* magazine for more than 10 years, and has contributed to several series of Time-Life Books, including *The Great Cities*. His books include *The Art and Times of the Guitar*, *The Hitler File* and, more recently, *Prophets Without Honour: A Background to Freud, Kafka, Einstein and their World*.

The Photographer

Michael Freeman began his photographic career after studying Geography at Oxford University. His pictures have appeared in many magazines and books, including volumes in two Time-Life Books series: *The World's Wild Places* and *The Great Cities*. He is the author of *The 35 mm Handbook*.

The Volume Consultants

Dr. Leo Alting von Geusau, Dutch anthropologist and fellow of the Institute of Social Studies in the Hague, has doctorates from Rome and from the New School for Social Research, New York. He is acting as a consultant for the United Nations Research Institute for Social Development in Geneva. Since 1977, he has lived among the Akha in northern Thailand, funded by grants from the Rothko Chapel Foundation, Houston, Texas, doing research on their ritual, mythology, history and economic life.

Dr. Paul Lewis, who has a doctorate in Anthropology from the University of Oregon, worked as a missionary for 20 years among the Akha in Burma, where he developed the first system for writing down the Akha language. He has published a detailed ethnographical account of the Burmese Akha, and since 1968 has lived in Thailand, working in health and education programmes among the hill peoples. He has lectured in anthropology at the University of Chiang Mai in northern Thailand.

Cornelia Kammerer studied Anthropology at the University of Chicago and Columbia University. She has held a number of scholarships and fellowships, and in 1979 went to Thailand to carry out research for a doctoral dissertation on Akha kinship and rituals, especially those rituals in which women participate.

The Series Consultant

Malcolm McLeod, Keeper of Ethnography at the British Museum, was born in Edinburgh. After studying History and Social Anthropology at Oxford, he undertook research in Africa, concentrating on the Asante region and other areas of Ghana. He has taught in the Sociology Department of the University of Ghana and at Cambridge, and is the author of a book on the Asante.

Introduction

Scattered through the forested mountains of eastern Asia dwells a rice-farming people who strive to follow the ways of their ancestors and live in harmony with nature. The Akha, more than half a million strong, have no books, no social organization above village level, not even the comfort of geographical unity; spreading over southern China, Burma, Laos and Thailand, they have always lived among more powerfully organized peoples of other cultures. Yet somehow they have retained an invincible belief that their traditional life is the right way to live.

When Time-Life Books planned the expedition whose outcome would be this volume in the *Peoples of the Wild* series, it was easy to decide where to send a writer-photographer team: of all the countries with Akha populations, only Thailand gives foreigners easy access. Thailand is not an ancient Akha homeland—most communities in that country have been founded in this century by Akha fleeing war and want farther north—but the 20,000 who now live there have built traditional Akha villages and remain as independent as they can from the native Thai.

The striking costume that Akha women wear is to the Akha one symbol of their separateness. But most crucial of all for their sense of themselves is the heritage of ritual poems that have been passed on orally for centuries from one generation to the next. The poems give minute instructions for every aspect of daily existence, and the Akha still faithfully follow them.

Understanding and explaining such an intriguing and complex people called for an author and photographer with uncommon gifts. Time-Life Books found them in Frederic Grunfeld, cultural historian, and Michael Freeman, a widely travelled photographer. To complement the first-hand experience, help was enlisted from three Western specialists on Akha society who were living in Thailand. The unpublished research they made available to the author and editors offered many insights into Akha life.

The author and photographer spent several weeks in an Akha village. (Called Napeh in this volume, the village in fact has a different name; the decision to use a fictional name was made to protect the vulnerable villagers from unwanted visitors.) Living in the household of one of the village leaders, Grunfeld and Freeman took part in everyday life and seasonal celebrations. Then, to hear from their own lips the saga of some recently settled exiles from Burma, the author made a journey north to remote Akha communities near the Burmese border. His encounters, recalled in Chapter Four, confirmed what he had already learned from his stay in Napeh: how powerful—and how effective—is the determination of this gentle people to survive and to continue their age-old ways.

The Editors

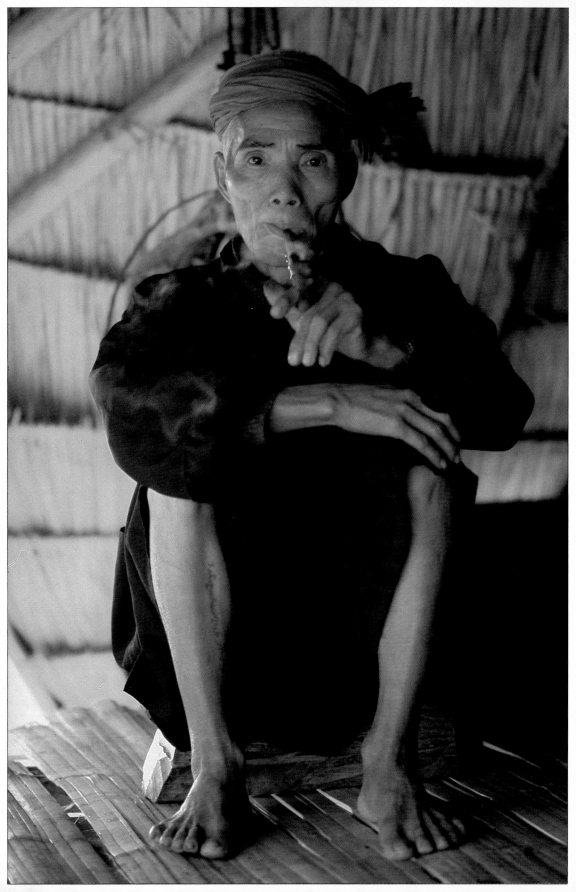

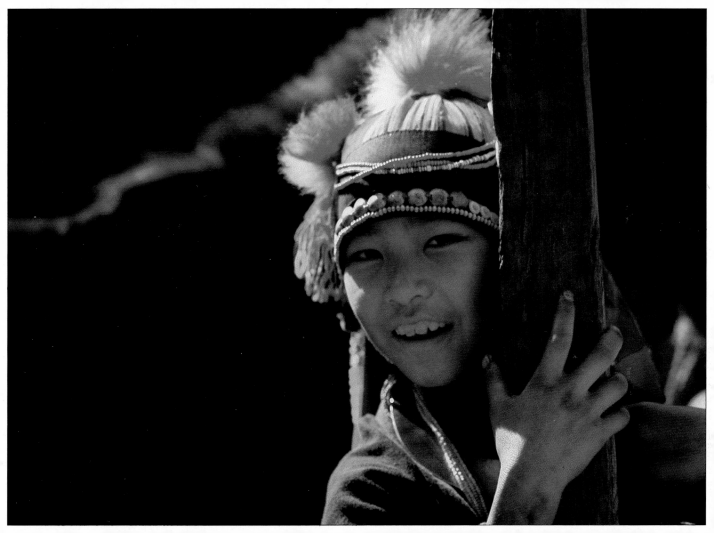

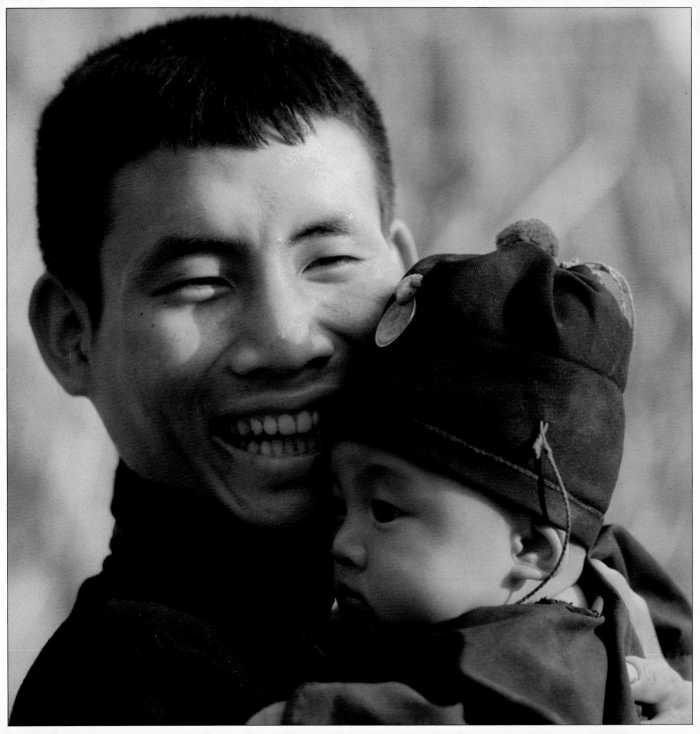

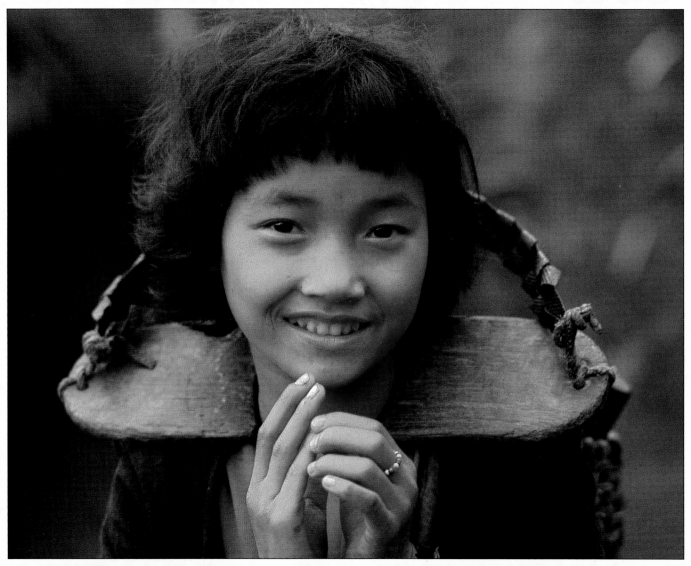

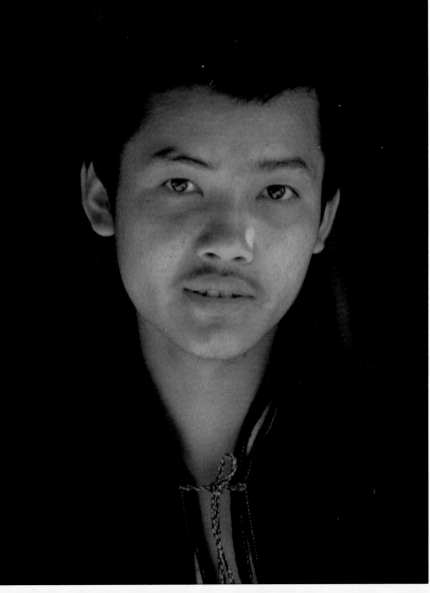

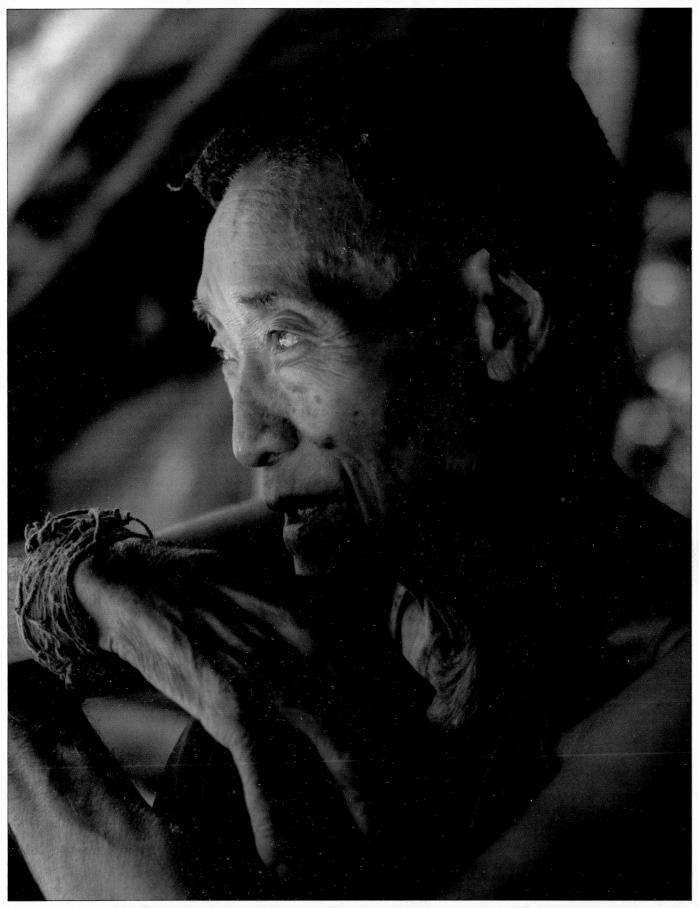

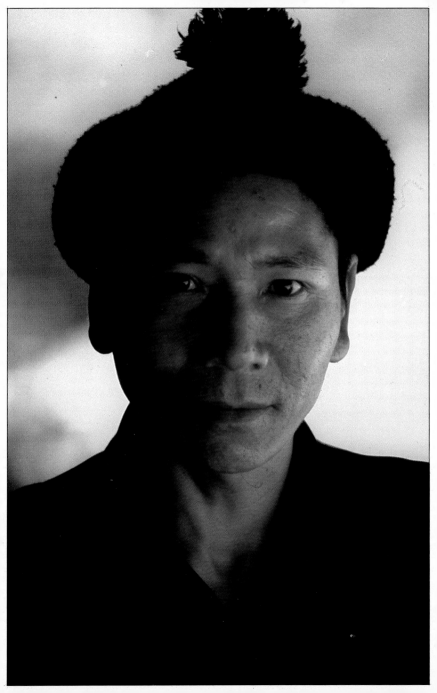

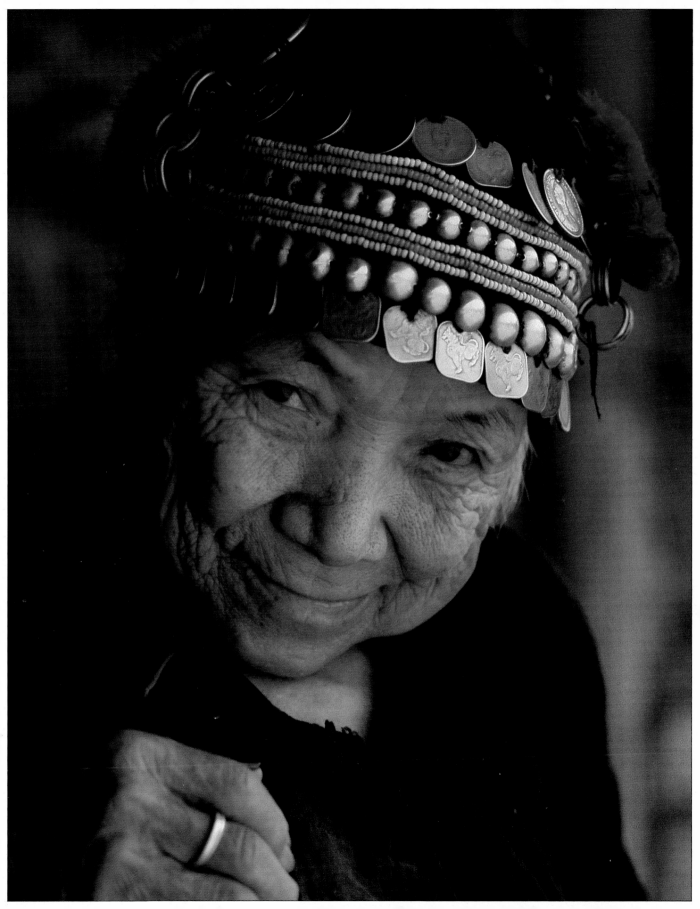

One | The Hidden Life of the Hills

From afar, the hills of northern Thailand look invitingly lush and green, especially during the heavy rains of August and September. Distant out-runners of the Himalayan system that stretches from India into Burma and China, many of the hills are so thickly wooded that travel agencies in Chiang Mai, the regional capital about 450 miles from Bangkok, can advertise harm-less walking tours through them as "jungle treks". But the visitor who ex-pects to traverse a tropical rain forest with towering, broad-leafed trees and hanging vines is bound to be disappointed. These curly-headed hills are chiefly covered with second-growth trees, competing for space with under-brush, bamboo thickets and the tall grass called *Imperata cylindrica*.

The disorderly scrub forms a forest screen behind which the life of the hills goes on almost in secret, ignored by the great world. In bamboo and grass-thatch villages live some half a dozen peoples very different from the Thai farmers who inhabit the plains and river valleys to the south. Known collectively by the Thai as the "hill tribes", they grow their rice on hillsides cleared by the "slash-and-burn", or swidden, method. Many are relative newcomers to this land, who came to Thailand during the present century from nearby countries—Burma, China and Laos—bringing with them a wealth of ancient customs. They have preserved not only their languages, but also their costumes and their special skills.

There are the Karen, trainers of elephants, who weave rust-coloured cot-ton fabrics for their clothes; the Hmong, specialists in batik, embroidery and silversmithing; the Yao, who brought with them priceless ancestor portraits painted generations ago in central China; the Lahu, hunters of forest game who have graduated from poisoned arrows to home-made shotguns and war-surplus rifles; the Lisu, in huge turbans, who make magnificent jewel-lery from silver coins; and the Akha, of all the hill peoples perhaps the most

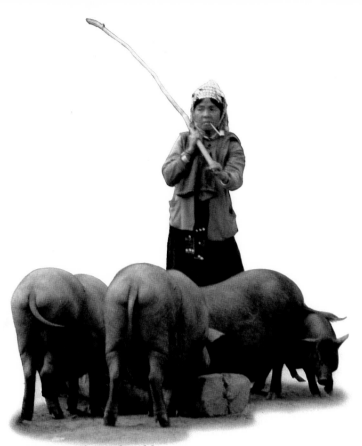

wedded to traditional values. Their women wear magnificent headdresses that would have done justice to warriors of an heroic age, and their religious leaders chant poetry of epic proportions.

More than 20,000 Akha live in Thailand, inhabiting an area that extends roughly from the Burmese border at Mae Sai to the hills below Chiang Rai, a provincial centre some 100 miles north-east of Chiang Mai. They share this frontier region with the other hill peoples; villages are scattered through the highlands with little regard for ethnic solidarity. The peaks they inhabit rarely rise above 5,000 feet—high enough, however, to afford commanding views of the countryside below. To the west, their horizon is dominated by a series of south-to-north mountain ranges that rise higher and higher as they recede into the distance towards Burma. The ridges, falling off sharply to the south, meet the green-and-brown chequerboard of the plains, where Thai peasants in blue cotton smocks raise two crops of rice each year in irrigated fields, using water buffaloes to plough up the black alluvial soil.

The wet-rice farmers have never had much use for the hills; from their point of view, these topographical intrusions seem like dragon's teeth sown by one of the demon divinities that are still propitiated by local spirit cults. For the hill peoples themselves, however, even the highest peaks hold no terrors. Like mountain peoples elsewhere—the Basques of the Pyrenees, for example, and the Sherpas of Nepal—they take comfort in the remoteness that enables them to preserve their ethnic identities.

For the present, at least, they remain isolated from the rest of Thailand. Dirt roads have been bulldozed into the hills from the market villages in the lowlands, but these tracks soon peter out. Thereafter the only easy way to move through the forests is on trails—just wide enough for a man and a packhorse—that cut across country, up-mountain and down-mountain, from

one village to the next. I do not recommend the alternative. I met a man who waded 10 miles upstream, knee-deep in the Mae Suai river all the way. In the absence of a path along the bank, it was the quickest route to his destination.

Even more than the Basques and the Sherpas, the hill peoples of Thailand value their isolation. For these groups are refugees from political upheavals in their previous homelands and their presence in this rugged area is merely tolerated. Most of them are not citizens of their adopted country and they have no established legal rights to the land they occupy.

Their position is precarious not least because their swidden agriculture has come under attack from ecologists, who accuse the hill peoples of damaging the physical environment. Burning, the scientists concede, is essential for cultivation in the hills, because the topsoil is deficient in chemicals: the ashes provide potassium and phosphorus, which balance the mix for a few years before fertility decreases again. But the damage to the hills is permanent. During the monsoon, heavy downpours on burned-over land cause severe erosion of the topmost and richest layer, which is washed downhill. As a result, the ecosystem of the whole catchment area is disturbed.

When I first arrived in Thailand, I spoke to a European agronomist who had been working in the hill country for 10 years on a pasture reclamation project. He was not unsympathetic to the hill peoples, but he had only sharp words for their farming methods. "Slash-and-burn is bad, bad, bad," he said. "It destroys the forests and depletes the nutrition level of the soil. For the last 10 years I have watched the vegetation of the hillsides getting thinner every year. Now all you see is bare fields with tree stumps standing in them."

In an effort to reverse this process, the Thai government has introduced draconian reforestation programmes and many hill farmers have suddenly found rows of saplings planted in the middle of their rice fields. There is nothing they can do about it, since according to Thai law the whole region is forestry reserve land, which can be exploited only by licensed timber concessionnaires. In other words, each time a farmer cuts down a tree he is engaged in timber poaching; and every swidden field is illegal.

The irony of this situation is that few communities have sought harmony with nature more strenuously than the hill peoples. They conduct numerous ceremonies and festivals, blessings and exorcisms, to maintain the equilibrium between themselves and the cosmos. They also attempt to practise a form of field rotation—cultivating only part of their land at any one time, while allowing the rest to lie fallow until it acquires a new covering of trees. Defenders of swidden farming point out that, far from having "found a forest and left a thorn bush savannah" as their critics claim, many hill peoples maintain their environment and live in the same location for long periods. They can farm very effectively ... so long as there is enough land to go round.

Formerly, when a village's population grew too numerous or their fields became exhausted, they could always split up or move on to another part of the forest. Their past history is the tale of many such moves. But from where they are now they have nowhere else to go: the crowded plains of Thailand begin at the foot of these hills. The lowlanders themselves are short of land

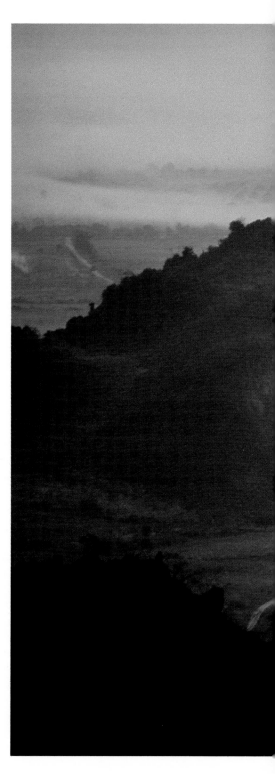

In the pale light of dawn, the Thai lowlands stretch beyond the forested hills where the Akha make their home. The flat countryside below is a populous and fertile region of irrigated rice fields and paved highways.

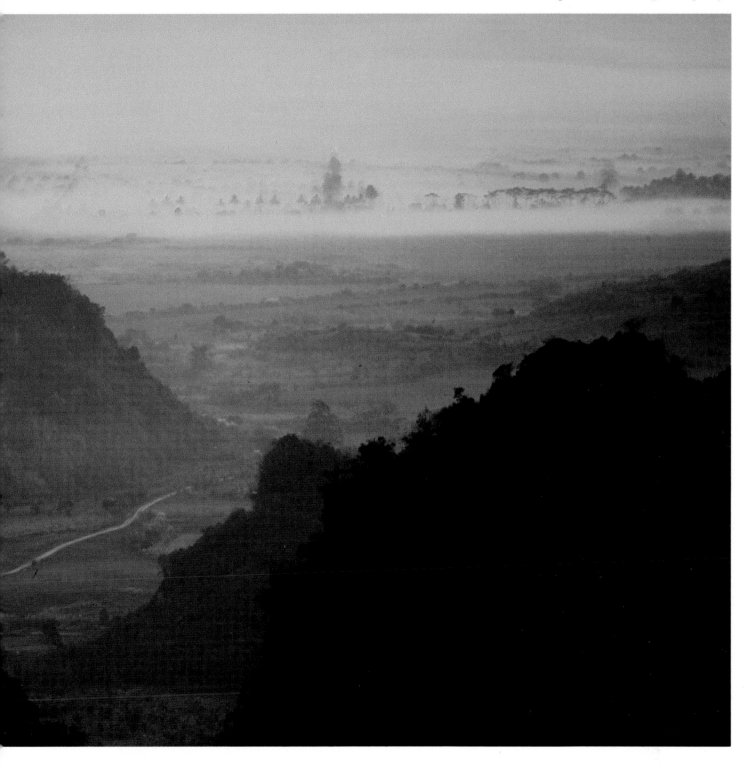

and have begun to encroach on the lower slopes of the hills. With increasing pressure on the limited resources of the highlands, the hill peoples have almost run out out of earth to cultivate.

My introduction to the Akha came through the Dutch anthropologist Dr. Leo Alting von Geusau, who has made his home in Thailand and has spent several years in an Akha village. When I visited him in Chiang Mai, he was staying in an old teakwood house on the muddy banks of the Mae Ping river. He told me at some length of the problems the Akha face. The forests they inhabit are being stripped—often illegally—by lowland logging companies; food is short; their health is poor and there are few medical facilities; and they are constantly harassed by the armed Thai bandits who roam the hills. For the moment, their traditional culture is alive; but the Akha, like the other hill peoples, are forced increasingly to seek work as day labourers or to produce handicrafts such as basketwork and homespun fabrics for sale to tourists. Yet, for the Akha, the predicament is no novelty. Dr. von Geusau's researches into their history have convinced him that they have been consistently at the mercy of more powerful groups and their way of life in the forested hills has been moulded by centuries of existence as a barely tolerated minority.

The task of reconstructing the Akha past is formidable for they have no script and hence no written history. Instead, their knowledge is preserved in more than 10,000 lines of poetry, which for centuries have been transmitted orally, generation by generation, along an unbroken chain of masters and pupils known as *pimas*. *Pimas* have a status akin to that of a teacher or priest, since the vast corpus of verses that they recite contains the wisdom of the Akha, much as the Bible once did for the Jews and the Koran for the Muslims.

Composed in different periods and constantly added to, the repertoire of poems has no fixed order or overall design. But it is an essential element in the totality of Akha traditions, which together are known as *Akhazang*—"the Akha Way". It spans almost the entire range of their experience, recording the exploits of their ancestors from the mists of time to recent generations, together with a mass of precepts and instructions on the right way to live. A Swedish linguist named Inga-Lill Hansson has both recorded and translated many of the verses, thus allowing scholars like Dr. von Geusau to trace the origins of Akha traditions. The verses are often ambiguous, but information from additional sources—most notably from Chinese chroniclers of the early centuries A.D.—confirms many of the verse episodes, so that the broad outlines of the Akha past can be established with some confidence.

Their history is essentially the story of a journey—a long migration from an ancestral homeland in central Asia. The Akha speak a tongue belonging to the Tibeto-Burmese language group, and they belong to the Lolo, a collection of peoples whose ancestors probably lived on what is now the eastern border of Tibet. It seems that by the second century B.C., the ancestors of the Akha, along with those of the other Lolo, had left this mountainous region.

The Tibetan massif is the source of most great rivers in east Asia, such as the Brahmaputra, Irrawaddy, Mekong and Yangtze. Like other populations

Deeply stained teeth and gums betray this man's predilection for chewing betel nuts— a habit common among Akha adults of both sexes. The betel nut, fruit of the areca palm, is a mild intoxicant. It also has anaesthetic qualities, and is used to relieve toothache.

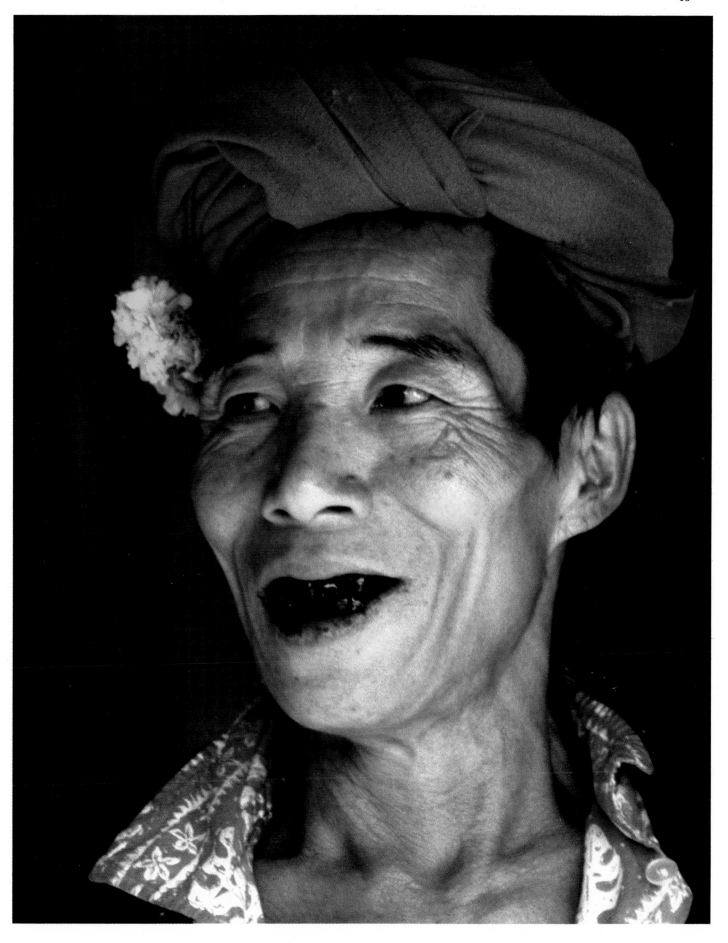

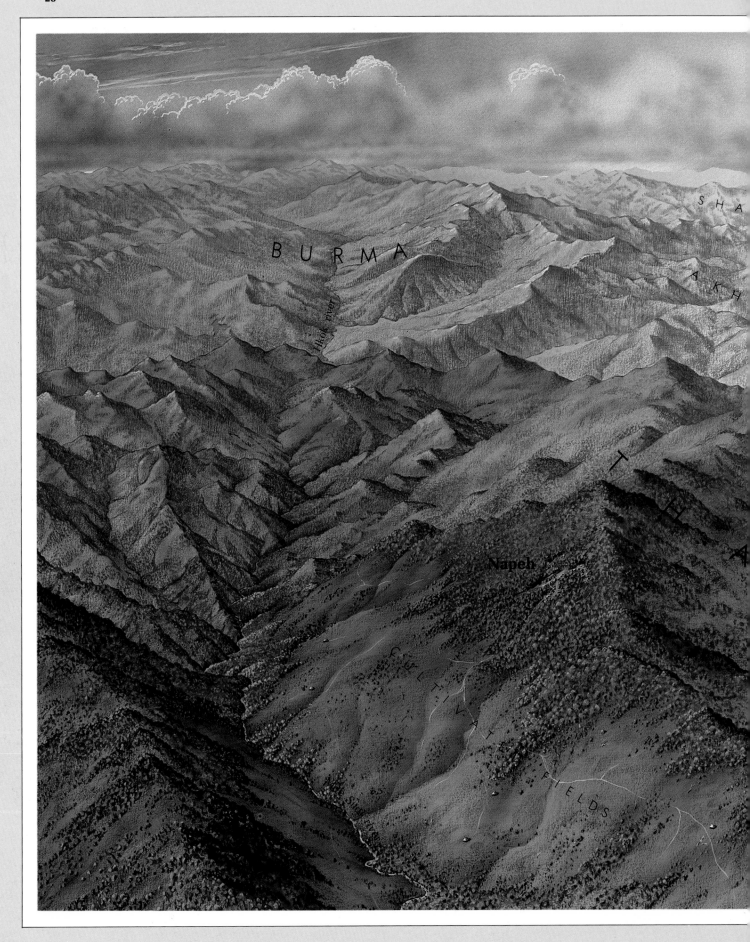

BURMA

Rhok river

SHA

AKH

T

H

A

Napeh

CULTIVATI

FIELDS

Sualti river

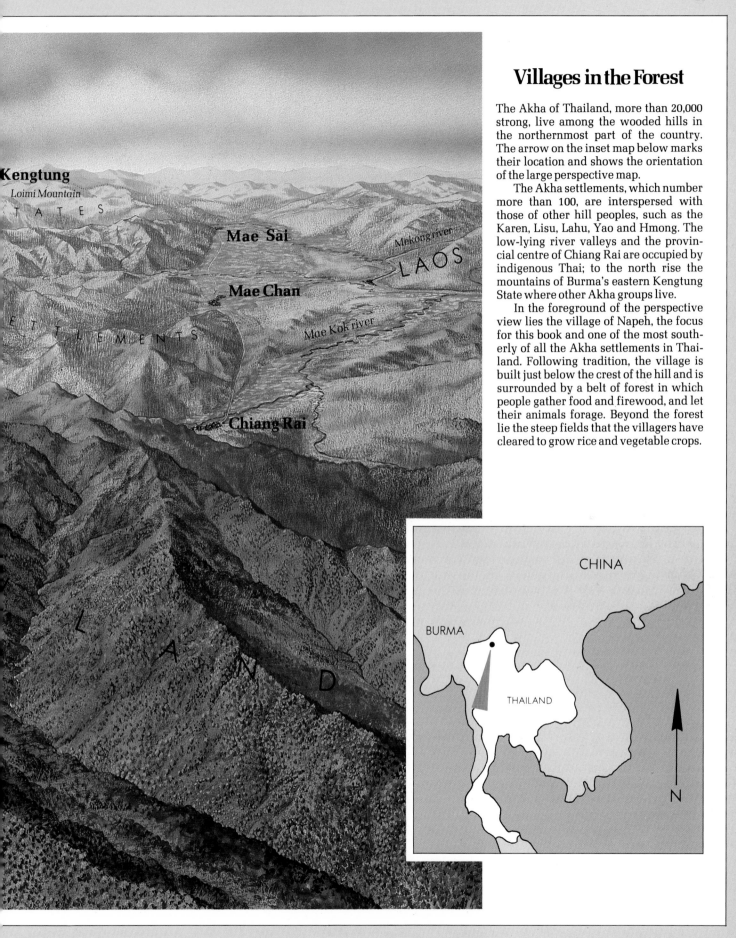

Villages in the Forest

The Akha of Thailand, more than 20,000 strong, live among the wooded hills in the northernmost part of the country. The arrow on the inset map below marks their location and shows the orientation of the large perspective map.

The Akha settlements, which number more than 100, are interspersed with those of other hill peoples, such as the Karen, Lisu, Lahu, Yao and Hmong. The low-lying river valleys and the provincial centre of Chiang Rai are occupied by indigenous Thai; to the north rise the mountains of Burma's eastern Kengtung State where other Akha groups live.

In the foreground of the perspective view lies the village of Napeh, the focus for this book and one of the most southerly of all the Akha settlements in Thailand. Following tradition, the village is built just below the crest of the hill and is surrounded by a belt of forest in which people gather food and firewood, and let their animals forage. Beyond the forest lie the steep fields that the villagers have cleared to grow rice and vegetable crops.

that the mountains could not support, the Akha's ancestors followed the river valleys down to more hospitable lands. The details of their journey are vague. The verses often are hazy as they relate a long series of events and places; and some of the rivers mentioned have not yet been identified. One verse makes reference to "Drawing water by the Na-kha river, going down to the Me-ho river, the Na-he and the Na-ba rivers." Others, however, such as the Mekong and the Mae Sai, are mentioned by their present names.

As they moved slowly south-east from Tibet into southern Szechwan and Yunnan in present-day China, the travellers began to split up. One group, the forebears of the Akha, went farther south than the other Lolo. Akha legends tell how "Our ancestor Gu-la moved south to Djm-pyu; our ancestor A-gaw moved to a place where the land was flat; our ancestor Mo-dzo moved to a place with many trees; our ancestor Man-dzan went to live at a place with many stones," and so on. By the seventh century A.D., this group of Lolo had spread to the very south of Yunnan. It was there that they gradually evolved a culture distinct from that of the other Lolo peoples; and began to call themselves Akha. Although many of the Akha themselves later moved on, the largest segment of the population along with other Lolo peoples remained in Yunnan and are there to this day.

In Yunnan, apparently, the Akha prospered for centuries. They probably grew their rice in paddy fields, using water buffaloes to pull ploughs, and their poetic tales—confirmed by the reports of the Chinese chroniclers—mention a time when they built a walled city. They also speak of three generations of powerful Akha chiefs. Had this development continued, it would seem, the Akha might have set up their own centralized state.

During this settled period, the Akha may have even learned to read and write. Old texts, written in a curious script quite different from Chinese pictograms, have been discovered this century in the possession of Lolo groups still living in Yunnan. But the verses go on to describe a "big burning"—a time of disasters when the Akha were forced to seek refuge in the thickly wooded uplands. If the Akha ever did have books, it was probably at the time of the "burning" that they disappeared, together with the art of writing.

The epic tale provides its own poetic version of the loss. Long ago, it is said, the spirit who designed the clouds gave the Akha their own alphabet, written on buffalo skin. When they became hungry, the Akha ate the skin; but the letters, when digested, were transformed into an excellent memory for words.

Indeed, the chanting *pimas* are not the only ones who can perform the feats of verbal memory for which the Akha are renowned. Every adult male is expected to learn the genealogy of his ancestors on the male side for the past 60-odd generations, going back to the earliest tiers of forefathers, when, as they say, men and spirits lived in harmony. This feat of memory is made only slightly easier by the fact that, in formal usage, the last syllable of the father's name becomes the first syllable of the son's. "No-dzah begat Dzah-loh, and Dzah-loh begat Loh-naw, and Loh-naw begat Naw-ce," and so on.

Some genealogical litanies go back to the names of the chiefs who ruled the Akha before they were forced to take refuge in the mountains, and thus

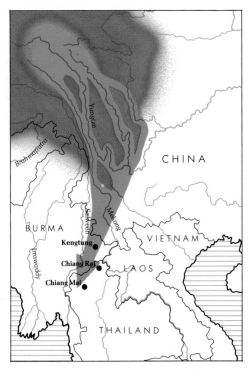

Converging arrows show the routes by which the Akha's ancestors migrated southwards as far as Thailand. Akha legend suggests that centuries ago their forefathers followed the river valleys leading from the Tibetan plateau to southern China. Towards the end of the 19th century, some Akha moved farther south, into Burma and Laos. All those now living in Thailand crossed the Burmese border during the 20th century.

reveal that the flight of the Akha took place some 30 generations—perhaps 700 years—ago. That would put it in the 13th century, when Mongol hordes from the west, under the great war-lord Kublai Khan, invaded China and crushed the Lolo state. It is impossible to say whether the "big burning" in the Akha's poetic account is a description of the troubles of that time. But, after that or a similar disaster, the Akha never again had powerful rulers who could organize them as a people; government stopped at village level.

Ever since, the Akha have been at the mercy of stronger groups. Driven from the fertile lowlands into the hills, they never reached the highest, most secure slopes, which were usually already occupied by some more powerful people. Instead, they kept to the forested middle slopes. Because they were always vulnerable from above and below, their only recourse in times of trouble was to move on. Over the centuries, they moved slowly but steadily south, escaping oppression when the neighbouring groups grew powerful, avoiding infection when epidemics broke out, or simply seeking more fertile soil. By the end of the 19th century, a time of great turmoil in Yunnan, the Akha vanguard was established at the southern borders of the province—and of China itself. There, they found themselves under the conflicting influence of two great foreign colonial powers: the British Empire in Burma, and the French in Indo-China. Some Akha moved farther south, one branch into Burma and another into Laos. Akha from Burma later flowed into Thailand.

The first Akha village in Thailand was founded in 1905, the second probably not until 1925. Most of the Akha living in Thailand now are immigrants or children of immigrants who have arrived since World War II. They fled from Burma when the eastern hills became engulfed in the civil war between the Burmese and the Shan people—relatives of the Thai—that broke out a few years after the British had withdrawn in 1948. Nonetheless, large numbers of Akha remained in their previous homelands. In China alone, according to the census figures, some 500,000 inhabit the province of Yunnan; there are an estimated 100,000 in eastern Burma and almost 5,000 in Laos.

By the 1950s, however, Thailand had become one of the last refuges in which the Akha—and the other hill peoples, numbering about 400,000— could live in relative peace. From the mid-Fifties onwards, the Royal Family of Thailand made the hill peoples one of its special concerns and the king sponsored several programmes designed to help preserve their cultures. Yet there seems to be little hope that the Akha can resist the pressures of the modern world very much longer.

Dr. von Geusau was at first reluctant to take me into the hills. Very often, he pointed out, journalists have presented the Akha as colourful primitives and failed to recognize the depth and sophistication of their cultural heritage. While weighing the likelihood of my following these woeful precedents, he introduced me to two other Westerners who were working with the Akha: Nina Kammerer, a young anthropologist studying their ritual, cosmology and kinship, and Dr. Paul Lewis, a voluntary worker who had spent 20 years as a missionary in the Burmese hills and who was currently running a birth-

control programme in Thailand for both the Akha and the other hill peoples.

Dr. Lewis proved to be a mine of detailed information. During his long stay in Burma, he had learned to speak the Akha language fluently, had compiled the first Akha-English dictionary and had published a four-volume study of their customs. I made it my priority to read these carefully and was soon immersed in the stories he had been told by the villagers. Almost every page I read brought home to me how far their world view differed from anything I had ever experienced before. It was obvious that, without such background knowledge, I could never hope to understand what I would eventually see, so I read voraciously for days.

From the fables told by Akha grandmothers to their grandchildren, I could glimpse the world in which the Akha culture had been formed: a forest environment where the hill peoples had carved out a precarious livelihood in the midst of danger. An Akha version of the Little Red Riding Hood tale, which Dr. Lewis translated for me, provided a typical example; clearly its purpose was to warn children of the dangers outside the village.

According to the story, a mother and her infant daughter paid a visit to the grandmother's village and on the way home they were escorted by some of the woman's brothers. When they were about half-way back, she said to them: "You can turn back now, brothers. It is not far. I can even hear the rich family in the village beating new cloth." (Hand-woven cotton contains bits and pieces of dirt, and the villagers would beat it with sticks to clean it.) "I can go on from here without trouble," the woman went on. But around the next bend in the trail she met a tiger, beating and thumping its huge tail, which was really the sound she had heard a moment before. The tiger ate the mother and baby, then put on the mother's clothes and went on to the village.

In some versions of this story, the village children are able to outwit the tiger; in others the tiger hoodwinks everyone and carries off more victims. Either way, Akha children are left in no doubt that the world beyond their settlement is an ominous place.

Wild animals were not the only threat: bandits, warriors and dangerous invisible forces also lurked in the jungle. So alarming was the outside world that Akha women did not travel unnecessarily, but devoted themselves to domestic tasks and left the forests to the men. As the proverb puts it,

A woman deals with what is between the house and the rice bin;
A man deals with what is between other villages and ours.

Since the people could not survive by rice alone, the men went hunting in the forest and came back with big game: wild goat and boar, deer and bear. They also travelled down into the valleys to trade tobacco and dried chili peppers for iron and salt—indispensable commodities that the Akha have always had to purchase from the lowland people. To Akha men, travelling outside the village became a mark of courage and independence, something they could be justly proud of. A young man, leaving the village for the first time, would feel elated at his new-found independence.

Over the generations, the Akha came to terms with the forest and could refer to its perils with confidence and humour, much as a mountain guide

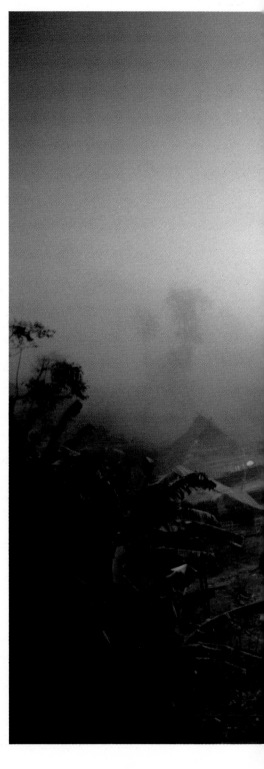

Early morning mist rising from the lowlands
shrouds the forest beyond the east slope
of the village of Napeh. These half-dozen
thatched houses, each flanked by a small
granary, make up only a fraction of the
65-house village built into the steep hillsides.

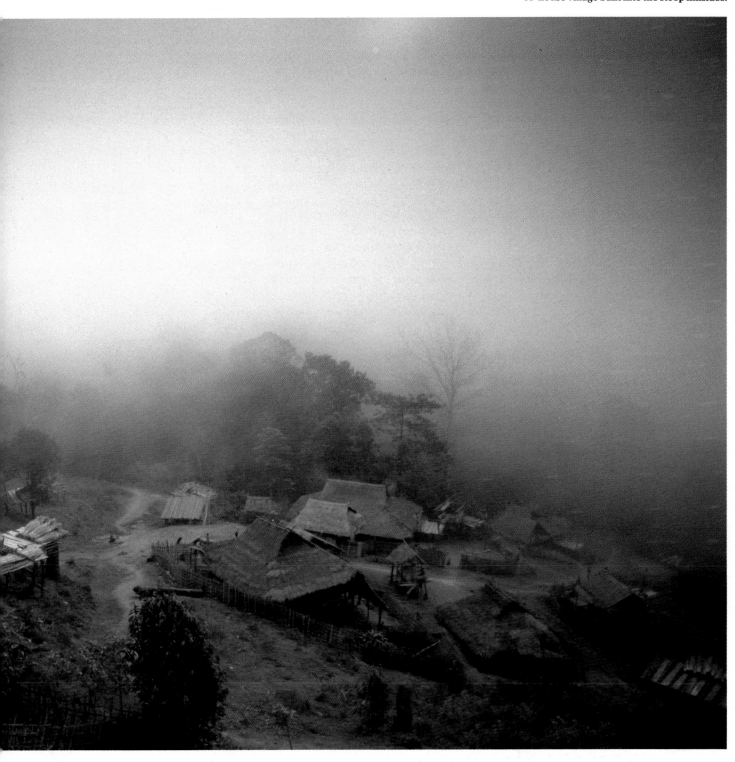

might recount dangerous exploits on the Matterhorn. Some of the most charming stories Dr. Lewis collected have a glint of this wry acceptance. One example tells of the sad demise of an Akha man who had just taken a bride. The "tragedy", like most adventures in Akha legend, occurred on the trail, as the happy ancestral couple were walking with packhorses towards the husband's village. During the journey, about midday, it was very hot and the couple grew tired. They were walking through the swiddened fields at the time, so there were no trees where they could tie the horse. "Where on earth can I tie the horse?" asked the husband. "Tie it to your big toe," said his wife. So he tied the horse to his big toe and they squatted down to eat. As they opened their packets of rice, a huge wasp came flying out and stung both the horse and the husband. The horse went galloping off down the mountain, dragging the man behind him, still tied by his toe. Down and down they went, finally tumbling into the valley, where both were killed.

This episode forms part of a long tale the Akha use to explain their origins as a people and the emergence of their society. In Akha mythology, everyone and everything, both human and spirit, is descended ultimately from the great ancestor, A-poe-mi-yeh. Originally, humans and spirits lived together in the same houses in the Ancestral Village, but humans slept at night and spirits slept during the daytime. Later, conflicts arose between humans and spirits, each of whom took advantage of their waking hours to steal from the other. Finally, they agreed to split up and live in separate worlds. Humans, who had the first choice, came to this world. The spirits had no choice but to retire to the spirit world, a place that is a mirror image of the human world. It has its night during the human world's day and its long rainy season during the human world's sunny months. The spirits came to love the rain, so now they come to the human world during the rainy months—between May and October—and plague the people with disease.

The Akha conceive of epilepsy, smallpox and measles, for example, as if they took a personal, spirit form. Dr. von Geusau pointed out, however, that the Akha were no more afraid of such spirits than is the average Westerner of bacteria or a road accident. They know the danger exists, but believe that, if they take certain precautions, the incidence of disaster can be minimized.

The Akha also believe that every significant element in their world—such as people, rice, money, animals, trees, streams, guns—has an indwelling essence which they treat as if it had a personal existence. They designate such essences by a word meaning "owner" and pay them great respect, for they assume that if the spirit owner of rice, for example, is not given the right consideration, the harvest will be poor, and a hunter who does not pay respect to the owners of large game animals will not be successful in the future.

For the Akha, today as in the past, prudent behaviour also means observing the ritual requirements, evolved by the generations of ancestors, that form the core of *Akhazang*. From their home in the Ancestral Village, where all dead Akha hope to return, the ancestors maintain a lively interest in the living, even though they play no active role. The living therefore must turn to the dead for guidance. The Akha do not worship the ancestors; but any who

fail to pay due reverence would not be showing proper respect to tradition, and ill-fortune would certainly be in store. By caring for their ancestors—whom they invite to appear at intervals during the year to receive ceremonial offerings of food and drink—the Akha tend and maintain the continuity of the generations, and help to ensure the survival of *Akhazang*.

As I neared the end of my reading and grappled with the complexities of the Akha world view, Dr. Lewis and Nina Kammerer impressed one crucial fact upon me: that *Akhazang*, the Akha Way, is not a static system. It makes many precise, minute demands; but in new circumstances, new procedures are devised. The Akha have never been loath to learn from their neighbours. Indeed, the ritual texts suggest that they were taught by the mountain Khmer, another wandering tribe, to build their houses, to embroider patterns on their clothes by the Shan, and to grow tobacco by the Chinese.

It was arranged that I should spend a few weeks as a guest of the *buseh*—or representative—in Napeh, one of the most southerly of Akha villages. Dr. von Geusau explained that Akha villages have two leaders: the *buseh* and the *dzoema* or headman. The *dzoema* is responsible for the smooth running of the village; he ensures that streets are cleaned, quarrels are resolved, and money for communal purposes is collected. He is a man of great importance and is considered to embody the spiritual well-being of the village. But because of this symbolic role, he must be shielded from the dangers of the outside world. It is, therefore, the *buseh* who conducts all the external affairs of the village and is recognized by the Thai government as the leader. In effect, he is a buffer between the government and the *dzoema*.

One morning, the photographer Michael Freeman and I set out for Napeh by automobile. Dr. von Geusau was due to arrive at 11 a.m. that day, for he had arranged to meet an international delegation there, up from Bangkok to review conditions in the hills. We were late leaving Chiang Mai, so Mr. Boontham, our Thai driver, sped down the highway taking incredible risks amid the heavy traffic of bullock carts and buses. An hour later, as we raced through a village, we were side-swiped by another vehicle. Fortunately no one was hurt and our car was still manoeuvrable. Further along, however, we had to turn off the asphalt road for a few miles of really rough track into the hills and it became obvious the car's suspension would never survive those ruts. Dr. von Geusau got out and started walking towards Napeh, several miles away, while Mr. Boontham, Mike Freeman and I drove back to Mae Suai, the nearest town, to fetch a sturdy four-wheel drive truck that would take us the rest of the way into the village.

Even with the land-cruiser, which we managed to hire, the going was still rough. The track curved up to the top of a ridge, then followed its spine, and in places the land dropped away precipitously on both sides. Finally, we turned up an even narrower trail, which rose steeply then emerged from the forest alongside one of the fields in which the Akha grew their rice—just one crop per year, since the autumn monsoon provides the only irrigation. The steep hillside had recently been cleared and blackened tree stumps rose out

Silver-Crowned Heads

The profusely ornamented headdresses worn daily by the Akha women set them apart from all the other hill peoples of Thailand. The examples here reflect the varied styles adopted by women of different ages and from different regions.

Even baby girls—and, in some of the communities, baby boys—wear a form of headdress: a cotton bonnet, sometimes sewn with cloth, buttons, beads and coins (top row, second from left). As she grows up, a girl will add silver discs, white seeds known as Job's tears, and red and white beads, until the cap is covered. When she reaches her mid-teens, she will adopt the full headdress of an adult woman, an elaborate construction hung with all the silver she can afford.

One style, worn by the Napeh women, is a bamboo cone placed over a band of silver coins (middle row, second from left), embellished with gibbon fur, beads, silver hemispheres and dyed feathers.

The women of another Akha group wear coif-like headdresses whose side-flaps are decorated with beads and silver coins (middle row, second from right); these can weigh up to 10 pounds. A third style has a silver-plated board decorating the back, with coins and silver pieces dangling at the sides (middle row, left).

A 19th-century rupee from India, stamped with the profile of Empress Victoria, adorns the fringe of an old woman's headdress. All silver coins, whatever their age and origin, are prized as headdress ornaments.

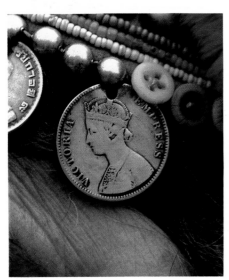

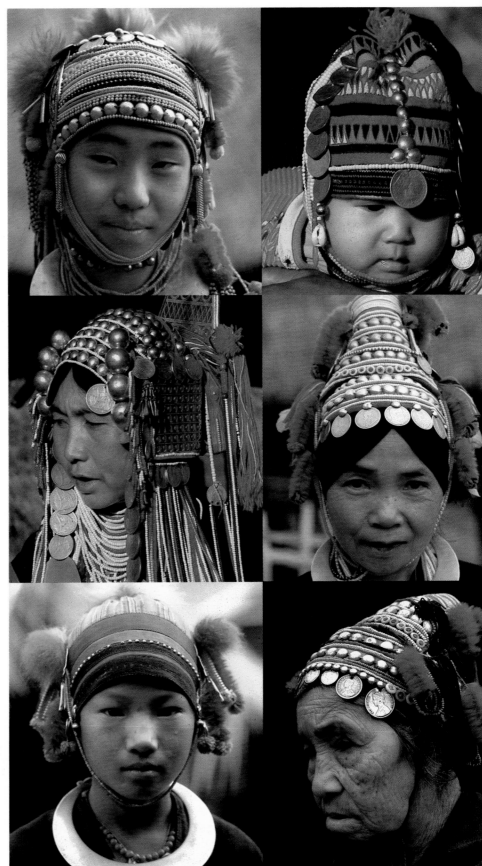

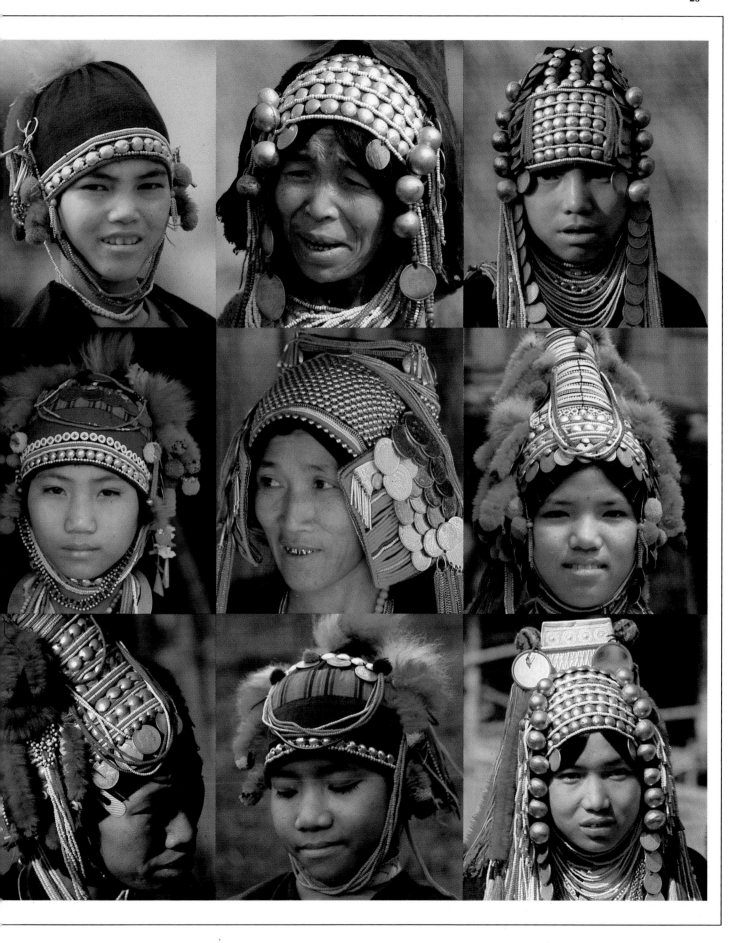

of the ground at odd intervals like funereal totem poles. In that isolated field, I had my first glimpse of the Akha. The glint of sunlight on silver caught my eye. Then I made out seven women who appeared to be wearing helmets. As we got closer I was struck by the breathtaking combination of their dark clothes surmounted by the most elaborate of headdresses.

All the women wore loose, open jackets of indigo blue over bodices of the same colour, and miniskirts, also blue, that hung low over their hips. Their knees were bare; their calves were covered in multi-coloured tubular cotton leggings that emphasized the lithe curve of legs kept slim and muscular by constant exercise. But the most striking aspect about these women was their headdress, which gave each of them an indescribably archaic and mysterious air, as of some almond-eyed princess from an oriental fairy-tale.

The four youngest women looked most fetching, their hats adorned with rows of silver coins and balls, strings and beads, and red and yellow ornaments of dyed feathers and gibbon fur that swayed and twirled with every movement. The older women wore less flamboyant ornaments, but they too struck me as impressively good-looking, with compact bodies and weather-beaten faces. As I was to discover, life in these hills is so demanding physically that it seems impossible for anyone to acquire what George Orwell called the "pudding faces" of comfortable city dwellers.

Indeed, for an outsider, just walking in these hills is exhausting. There are few opportunities for the easy strolling one is accustomed to in the West. Dr. Lewis told me that the everyday reality of their mountainous environment is deeply implanted in the Akha language itself. Their expression for "Goodbye" is "Let me go up"; "Go up carefully" is the standard reply. In normal Akha idiom, one goes either up or down. When Dr. Lewis translated the New Testament into Akha and had to recount the movements of Christ and the Apostles, he studied the topography of the Holy Land to determine whether the Lord and his followers had been going up or down. "What do you say when you walk along the level?" he asked his Akha informant. "Oh, we never walk along the level," he replied. "We are always going either up or down."

A mile or so beyond the field where I had seen the women, we came into the village itself, a sprawling hamlet of thatched houses built on stilts, looking like giant mushrooms. Dr. von Geusau had already arrived; the international delegation had overtaken him in their Land Rover and picked him up soon after we had turned back. After only an hour, the officials were ready to go, but Dr. von Geusau managed to tell them that a measles epidemic was ravaging the hill people's population—10 dead in the previous few months in this village alone and many more in the surrounding villages.

We had, in fact, arrived in Napeh on a day of mourning. A child had just died, either of measles or of the pneumonia that often follows. As a result, no one in the village was working. The people sat on the raised platforms of their houses, talking quietly to each other or eating. After the delegates had disappeared from view down the steep track, Dr. von Geusau took us to the house of Abaw Baw Soe, the village *buseh*. As is customary, we kicked off our shoes and ascended a few steps to the raised porch, where the *buseh* and his

A once forested hillside, cleared for rice planting by slashing and burning, rises steeply behind a large bamboo hut. Because the rice fields are more than an hour's walk from their owners' villages, such field huts provide temporary shelter during planting and harvesting. Stacked beside this hut are bundles of thatching grass, gathered nearby and ready to be taken home for roof repairs.

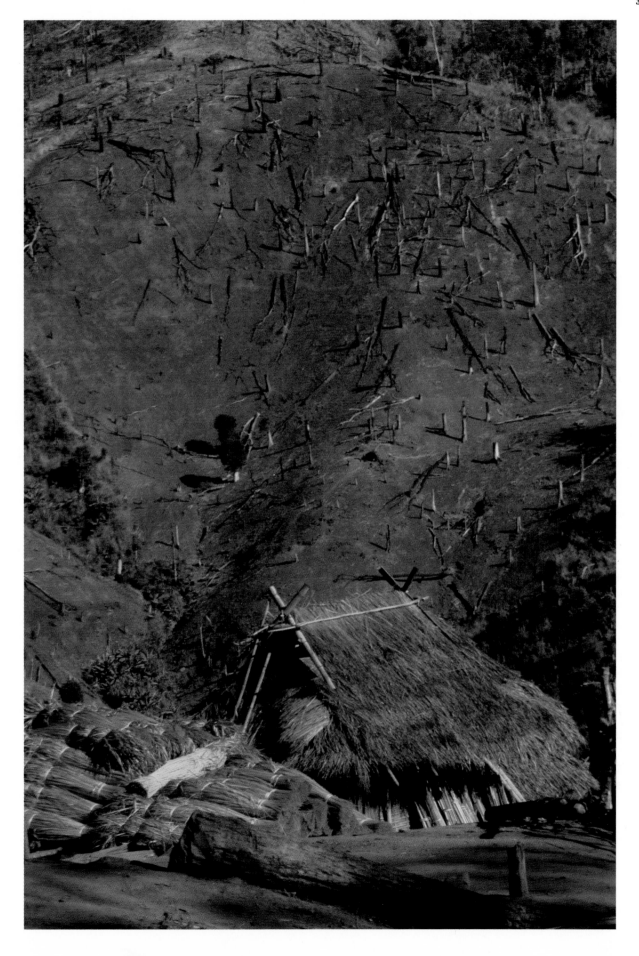

elderly mother awaited us. They served us strong tea and we sat on the porch exchanging names and pleasantries. Dr. von Geusau interpreted for us.

When we had finished, we went to the truck for our things and installed them in a small house at the back of the compound. It was a simple hut with a dirt floor. Dr. von Geusau explained that such small-scale homes are used by young married couples for the first years of domesticity; later, as resources accumulated, they would build a house raised from the ground.

While Dr. von Geusau sat with the *buseh*, I walked through the village. A group of children I met on my way smiled and seemed eager to make friends. When I reached the top of the ridge, I could see that the houses—65 of them, I counted later—were grouped in three clusters: one along the knoll, the other two nestling in the folds where it met the main bulk of the mountains. All the houses, large and small, were built to the same design, with high thatched roofs and, in lieu of chimneys, openings under the gables from which wisps of smoke drifted out. Where the slope was steep, only one side of each house was raised on timber piles; the other rested on the hillside itself. Bamboo fences surrounded each compound. The interlocking shapes formed a tight-knit pattern of thatch and bamboo against a background of red loam and green forest. An avenue about 30 feet wide ran down the spine of the central ridge and curved into the northern part of the village. Narrower tracks, laid out like the veins of a leaf, joined this avenue to outlying groups of houses.

It was now three o'clock and, before I could complete my tour, a child ran up to call me back for dinner. Inside the *buseh's* house, several village elders were seated on mats round a basket-weave table. The *buseh* was bending over one of three hearths set in the floor, stirring the contents of some pots.

The interior of the house was just one large room, divided by a shoulder-high partition. The house had no windows, only wooden doors at either end, which were both open at the time. It was quite dark even in the afternoon, yet suffused light entered through the bamboo wall. A shaft of brilliant sun-light—a single shaft, no more than six inches square, but almost as intense as a laser beam—cut through the top of the house from one gable opening to the other, illuminating the smoke that curled upwards from the hearths.

The thatched roof enveloped the living area in its shaggy mantle, creating a calm and almost womb-like atmosphere. And yet the house seemed alive and elastic. For one thing, the bamboo floor felt springy to the step. Its tram-poline-like vibrations were a constant reminder that we were on a platform that butted up against the hillside.

As I took my place at the table next to my companions, the meal was her-alded with cupfuls of home-brewed rice liquor. The oldest man present pro-nounced a blessing: "May good fortune come to you who drink rice liquor here; and may good fortune attend him who made the liquor, his house and his family. May he have enough to eat, and may he and his people be spared disease and misfortune." To toasts of *Daw! Daw!*—meaning Drink! Drink!—we raised our cups. Then the *buseh* brought pots of food over to the table.

It was one of those memorable occasions when the taste buds discover a whole new spectrum of sensations. The dinner began with several varieties

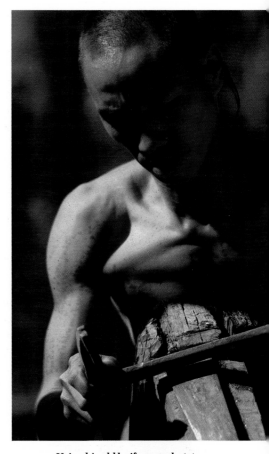

Using his old knife as a whetstone, a man sharpens the blade of a new machete that is held secure in a wooden vice. The village blacksmith will perform such tasks in return for work done in his fields, but many of his neighbours prefer to borrow his forge so that they can shape the metal themselves.

of pickled forest plants and field-grown vegetables, stir-fried beef and boiled yams, which the *buseh* had peeled himself with a huge knife carefully honed on a whetstone worn smooth with use. Akha men do their fair share of cooking; they often prepare the meat dishes and the vegetables, while the women prepare the steamed rice that appears later in the meal. But men and women eat separately: Abaw Baw Soe's wife remained at the other end of the house behind the partition; and when I asked about her, I was told, "She's not hungry," although in fact she was then munching something. We ate slowly and decorously, taking a mouthful of food with our chopsticks, then laying down the chopsticks for a while. Our cups of rice liquor were refilled at intervals, but nobody drank more than a sip at a time. A pure distillation of fermented rice, the liquor had a deliciously smooth, slightly smoky taste.

I soon discovered that you consume it only with the meat and vegetables; you must drink it up before the rice arrives and, if you are unable to finish it, you may pour it through a crack in the bamboo floor. I hasten to add that I did not pour any of mine through the cracks in the floor, but drank every drop I was offered. My hosts, too, consumed their liquor with enthusiasm; I discovered later that it is not a standard element in an Akha meal, but reserved chiefly for ceremonial occasions and entertaining guests.

After the last cup of liquor was drained, baskets of steamed rice arrived from the women's area and were placed on the floor between the guests. Hill rice has a distinct, nutty flavour and a more palpable texture than the bland white rice of the plains. It came to the low, basket-weave table steaming but quite dry; we rolled it into balls with our fingers and popped them into our mouths without the intervention of spoon or chopstick.

When the meal was over, the elders lit up their long-stemmed pipes and offered one to me. I joined them and we all smoked pensively. Dessert is not a standard item at Akha dinners, but Abaw Baw Soe served unlimited cups of bitter forest tea that I found invigorating. A small boy came in from the women's area and removed the table, dishes and all, to their side of the house; the whole thing weighed only a few ounces.

Beyond the partition I could see the women give the table a cursory washing down with water from a gourd and then store it on a rack overhead. The food left in the dishes went towards their own meal. Dogs came and licked up every grain of rice that had fallen to the floor. Then the women came to sweep the floor with a broom. The dogs had already cleaned up the place adequately, but the sweeping was an essential element in the meal. We did not even have to look up from our pipes while everything was cleared away.

At last it was time for Dr. von Geusau to depart. The roads are dangerous after nightfall, when bandits may lay ambushes at any point where the trail turns sharply. Every foreigner who has lived in these hills for any length of time has been robbed at least once. We watched from the porch as the anthropologist drove off with Mr. Boontham, then took an evening stroll through the village as dusk closed imperceptibly over the plains far below.

The Women's Role

The sphere of women in an Akha village is quite apart from that of men. The thousands of lines of oral history enshrining Akha traditions and customs in poetry not only lay down specific tasks for each sex but also divide the world into male and female zones, beginning with the partition of each house into men's and women's sides. While the village as a whole, the forest and the trails and places to which they lead are male territory, females confine their attention to the house, its immediate surroundings and the fields. The men usually cook the meat dishes for a meal, and may occasionally help out with such domestic chores as sweeping the floors and feeding the animals, but the women run the household, getting up first each morning to make sure it is well stocked with essentials: water, rice, firewood, and fodder for the livestock. Each stage in the preparation and cooking of rice is the women's domain, as is everything to do with cloth—from growing and picking cotton to embroidering and mending garments.

Only very young girls are free to play all day; working life begins at a tender age. "Seven years pass; she can learn to break firewood. . . . Eight years pass, she can learn to fetch water," runs an Akha text. Before a girl reaches her teens, she will be working in the fields; and the rest of her life will be a constant round of duties. Even old age brings little respite; elderly women continue to work as hard as their strength allows them, staying at home to cook and sew, and to raise their grandchildren while the younger generations go to the fields.

Every Akha woman, however, finds moments to relax. Unmarried girls skip and sing almost nightly at the village dancing ground. Married women may congregate nearby to hear the young people's songs, or meet round the fire of a friend's house. But even during such companionable evenings, the women rarely let their hands lie idle: stitching and spinning and bead-stringing accompany the chatter and laughter.

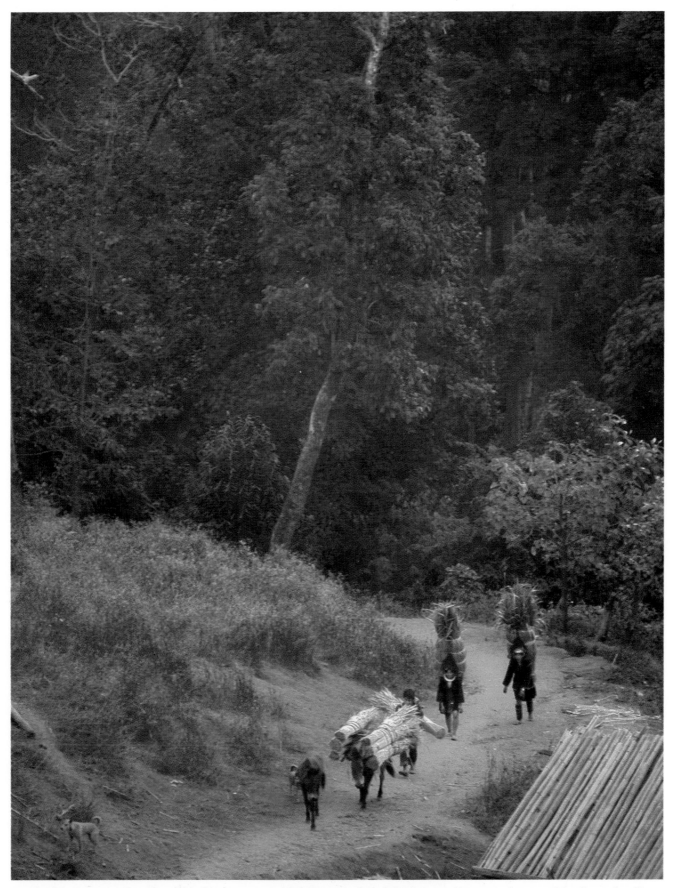

Weighted down by giant bundles of thatching grass, two girls follow a similarly laden horse and its owner along a path leading to the village.

A woman dressed in her everyday costume and silver jewellery returns home from her plot with a full basket of freshly picked raw cotton that she will spin and weave into cloth. Akha women traditionally wear their finery all day long, even when they are working hard in the fields or the forest.

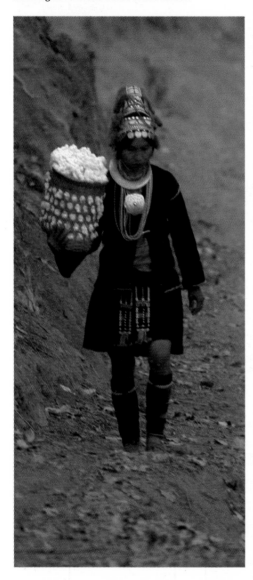

Using a section of bamboo bent into an arc and held taut with string, a woman seated on her porch whips up seeded cotton to prepare it for spinning. Poking the implement into a mound of cotton, she twangs the string; the vibrations lift the cotton into the air and fluff out the fibres. Afterwards, she will roll the cotton into loose cylinders, from which the thread is spun on hand-held spindles.

A woman fixes a newly washed ornament to the bamboo framework of the top part of her headdress. When she has attached the decorations that are lying beside her—silver discs and coins, and a string of dyed chicken feathers—she will place the ensemble in position over the circlets of beads and silver coins already on her head. Women rarely remove their headdress except for cleaning.

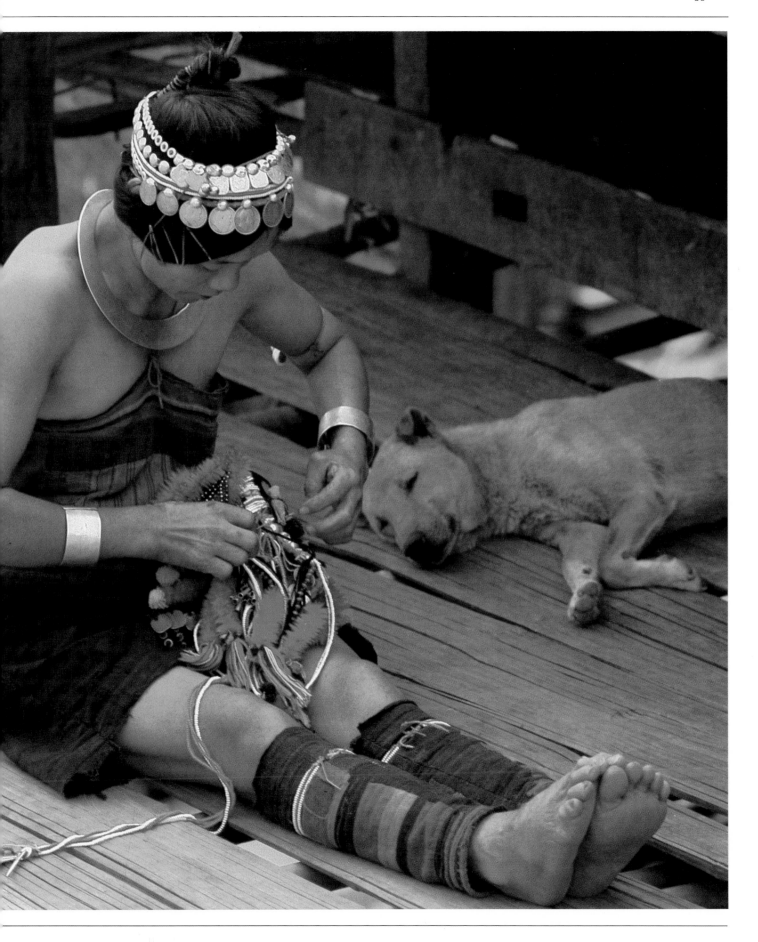

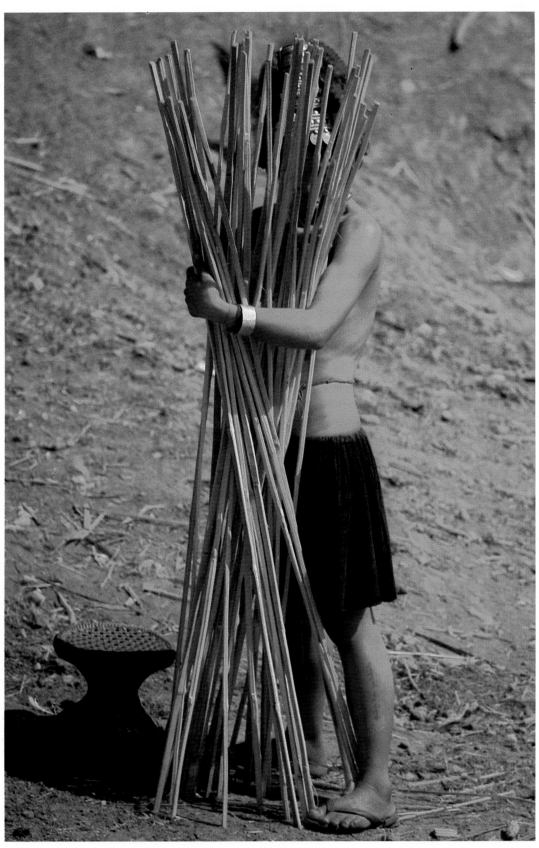

Stripped to her skirt in the heat, a woman picks up an armful of split bamboo to be used in the building of a roof.

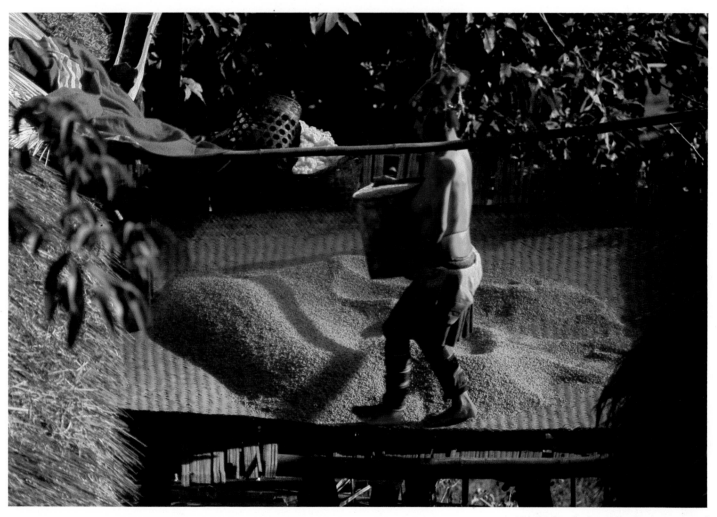

Newly threshed rice that has been spread on a mat to dry in the December sun is carried round to the granary in front of the house. From there, the women of the household will fetch a fresh supply each morning and spend an hour or so husking it.

With a threatening wave of her stick, an old woman wards off feathered interlopers as a litter of piglets devour their afternoon feed. Piglets are usually fed separately from adult pigs, in case the larger animals crowd their young away from the feed trough. Ducks and chickens are left to forage for themselves.

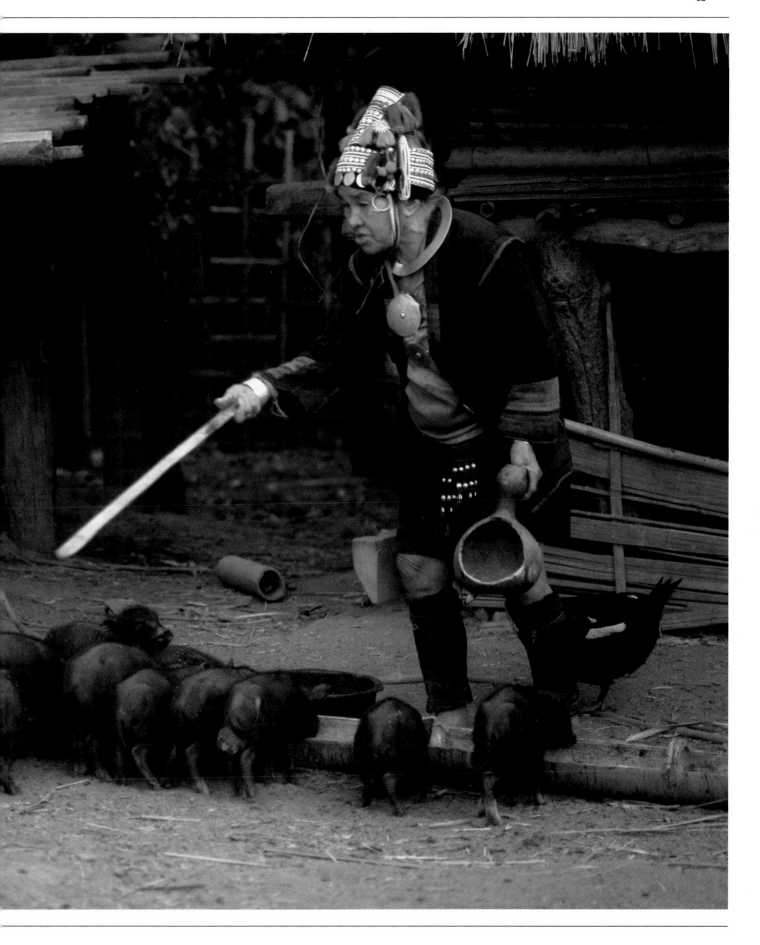

In the brief span of idleness at the end of the day, a group of matrons—one puffing on a pipe—chat on a neighbour's porch. While young girls prefer to spend evenings at the village dancing place, married women share their few leisure hours talking together.

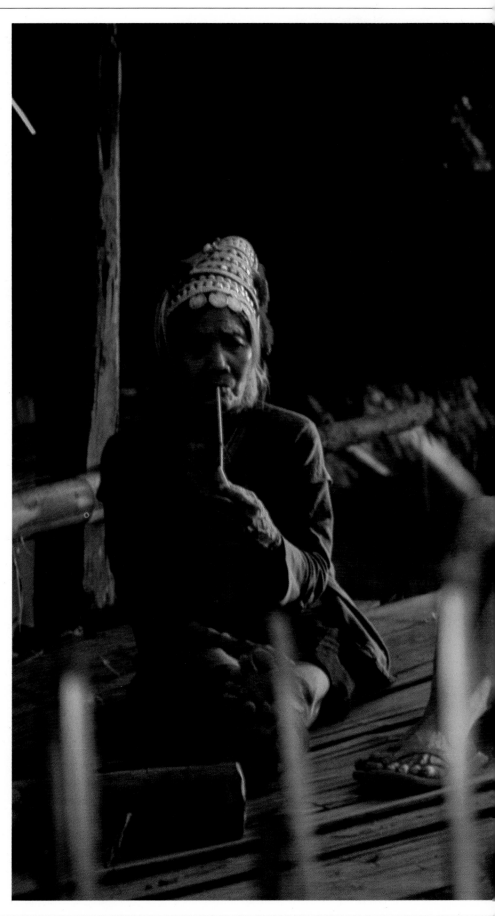

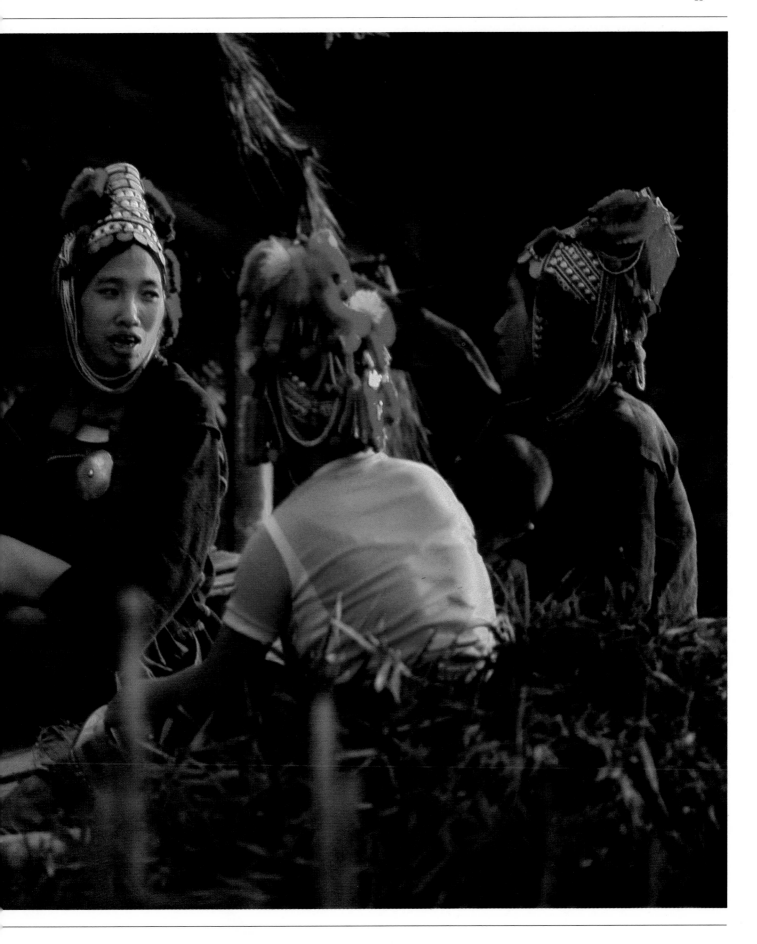

Two | Within the Village Gates

At the crack of dawn I was awakened by a sound that might have been made by a kettle drummer: de-bum-de. The whole village reverberated with it, de-bum-de (rest), de-bum-de (rest). Climbing from my sleeping bag in the little hut behind the *buseh's* house, I opened the bamboo door to look around.

A morning mist obscured the village. It had been raining all night—a rarity for northern Thailand in December; except between May and September the climate is usually dry and warm, unlike the sweltering, humid heat of the lowlands. Even the nearest houses were shrouded in low-lying clouds, but I could just make out the infernal machine that was causing the commotion. In the gloomy crawl-space underneath her family's stilt house, my neighbour Abeu, the first woman to begin her chores that morning, was husking rice by pounding it in a foot-treadle mortar. There was very little light to see by, but Abeu was entirely capable of pounding rice blindfolded, having performed this task almost every morning of her life from the time she was 12 or 13.

I walked over to her bamboo fence to have a closer look. She stomped on the treadle: first beat. The heavy beam of the mortar rode up in the slots of two supporting posts and hit the top with a crash: bum! The third beat, weaker than the second, was the muffled thud of the pestle at the end of the beam smashing down on to the rice. For a few minutes more, Abeu played her mortar solo; then, one by one, as other women joined in, the whole village throbbed with the sound of rice-husking. Abeu, who was young and energetic, was allowing just one beat of rest to each sequence, but women who were older or less robust tended to rest for three beats between stomps.

After pounding the unhusked rice in the mortar for 15 to 20 minutes, Abeu propped up the pestle with a stick and removed the grain in the mortar, scooping it out on to a winnowing tray of loosely woven bamboo strips. As she stepped out into the compound carrying the tray, the gibbon fur and silver coins on her headdress swayed and jangled. She began tossing the grain into the air with a light, rhythmic motion; then she shook the tray, one-two, one-two, rocking back and forth on her heels and bending from the

waist. She turned this routine chore into a kind of dance, with the rice as her partner. The grains, being heavier, fell back into the tray; the chaff described an elegant arc and fell past the end of the tray on to a mat at her feet.

It was all incredibly neat and accurate; hardly a grain of rice was lost from the tray. After winnowing for a few minutes, she first picked the impurities out of the grain, then tossed any rice that had remained unhusked into a container. About half the rice had escaped being husked and eventually would go back into the mortar to be subjected to another beating.

Periodically, when a significant pile of chaff had accumulated, Abeu sifted it through a fine-meshed screen. The outer husks were too coarse to pass through the sieve and also, supposedly, too stiff and rough to serve as pig food. Nevertheless, whenever she poured this residue on to the street it was snapped up by a passing pig. The lighter (and more nutritious) bran that fell through the sieve was collected in another container, to be cooked with the pig food. What fell to the ground was devoured by pigs and chickens, as well as dogs, who licked the rice powder from the ground with obvious relish.

Having pounded her quota for the day, Abeu piled five or six gourds into a bamboo-and-rattan back-basket and went to fetch water, another of her morning chores. A steep path led to the water source, a few hundred feet below her house. A spring deep in the forest had been channelled into a bamboo conduit six inches in diameter that carried the water to a wooden platform where people could wash and fill their gourds. Abeu washed her face, arms and legs; then filled the containers and started the arduous climb home.

By the time she had returned with her heavy load, the rice-pounding in the rest of the village had died away. Her young brothers-in-law, who had slept through the entire barrage, had risen from their bed rolls and were making tea while waiting for breakfast. Abeu disappeared with her water into the back of the house to start cooking. After their breakfast of rice, with a few peppers added for flavouring, one of the brothers took his gun and went hunting in the forest. The other two set off with packhorses to collect the

48

A stylized wooden figure of a man stands
near one of the two symbolic gateways on
the main paths into Napeh. A female figure
leans into the shadows (left). The gates—
seven-foot free-standing uprights that
support an ornamented crossbeam (inset)—
mark the dividing line between the village
and the hazardous world outside. The two
figures guard against evil forces and, as well
as the gates, are renewed each year.

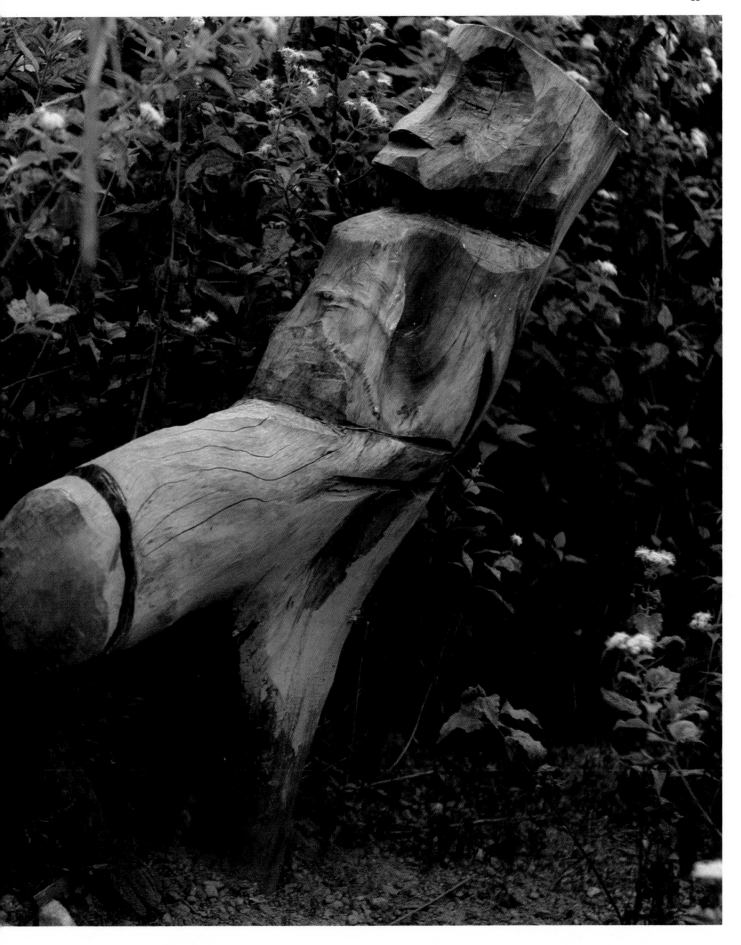

grain from one of their fields. I had arrived in the village just after the rice harvest had been completed, and the grain had already been reaped and threshed; all that remained was to store it safely. I knew that for much of the year the villagers had little enough of anything to eat; but just then there was an air of well-being as the bulging bags of rice—reminiscent of the bellies of the Chinese gods of prosperity—accumulated in the family granary, a small hut within the family compound, located just a few steps from the house.

At other times of the year, the constant heavy work of hoeing and weeding took all the women and most of the men out of the village to the fields, as much as two hours' walk away. But for a month or so following the harvest, there was little to be done in the fields and many people in Napeh stayed at home all day to work in and around their houses. The village fairly hummed with activity: women weaving cloth, men making baskets, fixing fences, repairing roofs. Everybody in an Akha village works from the day they are old enough to contribute anything to the family effort. Even the oldest people, and especially the old women, were perpetually busy: cooking, sewing, cutting up banana stalks, feeding animals, looking after the young children.

That first morning, the *buseh* Abaw Baw Soe had invited me to breakfast at his house, so I wandered across the compound and stepped up the ladder to his door. He was busy preparing food, so I took the opportunity to have a close look at the family home, where he lived with his aged mother, his wife,

At a water source near the rice fields, two children enjoy a splash before filling gourds they will carry in a large back-basket to thirsty field workers. In an Akha household, children of only six or seven are expected to fetch water and gather firewood.

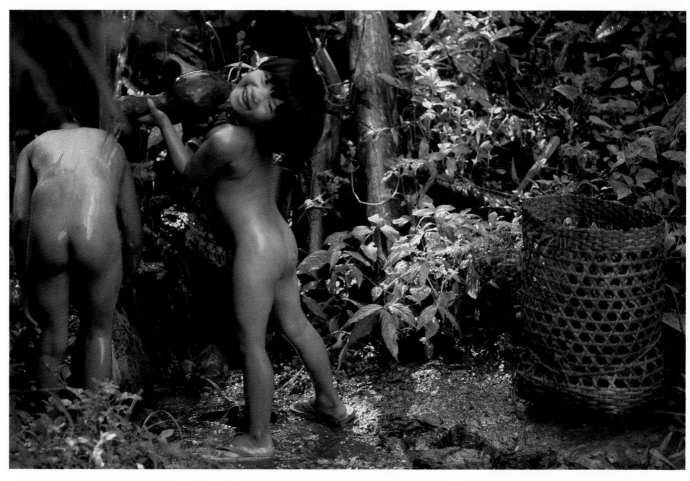

his son and daughter-in-law, and three grandchildren. Like all Akha houses, it was a miracle of ingenuity and made entirely of forest products: hardbeam timber, hewn with a narrow-bladed axe, for the uprights and crossbeams; imperata grass, cut and dried, for roof thatch; and the rest made of bamboo.

Bamboo formed the web of struts supporting the roof, bamboo served as cross-bracing at ceiling height; bamboo provided floor joists and shelf supports; and bamboo—split and flattened—made floors, walls and the central partition. The whole structure was elegantly counterpoised and interwoven, and strong enough to resist the strongest monsoon gales.

The shoulder-high partition across the width of the house divided it into a men's half and a women's half; but the barrier at the upslope end stopped short of the wall, leaving a passageway through which the family could pass back and forth to talk to each other or to carry food. Large hearths—square wooden boxes filled with earth—were sunk into the floor on either side of the partition, and that morning a fire was smouldering in each of them. The main floor beam ran the length of the house beside the fireplaces, splitting each room functionally into a working and a sleeping section.

The division of the house into zones for men and women, for sleeping and working, is just one of the countless traditions that govern every aspect of the Akha's lives—the poetic texts, couched in an archaic form of their language, are only a small part of the totality of *Akhazang*. During my stay I gained the impression that the villagers drew from their minutely ordered existence a secure sense of knowing the scheme of things and their place in it. It gradually became clear to me that underlying the apparently random and spontaneous nature of Akha village life was a complex tissue of the unwritten rules of *Akhazang*. These govern the villagers' relations with each other, with animals, with the natural world and its powers; they specify the correct way of doing everything, from building a house to laying out a village, from planting the rice to serving a meal, from welcoming the new year to dealing with outside communities. For the Akha, therefore, there is no real distinction between the level of ritual or prescribed behaviour and the level of secular daily life. They consider human activity to be intimately interrelated with the surrounding work, and their prime concern is that all such activities should be performed in the right way, at the right time and in the right place, so as to harmonize properly with the nature of the universe, and avoid disturbing its existing delicate balance.

During the daytime, there was constant coming and going on the men's side of the *buseh's* house. Men from all over the village, as well as from neighbouring communities, appeared at intervals and discussed the newly gathered rice harvest or the perennial problem of relations with the Thai authorities. They sipped tea or rice liquor, and smoked tobacco in their long, silver-mouthed pipes. Mats woven from split bamboo were laid out for the men to sit on; and I saw that if a guest who had been chewing betel wanted to spit, he politely lifted up the mat and did so through a crack in the floor.

The women's side of the house was darker and less frequented by visitors. Against an outside wall, just a foot or two from the partition, hung a tubular

bamboo container and below that stood a woven basket, about three feet high, with a lid; both were used in the ancestor-offering ceremonies that take place in each household several times a year, and their location makes that part of each house very important. A cauldron of pig mash—wild banana tree stalks, sliced like giant onion rings, mixed with water and rice bran—simmered in a separate fireplace at one corner. As the liquid in this pot was usually at boiling-point, the dishes were washed in it. Above the women's main hearth, a lattice-work rack hung just out of reach of the flames; it was used to store utensils and the gourds for carrying water, and to dry foods.

A similar rack on the men's side was decorated with all sorts of animal skulls, hooves and desiccated bones, most of them covered with a heavy layer of soot and dust. Abaw Baw Soe explained that some trophies helped to lure animals of the same species into the snares and traps that were laid in the forest. Others were meant to ward off scavengers, which might otherwise devour the food kept in the house and granaries.

Although most of the hill peoples build very similar houses and use the same materials, only the Akha have separate areas for men and women, where they sleep on soft bark-fibre bed rolls on the bamboo floor. *Akhazang* demands that parents should sleep apart, the father with the unmarried sons on his side of the partition, the mother with the unmarried daughters on the other. "Before something embarrassing, put a wall," runs an Akha proverb; "before a mouth that is laughing, put a hand." Yet, if the population is to increase, husband and wife must sleep together sometimes. During the early years of marriage, while a man is still living in his father's household, he and his wife will have a small sleeping house to themselves in the family compound. But later, when they have their own household, conjugal relations may be a delicate and difficult matter to arrange in a dwelling where eight or 10 people sleep every night. An anthropologist who worked among the Akha in the 1930s, H. A. Bernatzik, noted that in those days the father went to the mother, or vice versa, "when everybody is asleep", but said that nothing prevented the children "from observing sexual activities from the earliest age."

Today, too, married couples with children handle the matter with great discretion. "In the evenings, when the older children are away at the village dancing ground," one of my Akha friends explained, "the husband will go and fetch his wife and bring her round to the men's side."

It is very important for an Akha couple that their discreet love-making should result in as many children as possible, especially sons. The emphasis on having children is almost certainly a result of centuries of the unusually high infant mortality that typifies poverty-stricken hill peoples. At least one son is essential, not only for the protection of each family and the care of the parents when they get old, but also for the continuation of the ancestral lineage by which the Akha safeguard the survival of their identity as a people.

Most of the senior men in Napeh had lived there since the village was set up, some 20 years previously. With their wives and families they had moved south from Kajeh, one of the earliest Akha settlements in northern Thailand,

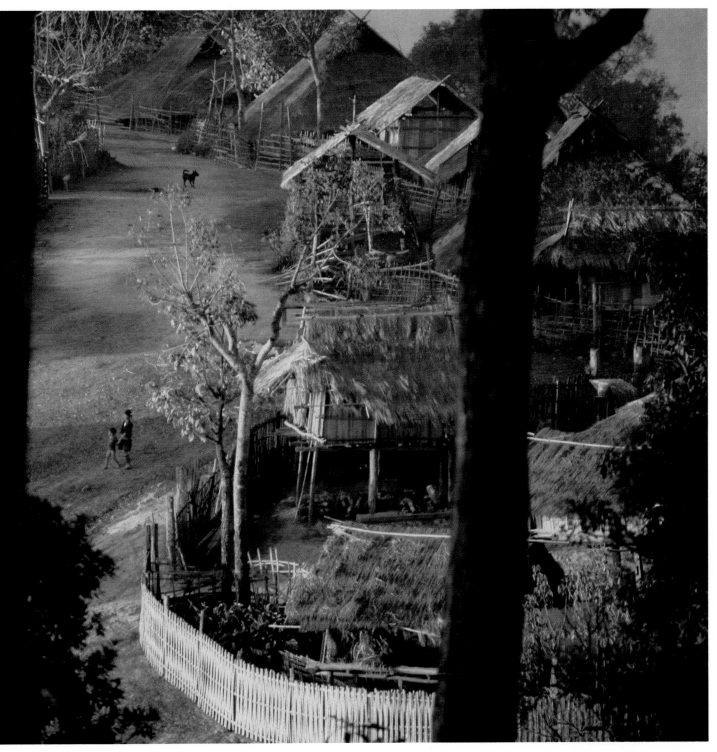

As the sun rises over Napeh, a girl and her brother stroll across the main thoroughfare of the village. Built wide to act as a firebreak, the avenue is an evening meeting place for men and women, while younger folk go off to the dancing ground at the village perimeter.

which was founded about 1925 very near to the Burmese border. The move to Napeh was undertaken to escape fights in the border area, where armed groups were operating. The families from Kajeh left the north-western part of Chiang Rai province, where the vast majority of Thailand's 140 or so Akha villages are concentrated (and where the Thai government prefers them to stay) and travelled more than 60 miles before they settled on a mountainside about 3,000 feet above sea-level, where a secondary ridge running east-west branches off from a main ridge running north-south. There were magnificent views of the surrounding countryside (although the Akha take that for granted) and several springs provided good, clear water for most of the year. The soil was fertile, and large tracts of undisturbed forest lay round about. The site seemed to fulfill all their practical requirements; but before building, the founders had to establish that their choice was indeed cosmically correct by conducting the ceremony required by *Akhazang*.

To determine whether the site was propitious, the *dzoema* dropped an egg, held beside his right ear, at the chosen place where a symbolic pattern had been laid out on the ground to represent a village. The Akha code holds that the shape made by the egg when it breaks will show whether the roads leading to the village will bring good fortune in the form of money, cattle and industrious people. Nature, in her infinite wisdom, has made eggs extremely frangible; when dropped from the height of a man's ear—even if, like many Akha, the man is rather short—they usually oblige the tester by breaking. Still, there are stories that now and then an egg remains intact. The *dzoema* must then take the same egg to another location and try again. Should it fail to break a second time he will take it to yet another place. There is a tale of one hillside where the egg failed to break once, twice, three times, each time forcing the settlers to conclude that the place was not the right one for them.

During the founding of Napeh there were no untoward incidents; the egg duly shattered, making a propitious pattern, and the *dzoema's* house was built on the spot. As soon as his home was completed, the incipient settlement acquired the status of a village and his followers could begin building their own houses. As in other Akha villages, no one tells people where to put up their houses, yet invariably the result not only has an organic unity that fits the landscape like a glove, but also conforms to the conventions of *Akhazang*, by which humbler families usually live downhill and more important households, including those of the village leaders, are located uphill.

It took me some time to arrive at a general understanding of the role of the *dzoema*—the village founder-leader—in the complex life and organization of the community. His authority and influence in the village are considerable, but they are based chiefly upon his personal qualities and his knowledge of *Akhazang* rather than upon his position. A council of elders—the men of 45 or 50 or over—meets to make day-to-day decisions affecting the village, and to deal with such problems as quarrels, theft and adultery when they arise. If an important crisis occurs—an epidemic, for example, a serious fire or an attack by bandits—all the heads of families gather to agree on a course of action. In this egalitarian society, where decisions are reached by

Cradled in a small cotton hammock strung between two house posts, a baby sleeps peacefully under the covered porch of the village leader's house. The dried bones that hang from a rafter above the cradle are all that remain of gifts from village hunters: the village leader is entitled to the right foreleg of each large animal killed.

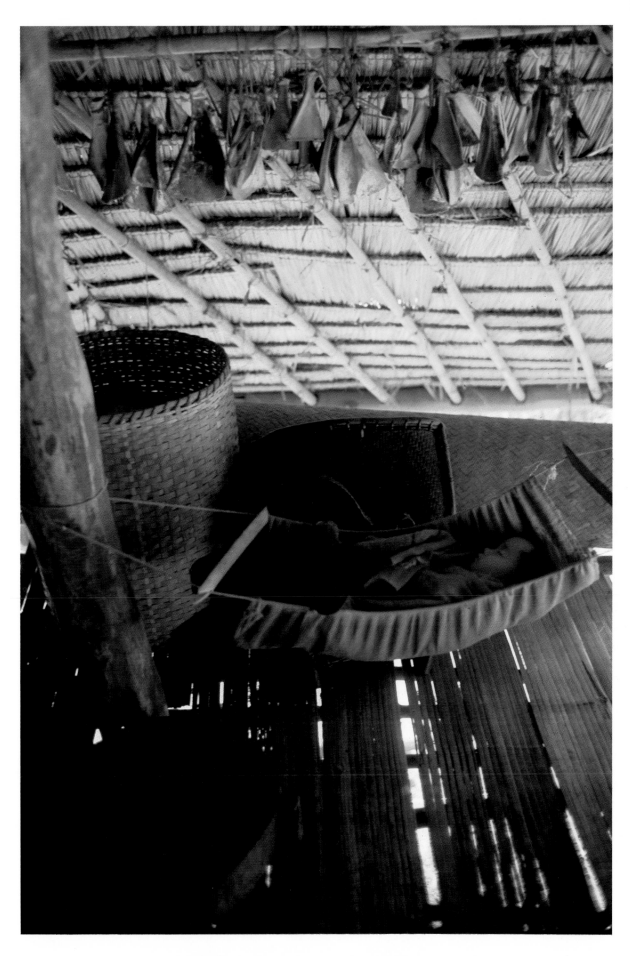

mutual agreement, the *dzoema* presides over the governing bodies, acts as judge in legal cases and has the final word on individual issues. Guided by his knowledge, the elders appoint the propitious days for starting to plant and harvest the rice, and so on, and the *dzoema* is responsible for initiating the ceremonies that accompany some of these important occasions.

In Napeh, a village of greater than average size and substance, there was another level of organization below that of the *dzoema*. As I had noticed before, the village consisted of three groups of houses connected by a network of large and small paths. I soon learned that each of these groups constituted a "sub-village" with its own leader, and that one of the three acted as the *dzoema* for the whole village.

The role of *buseh* in an Akha village is not such a venerable one, although it pre-dates the present-day function in Thailand of dealing with the authorities and any government representatives—such as schoolteachers, policemen or forestry officials—who may be stationed in a village temporarily or permanently. Since the hill-dwelling Akha have in various periods of their history been in contact with more powerful civilizations in the plains and the valleys below their slopes, it has long been important for them to have someone experienced in dealing with outside groups. Indeed, in some villages, a *buseh* of forceful character may have considerably more influence over village affairs than the *dzoema* himself. The blacksmith, too, whose functions are defined in the texts of *Akhazang*, has an important place—partly practical, partly formal—in the life of the village. Among other functions he acts as a sort of master architect, advising on the construction of new buildings.

Generally, however, the *dzoema* will guide the village, but by consent and not by force; and if any family head is dissatisfied with the way things are being run, he is free to leave the community and join another. Strong links of loyalty and mutual support are maintained between related families living in different villages. Sometimes, however, a whole group of families breaks away and establishes a new village elsewhere; but to do that, they must find someone properly equipped to be their own *dzoema*.

The *dzoema* must be a good leader and a wise man, who knows the rules of *Akhazang*, particularly those defining his own duties. In a settled community, the position of *dzoema* will often pass from father to son, but when a new village is to be founded, the elders will select by mutual agreement from among their number the man whose knowledge and character best qualifies him for the position. If possible, he should come from the clan to which the majority of the villagers belong.

But knowledge and ancestry alone are not sufficient: the *dzoema* should not come from a family afflicted by moral scandal or other irregularities, among which the Akha count the births of twins or deformed children. They consider all such births against the natural order, and the babies are suffocated at once, before the naming ceremony by which a child joins the Akha community. This attitude towards twins has much to do with the enormous burden they put on a mother who, in a community that always hovers at subsistence level, has to go on working in the fields to survive. But it is also part

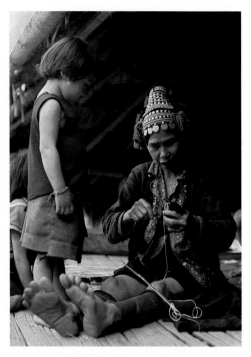

An old woman makes a living toy for her granddaughter by threading a length of cotton through the beak of a bird caught in the forest by a hunter. The other end of the string is tied to a stick that the girl will hold to guide the bird as it flutters about.

of the larger beliefs by which the Akha make sense of the world. For them, the human world of the village must at all costs be kept separate from the forest world of animals and spirits. Single births characterize human life and multiple births belong to animal life, so that the twins of a human mother are endangering the proper order as much as a single offspring of a bitch or sow.

The family of a potential *dzoema* should also be as free as possible from the taint of a "terrible death"—that is, any death that occurs outside the village, especially if it involves violence. According to *Akhazang*, a man should die in his own bed and if the *dzoema* and any member of his family do not conform in this respect, the prosperity of the village is bound to suffer, since it would argue a culpable lack of caution, and it is assumed something must already be awry for the family to have sustained such a misfortune.

In the spring that followed the founding of Napeh, the *dzoema* had a second major ceremonial function to fulfil: the setting up of two ceremonial gateways, one above and the other below the village. Akha gateways, unconnected to any fence or wall, always consist of two massive wooden uprights and a crossbar. The crossbar is decorated with carvings of birds—intended to prevent the village from losing too many chickens to the hawks—and a variety of other emblems. The uprights are festooned with bamboo garlands and, when one of the numerous annual village ceremonies is in progress, several large asterisks of split bamboo are also fixed to the gates in order to warn strangers not to enter until the occasion is concluded. The Akha are the only hill people in Thailand to possess such guardian gates, although several Burmese groups take similar precautions.

The village gates mark the dividing line between the human beings who dwell within and all forces that dwell outside; they are considered to be the community's main defences against vampires and werewolves, leopards and tigers—and, as the Akha themselves put it, against everything vicious or destructive: smallpox, leprosy and epilepsy; bandits and robbers; violent death abroad or sudden death at home. Visitors to the village are not obliged to pass through one of the gates, since narrow paths converge on the houses from all directions and the settlement as a whole is not fenced in. But the conceptual line surrounding the village is very real to the inhabitants.

Immediately outside the village is a surrounding belt of uncleared forest in which the villagers gather food for themselves, hunt for small game and cut wood for their daily needs. Bamboo fences and gates bar the trails out from the forest zone so that animals from the village will not damage the all-important rice crop grown in the swiddened fields that lie beyond, scattered over a wide area. The traditional forest belt surrounding each village has served the Akha in their beleaguered life as a protection and concealment from outside threats. Pressure on land due to the overcrowding of the hill peoples in Thailand and the encroachment of the lowlanders has, however, led to the dwindling of the forest belt around many villages, and to the unremitting use and exhaustion of the cleared fields.

Next to each village gate there are always two figures carved in wood: those of a man and a woman, about one-half life size, naked and placed close

Building to Plan

The typical Akha house is built on a steep slope with one wall resting on the bank and the opposite wall on stilts. Its one chamber—usually about 10 by 20 feet—is divided by a shoulder-high partition into separate sides for men and women, each side with its own entrance. A single floor beam running the length of the interior marks off the sleeping quarters of each section from living areas.

Life in the house centres on the two cooking hearths on either side of the partition; a third hearth near the women's entrance is used to cook food for the family's pigs. Also on the women's side are a special basket and a bamboo container that are used in ceremonies honouring the family's ancestors.

Since an average Akha house contains eight or more people, floor area is at a premium; the walls and space under the high-peaked roof are used for storage. A loft platform holds spare bedding and baskets, foods are dried above the fires, and utensils are kept on shelves. Outside the men's entrance, an open veranda provides a space where cloth and food can be dried, and the family can sit and talk with neighbours. Under the house is the women's rice-pounding mortar.

A MEN'S SIDE
B WOMEN'S SIDE
1 partition
2 floor beam
3 men's sleeping area
4 women's sleeping area
5 men's hearth
6 women's hearth
7 pig-food hearth
8 ancestor basket
9 ancestor bamboo container
10 storage space
11 open veranda
12 rice pounder
13 rice steamer
14 pig trough

together. They are simplified, elongated figures with large genitalia, carved from forked branches of softwood. Their predecessors lie on the ground. Both the figures and gates are renewed each year during the spring festival while the ones from previous years are left standing. One can tell the age of some villages by counting the number of accumulated gates, like tree rings; but eventually they collapse, moulder away and become overgrown with thorns and creepers. The Akha themselves are not altogether clear about the meaning of the carved figures. Some observers think of them as fertility symbols; in Burma, the Akha apparently believe that if they make the female figures quite fat many babies will be born in the village. But the Akha's texts seem to indicate that the unclothed figures at the gateways really are meant to frighten off intruding dangers.

Life in an Akha village is governed by innumerable rules, few of which at first sight seem to have a rational explanation: don't touch the gates, don't destroy termite hills in your rice field; don't drink rice liquor while you're eating. On consideration, though, some contain an obvious practical element—strict rules for the preparation of rice, for example, which also ensure its cleanliness. Others are primarily to show respect where it is due: it is never correct, for example, to make love in the fields in daytime, not only because it intrudes on working hours but also because it offends the spirit or life-force of the rice. Similarly, on days when the ancestors are invited into the village for offerings, people should not be absent working in the fields, hunting or gathering firewood in the forest, so these activities are specifically forbidden. However, other rules, such as those that prohibit people from combing their hair on ancestor-offering days or during certain healing ceremonies, are best explained in the light of the constant desire of the Akha that everything should be done at the right time and in the right way as dictated by their ancient texts, so to fit in correctly with the cosmic order as they see it.

Not all the villagers, of course, know the intricacies of *Akhazang*, and this explains the importance of another public figure in the Akha scheme of things: the "teacher-leader", whose title is *pima*. The *dzoema* concerns himself mainly with the well-being of the village as a whole, but an individual villager who needs spiritual or medical help will turn to the *pima* who is the perpetuator of the knowledge embodied in the ancient texts. In return for payment—usually some of the meat and money that is provided for the ceremony—the *pima* chants the long recitations that must accompany various important occasions, including funeral rites; and he also helps to heal the sick by his recitations, in which he goes in search of the soul or life-force of the patient that is considered to have gone astray in the spirit world.

The *pima* also knows rites designed to avoid future trouble if a bad omen or a dream has forewarned someone of an approaching danger. The *pima's* recitations serve to fortify the client's soul against the threat.

Since training in the ritual poetry takes years of patient study, not every village has its own *pima*. Napeh's *pima* was often called away to conduct ceremonies in neighbouring Akha settlements. No village, however, can exist without a *dzoema*, to provide leadership in the internal affairs of the village;

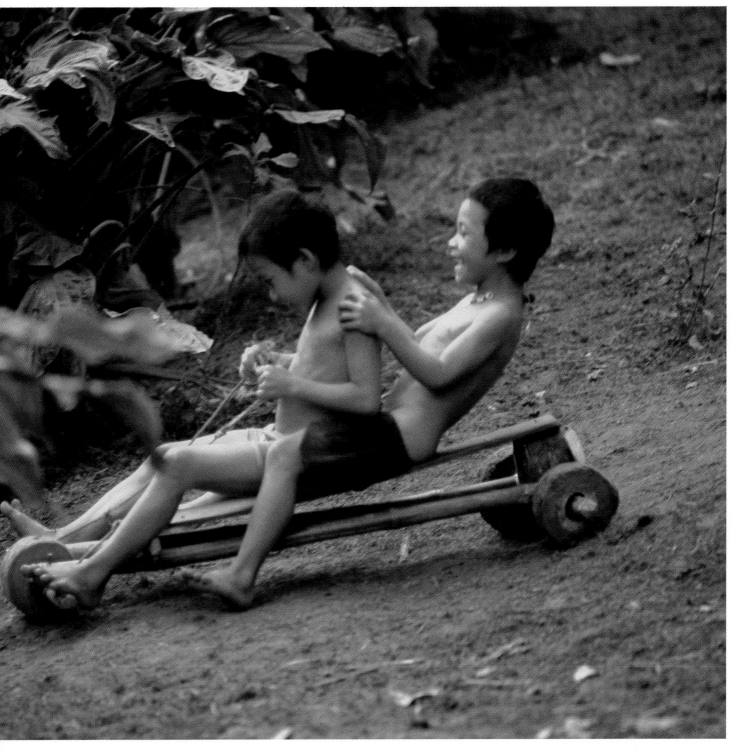

Two playmates race gleefully downhill on a
three-wheeled go-kart that is fashioned
from bamboo and hardwood. Fathers
and elder brothers usually build the vehicles
for the little children; the older ones
soon learn how to make their own go-karts.

and each community must have a *buseh*—chosen for his diplomatic skill and knowledge of the Thai language—for dealing with the outside world.

During the afternoon of my first day in the village, I sat outside the door of the men's side of Abaw Baw Soe's house, on an open platform, or veranda, of split bamboo that served as an all-purpose work area. It was at a slightly lower level than the rest of the house, but still raised a few feet from the ground. On it the women sewed and children played; peppers and forest plants dried in the sun; and newly woven cloth was hung out after being dyed. There were sacks and baskets to lean against and the veranda floor was comfortably springy, making this an airy and convenient vantage point from which to observe all that transpired in the village.

Mothers passed by, carrying their babies in sheets of cloth wound round their backs. The babies rarely cried; in fact, they seemed to sleep most of the time, soothed by the constant movement. When the mothers were standing at rest, they always performed a curious little dance step, on the spot, that imparted a steady rocking rhythm to the entire body: jig-jig forward, jig-jig back. At one point I noticed four or five baby-carrying women had stopped to talk to one another, all of them jigging in place as they chatted, while all the babies were sound asleep on their backs.

The toddlers, however, were less easily subdued. Indeed, small children were the only Akha I ever saw who seemed the slightest bit rebellious. On the whole, the villagers were very gentle with them; but when sweet reason failed to work, a good whack was sometimes called upon to do the job. I watched one little boy running down the street with his older sister in hot pursuit, the silver on her tall hat flashing in the sunlight. She kept calling after him, but he neither looked back nor answered. She ran faster, finally caught up with her disobedient brother and fetched him a painful wallop round the ears. Then, disregarding his tears, she put her arm lovingly round his shoulders and led him back uphill.

Oblivious to these domestic dramas, chickens squawked and scrabbled for their living in the compound below the terrace. Dogs, pigs, cows, goats and horses were everywhere. Over the next few weeks, I spent many hours surveying the scene from this vantage point and I came to understand just how important animals are in the existence of the Akha. Whatever the villagers do—eat, sleep or work—animals are never more than an arm's length away. Dogs stand at one's elbow during dinner and will lick the plates clean unless someone shoos them away. Ducks, like Capitoline geese, challenge visitors approaching the village; goats and kids venture up the steps of the houses unless actively discouraged. In spite of the omnipresence of animals, strict rules also apply to them. Pigs, cows, goats and horses must never enter the house; if they do it must be ritually cleansed. If a pig or a goat gets on the roof, it is a very bad omen and the house must be rebuilt.

Nobody thinks it the least bit unusual that every activity may at any time be interrupted by minor animal crises. Dogs begin fighting in the middle of breakfast and someone has to separate them by throwing a bucket of water

over them. Pigs dash between one's feet at night as one gropes for the forest fringe that serves as a lavatory. If one were to make a tape-recording of life in an Akha household, one would hear something like 17 animal noises—yelps, growls, grunts, the neighing of horses—for every human sound.

An Akha village, so it seemed to me, was a community of free creatures bound together in voluntary association. Horses are often put out to graze on the stubble in a harvested field where nothing prevents them from wandering off; they rarely do. Cows are allowed, even encouraged, to amble into the forest to feed on tender bamboo shoots. The pigs, too, are at liberty to root in the forest, although they are also fed daily from the bamboo trough in the family compound. Black and half wild, Akha pigs are certainly the fastest eaters I have ever seen: in a single slurp they work their way down the trough with incredibly rapid motions of the jaws.

Every householder knows exactly which pigs belong to the family and if a stranger piglet sidles up to the trough it is ejected by one of the women giving out the mash. The pigs themselves recognize their owners and respond instantly to the voices summoning them to eat. So do the chickens, although they are fed less systematically, and essentially have to make their own way in life. But they co-operate with the pigs to their mutual advantage. I saw one chicken on a pig's back, picking out its fleas; and sometimes a pig will deliberately present its snout to a chicken to be deloused. For the Akha, eggs can have important symbolic significance and are eaten chiefly in ceremonial circumstances. They are not daily food; most are left to hatch and, as a result, each hen is accompanied everywhere by a scurrying brood of chicks.

Nearly all the animals in the hills are only about half the size of the equivalent species in the lowland world. Akha horses are small, rarely more than 12 hands high—a pony by Western standards, but as sturdy as the Tibetan mountain horses from which they are presumably descended. They are seldom ridden, although occasionally a boy riding bareback will gallop down the main street just to show that it can be done. Yet, despite their lack of size, Akha horses can carry heavy loads over long distances and are used to transport produce from village to village. They are very agile, but on the steeper trails leading out of the village, even they sometimes have trouble keeping their footing. The path from Napeh leading to the next village crosses a forested slope that falls away sharply for about 400 feet, and anyone slipping over the edge of the narrow trail would not be stopped by a tree for at least 50 or 100 feet. The Akha slap the horses on the rump and hang on to their tails, hoping for the best and taking the hazards in the cheerful spirit of people who are riding a roller coaster at a fun fair.

The cattle are built on as small a scale as the horses; they are raised only for beef (and generally for sale rather than for consumption by the Akha) since drinking milk is virtually unknown among the peoples of the region. And the dogs, most of which have the features of a German shepherd, are only the size of a terrier.

The Akha take good care of their beasts and there is no malice in the way they kick or strike them to keep them under control, but they never treat

them as pets. *Akhazang* discourages stroking and patting animals—wisely enough as it reduces the danger of transmitting parasites and infections.

The ultimate fate of almost all these animals is to be eaten. That fate extends to dogs, since—like many peoples of South-East Asia—the Akha rely on dog meat as an economical way to boost their meagre supply of protein. Yet the Akha do not quite class dogs with their other creatures. They believe that their household dogs see spirits, undetectable by humans, that threaten the family; and though they will eat a dog they have bought from somebody else, they prefer not to consume their own.

One afternoon, a neighbour brought a young terrier to Abaw Baw Soe's house. The dog was a stranger to the family and tried to make friends, yelping and wagging its tail. The *buseh* and his guests climbed down the ladder from the veranda and one of them took the dog firmly by its lead. As it stood there, sniffing the air, another man came up from behind with a hardwood branch and gave it a tremendous blow on the head. The dog staggered and then fell forward; someone caught it, clamped its mouth shut with one hand and cut its throat with the other, all in the space of a second or so. There hadn't even been time for the dog to bark.

Without pausing to skin or eviscerate the animal, the men threw its body into the middle of a fire built in the adjoining roadway. After 15 minutes, it stiffened and the head bent back, as though baying at the sky. Later they removed the steaming carcass from the flames and carved it up on the terrace. The paws were cut off and distributed to the waiting boys; the rest of the carcass was divided into chops and joints. It was a man's work; but the small boys who crowded around were given a chance to learn by doing: hacking at the ribs with a huge machete. By way of light relief, a cockfight started shortly thereafter in the yard between two resident roosters; soon another joined in and it became a free-for-all. Later we all had dog and rice for dinner.

On this occasion, the dog had been slaughtered and consumed without any ritual, but on special days—whether for a village ceremony or a family occasion—dogs, pigs or even a water buffalo are killed according to precise rules. The *pima* chants the texts of *Akhazang*, and the head of the family touches the animal lightly with a knife on the legs, head, body and tail before slaughtering it. Sometimes the liver of a pig is removed so that the elders can "read" or interpret from its appearance what is augured for the future of the household. Finally, the most cheerful part of the ceremony arrives: the roasting and consumption of the meat.

The niceties of *Akhazang* also provide the occasion for varying from time to time the rice and vegetable diet on which the Akha chiefly subsist. Like humans, animals have their appropriate sphere of action and patterns of behaviour. Deviation from these norms endangers the proper order of things and the offending animal must be killed. A bitch must not whelp in the forest because she belongs in, or underneath, the house. Conversely, a pig must not give birth within the house compound, since its assigned domain is the forest: a brood-sow that offends must be slaughtered with the piglets. Whenever such a terrible thing occurs, the whole village is delighted. In effect, the

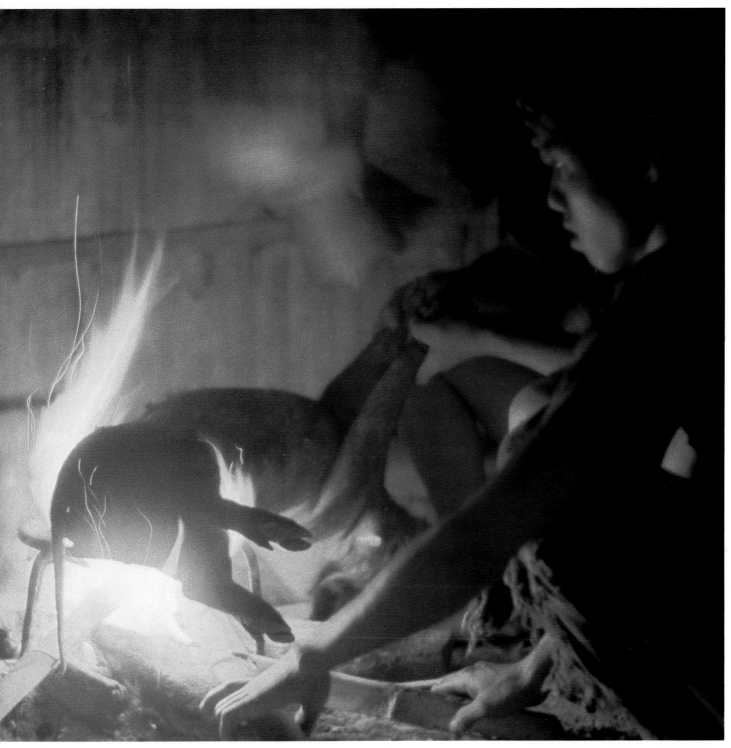

A pig that has been slaughtered for a family
meal to commemorate the death of a relative
is held over a blazing fire in the men's
hearth. When the bristles have been singed,
the meat will be cut up and boiled in a wok.

consequence is that such wealth as the village has is shared out in ways that are almost as unpredictable as a roulette game. And the poor tend to win more often than the rich, because the latter obviously own more animals.

At the end of the day, on the main esplanade—the broad avenue through the village that served as a road, firebreak and marshalling point for journeys—I watched the whole of Akha creation coming together: young girls, back from the forest with baskets of firewood; hunters with a few birds in their game-bags; and all the animals—the packhorses, the mares with their foals, the cows with their calves, the goats, dogs and ducks. Although the wolf did not dwell with the lamb, nor the leopard lie down with the kid, the scene brought to mind that splendid 19th-century vision of harmony in the animal world painted by the American Edward Hicks: *The Peaceable Kingdom.*

Of course, the realities of Akha life are harsh, and the noise they made was far from peaceable; the animals—barking, grunting or bellowing—seemed to work in relays to keep silence from falling. And in the evening, the boys and girls had their own boisterous gathering at one of the most important places in the village: the dancing ground that had been levelled on the central ridge just beside the upper gate. Here, where three long wooden benches were arranged at right angles to form an open-sided square, 50 or 60 of the village adolescents and children danced and sang in the evening moonlight. As the Akha poem has it:

> *Tonight I'll go to the dancing place,*
> *Many people go to the dancing place,*
> *As many as go to the fields in the morning.*

There were wispy clouds in the sky and Orion rose over the south-eastern horizon. The thatched roofs were silhouetted in silver against the dark trees of the adjoining forest. Girls in their early teens formed circles and did round dances with short, quick steps, chanting all the while—pentatonic melodies, sung in unison, or at least that was the intention. One boy had a cylindrical drum made of deerskin stretched over a hollow log, which he slapped fitfully, but the dancers paid only intermittent attention to his beat. They moved to the easy swinging rhythm of their dance songs, linking their left legs together now and then in order to hop in a circle on the right foot.

In the moonlight, the girls looked like pint-sized Amazons in gleaming silver helmets. The boys occasionally sang answering choruses, but tended to be shy about dancing and singing. They watched the girls perform ring dances, hopping dances and courting dances, shoulder-to-shoulder, circles moving within circles; the simple steps to basic rhythms. Some of the older people were present, but they held back from the dances. Compared to the exuberant young girls, even the young mothers, with babies on their backs, seemed impassive and distant. Lively and voluble though they may have been at their own firesides, it was apparently more seemly for them to behave in a detached manner at the dancing ground.

Uncomprehending lowlanders who have watched these moonlight revels have jumped to the mistaken conclusion that they are a prelude to a forest

orgy. In fact, they are simply a happy social occasion. Over a period of time I was to observe a consistent pattern: some of the teenagers sitting on the young people's benches indulge in great bear hugs and other overt signs of mutual interest, but their petting is in the category of horseplay rather than foreplay. The boys do a lot of running around, teasing, touching. A girl of 15 may be "caught" by two boys her own age and pretend to be struggling. But it is all a game. Romances certainly occur, for the dance sessions provide an opportunity for the beginning of a courtship, and Akha moral conventions permit couples to wander off into the forest, provided they are not so closely related as to preclude an eventual marriage. If a relationship prospers and a marriage is arranged, the young couple will go into the forest for a few days just before the wedding as a sort of pre-nuptial honeymoon. The Akha are proud of this custom, which symbolizes their freedom to choose the partner they want, instead of having to submit to the arranged marriages that are common among many of their neighbours.

One real purpose served by the nightly sessions on the dancing ground is to keep the children happy—a great ingathering of the community of the young. It is the high point of their day, and the occasion for learning songs—not from grandmother for a change, but from one's peers. The dancing ends well before midnight on most evenings and everyone goes home to bed.

If the moon is down, the Milky Way will light their path. The edge of the forest is alive with strange sounds: cicadas imitating birds (there are 20 varieties of cicadas in the hills); frogs croaking, hooting, burping and whistling. Once the people have gone to sleep, the animals can take over again. Though the chickens have gone to sleep, cattle bellow and pigs grunt through the night to an ostinato of pony and cow bells.

Bamboo walls admit every noise, even the rustle of a small animal's feet. Just when things seem to quiet down a little, some new theme will suddenly appear in the cacophony. A cow ambles down the village street and urinates just outside the house. A chorus of dogs bays at the moon. A fight breaks out among the pigs under the house. The grandfather next door can be heard snoring serenely across half the village.

The Akha are oblivious to all this and sleep through everything. But for me, night in an Akha village was sonically too exciting to be ignored. I would lie wide awake until shortly before dawn, then doze off just in time to be roused by the rice pounders.

Raising a Family Home

An Akha house is sturdy enough to last for seven or eight years yet it takes no more than three days to erect once the materials have been prepared. The family members who will live in the house do the work themselves, aided by friends who will expect reciprocal help when they in turn come to rebuild. Because a building can be finished so quickly, the Akha often pull down an existing house and build a new dwelling on the same site in order to make a fresh start after a misfortune, such as a death in the family.

All the materials for the house come from the surrounding forest and fields. The main beams and the piles that support the raised floor are hewn from hardwoods; the rafters, walls and floors are constructed of flexible bamboo; tall imperata grass provides the thatch for the huge overhanging roof. The feat of construction is all the more remarkable since the Akha have only the simplest measuring devices, and the only tools they use are a knife for cutting wood, a narrow spade for gouging out post holes in the ground, and a machete for hammering in pegs and shaping the materials. No nails or screws are needed; each element is trimmed to size on site, then slotted, pegged, lashed or woven to the next one. The result is a strongly knit, resilient structure able to withstand the heavy rains and buffeting winds that sweep the hill country during the monsoon.

Having decided to build, the members of the household prepare by cutting down trees, shaping posts and making the hundreds of grass shingles needed to cover the roof. Soon after dawn on a propitious day of the week—such as the day of the rabbit, an animal adept at digging—the head of the family collects his helpers, who eat a festive meal of dog meat and get to work. First, post holes are dug to hold the piles of the new house. Then comes the positioning of the ancestor post: the central pile in the front elevation that marks the division of the men's side of the house from the women's. Before the ancestor post is set into the ground, a short offering ceremony is carried out by the householder as a token of respect to the spirit that links the house to the soil where it stands. Once the dedication has been made, the house raising goes ahead swiftly. By the end of the second or third day, the family are usually settled in their new home. To celebrate, they invite the village elders to a meal at which the *pima* recites ancient verses describing how Akha houses are built.

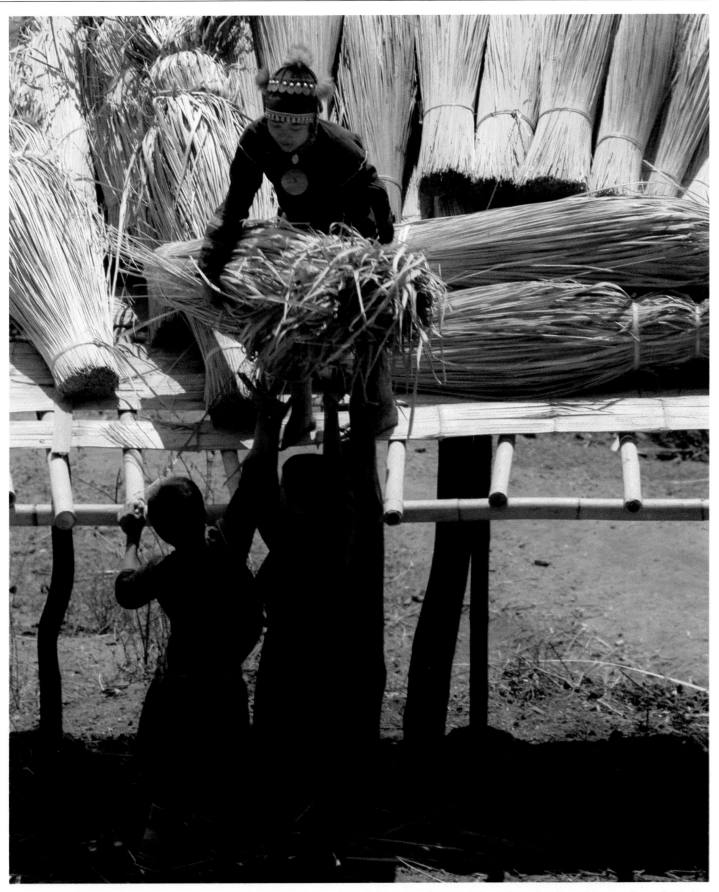

Several weeks before building begins, girls stack imperata grass on a drying rack. Later, the grass is looped over bamboo sticks to make roof shingles.

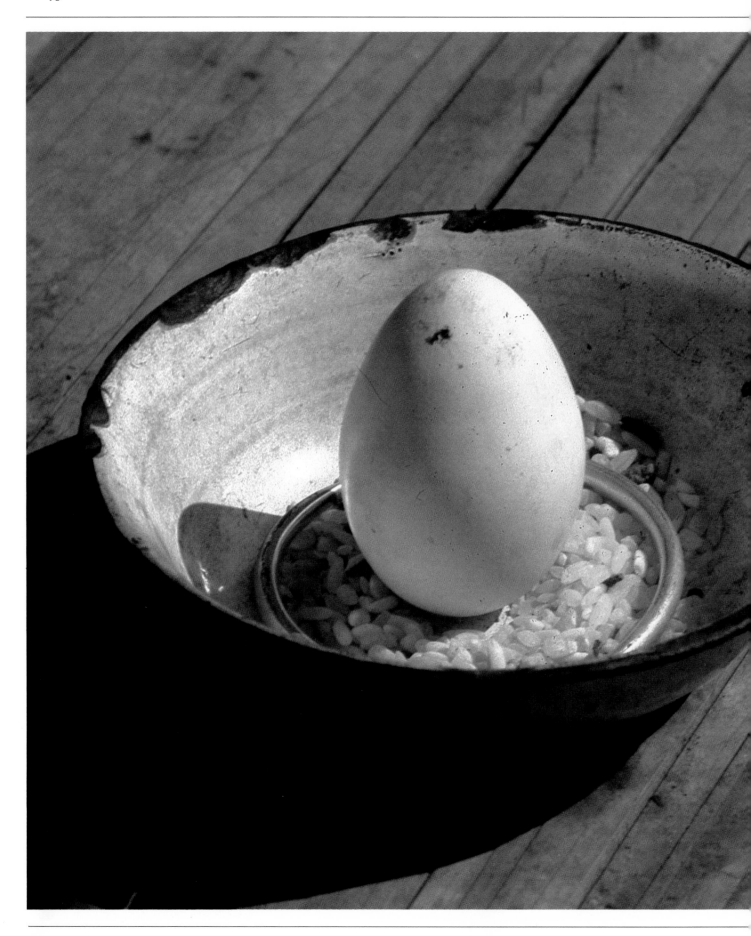

In a ritual marking the start of construction, an egg, symbolizing good health, balances atop offerings to the spirit of the new house and the earth beneath it. The rice invites plentiful harvests; the silver shavings taken from a bracelet belonging to a member of the household seek prosperity for the family.

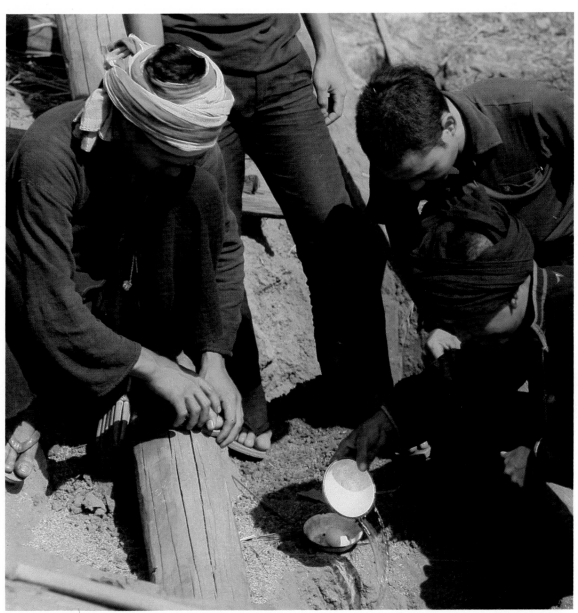

Watched by a few of his neighbours, the head of the house pours water into the hole that has been dug for the ancestor post—always the first to be set in the ground. The rice grains and silver shavings have already been placed in the hole; the egg will be saved for a ritual meal later in the day.

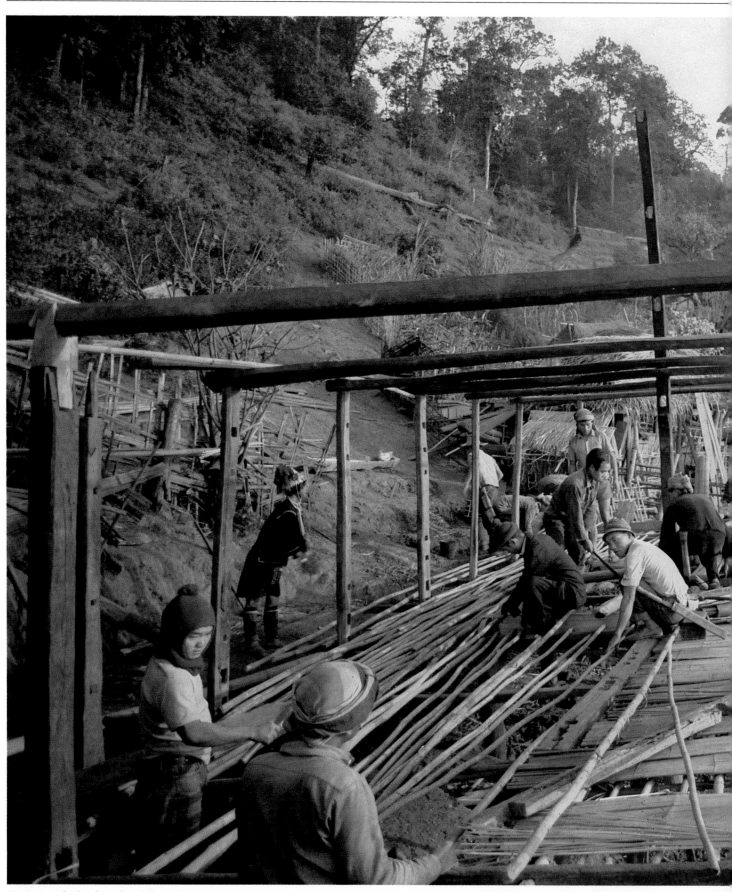

Having set the hardwood uprights and crossbeams in position, men cover the floor joists with long bamboo poles (foreground, left). Behind them, a team

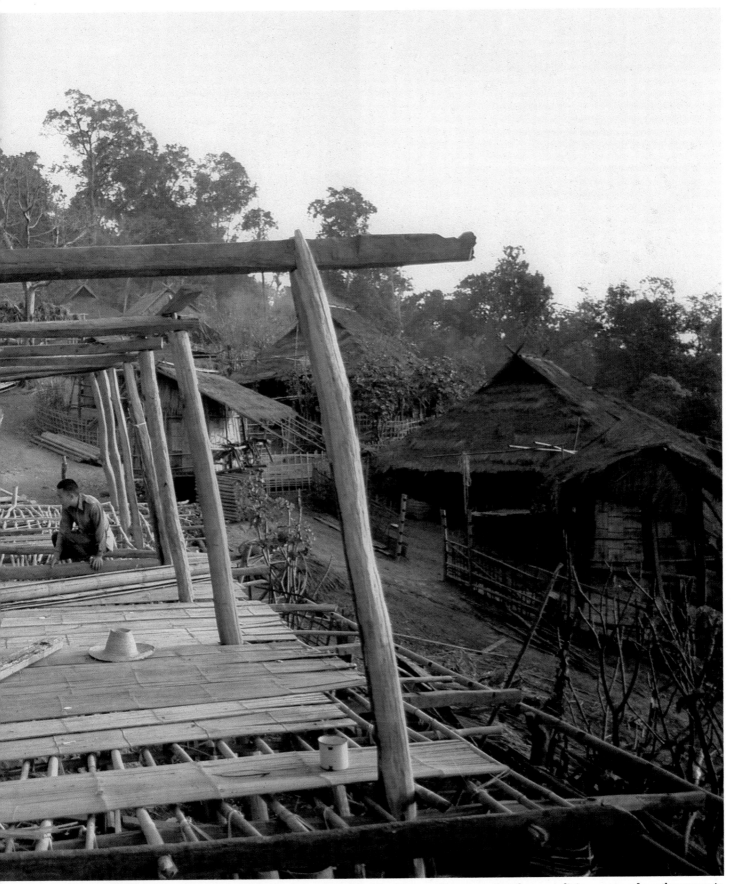

of three lays a beam across the width of the house; it will support a shoulder-high partition separating the men's living quarters from the women's.

Balancing on a cross-pole slotted into two of
the three main roof posts, a young man waits
to be handed a rafter, which he will cut to
size with the machete carried in his rattan
scabbard. The bamboo poles on either side
of the hardwood roof post serve to steady the
structure until the rafters are in place.

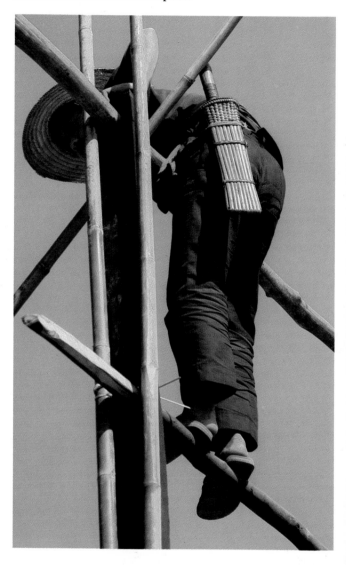

Working beneath the bamboo rafters, a man
eases a grass shingle into position so that
he can lash it down with one of the bamboo
strips held between his teeth. The strips
have been soaked in water to make them
flexible. To secure a shingle, the ends of a
strip are simply twisted together; as
the tie dries out, it shrinks and tightens.

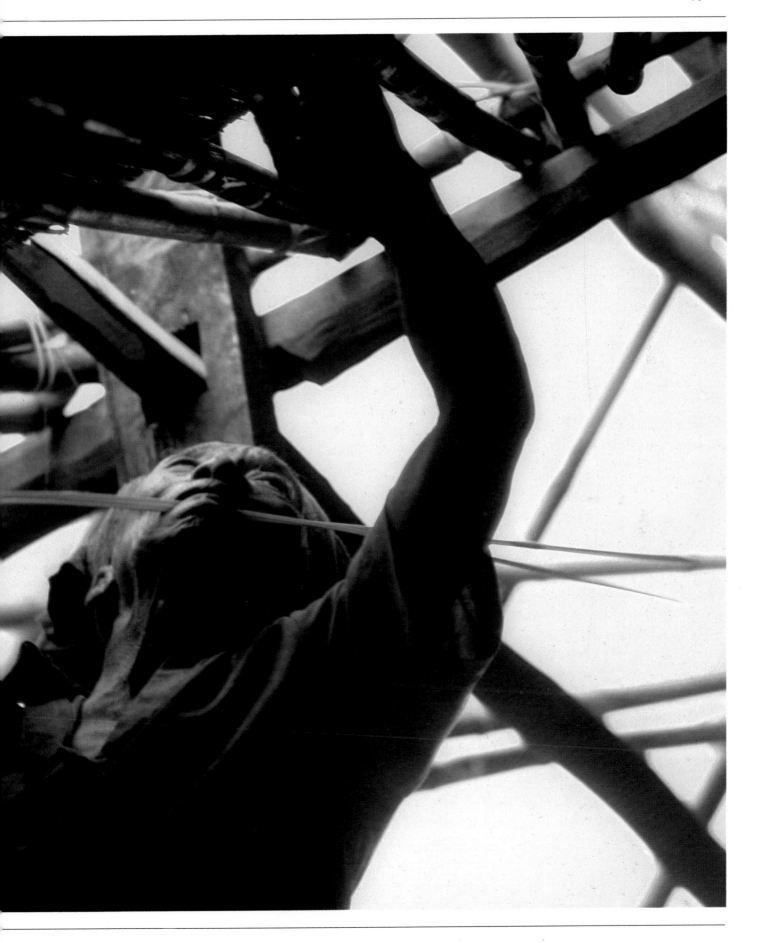

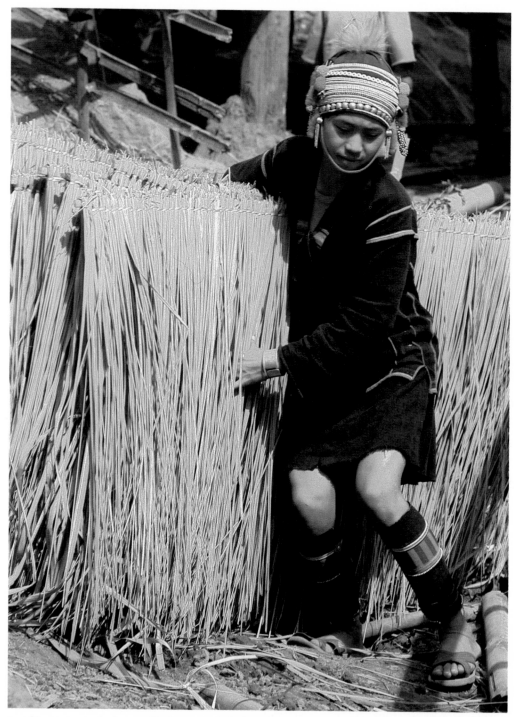

A girl heaves a stack of grass shingles towards the house, where she will pass them up to the roof workers.

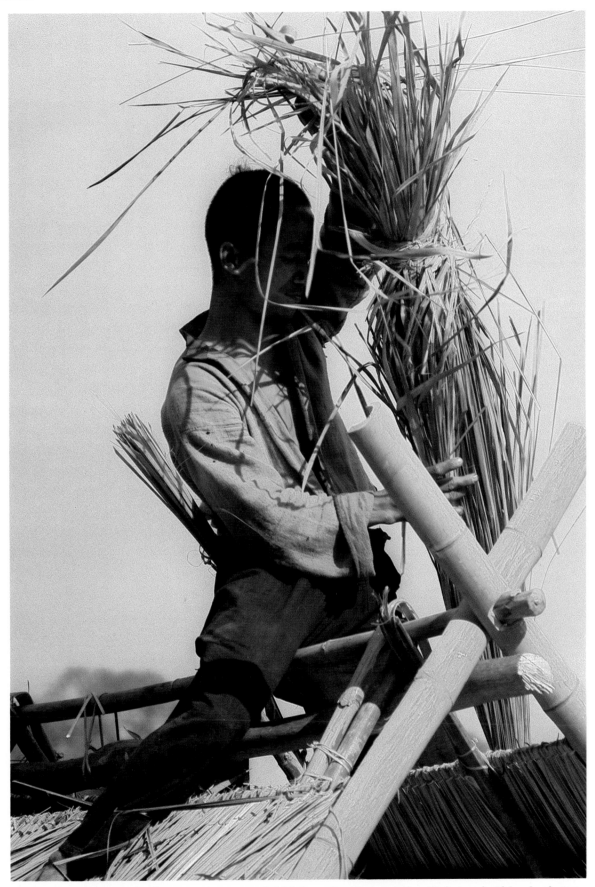

To make the roof both wind and water-resistant, grass is folded over the ridge pole before it is fastened with bamboo battens.

Shortly after moving into the new house, the owner is free to feed the pigs while his wife and mother tease cotton on the platform that leads into the dwelling. The thatch roof is already turning brown and will soon match those of the older neighbouring houses.

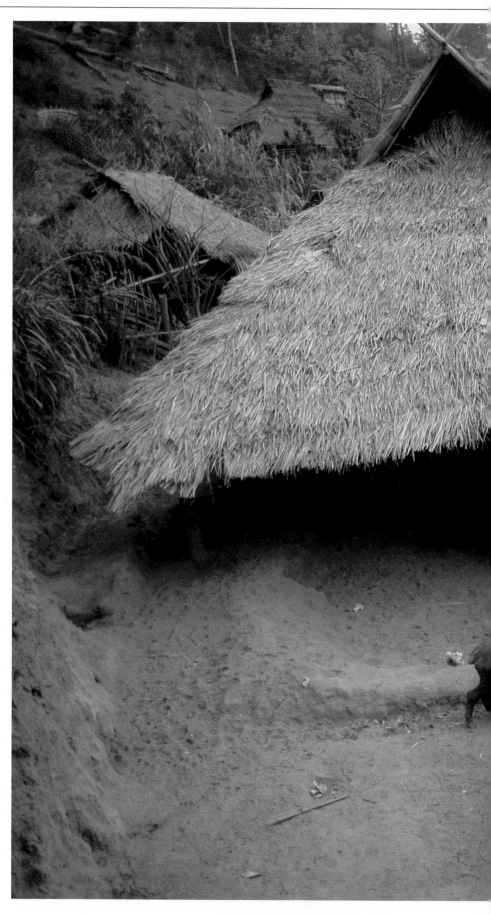

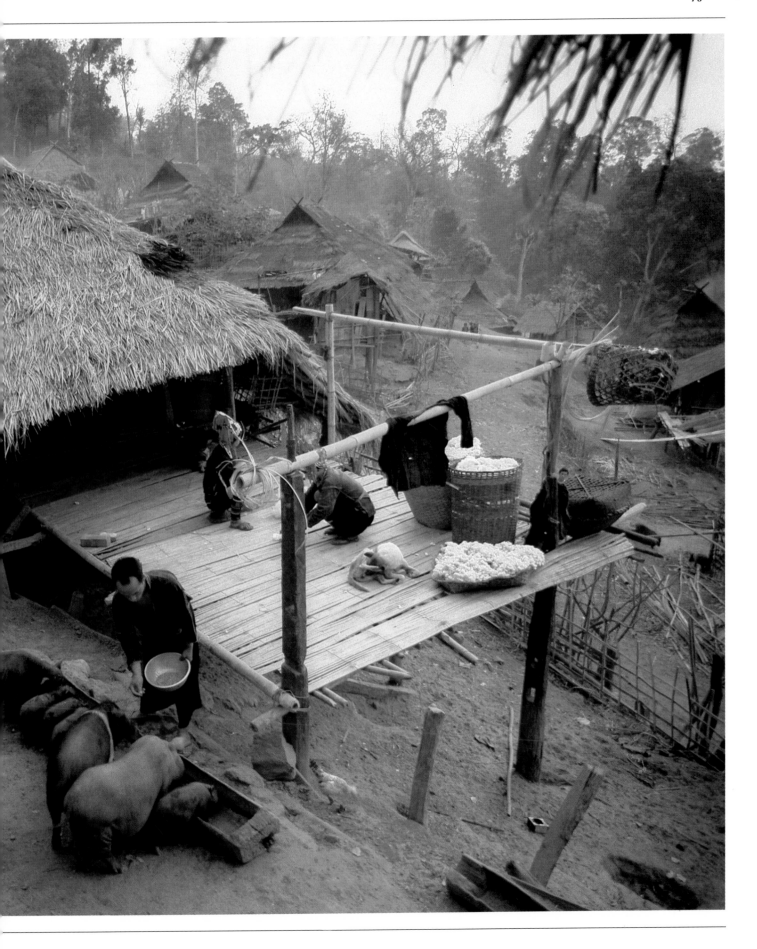

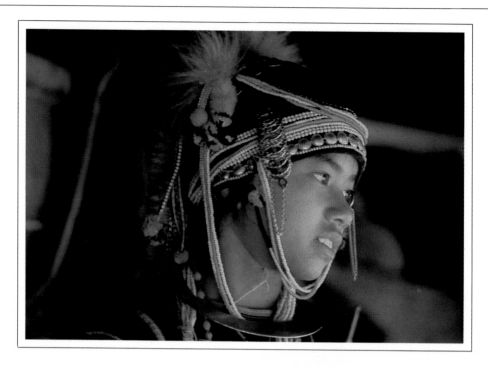

A Day in the Life of **Apoe**

When 14-year-old Apoe awoke at 5.30 a.m. on her bark-fibre sleeping mat in the women's half of her family's house, the bright December moonlight was still streaming down over the village and her mother was already up. Later on it would become very hot; but at this time of the morning the hill-country air was refreshingly cool. Sunrise was more than an hour away and her father continued to sleep soundly on his side of the partition. For a few moments, Apoe lay there watching her mother move around the house carrying the youngest child—three-year-old A-eh—slung in a cloth on her back; then Apoe got up herself. She had work to do.

A pretty, gentle girl, rather small for her age, Apoe had slept in her indigo cotton skirt, T-shirt and knee-length cotton leggings that were decorated with sewn-on bands of coloured cloth. She now donned her woven cotton jacket and put on her silver-trimmed headdress, taking time to adjust the dangling strings of beads.

Her first task of the day was to ladle rice, which had been left to soak overnight, into the rice steamer to be cooked for the family's breakfast. The steamer was a large wooden drum open at both ends. It consisted of a hollowed-out section of a tree trunk with a basketwork partition part-way up; the purpose of the basketwork was to hold the rice above the water whose steam would cook it. She stood the steamer in an iron *wok*, poured water into the *wok* and set it on an iron tripod over the embers on the women's hearth. She added twigs to the embers, then bent low and blew the fire into life.

Her mother now took Apoe's place at the hearth; and she and her sister Apha, three years her senior, left the house to start pounding rice with the treadle-driven rice husker located below the women's porch. The two girls worked together, one operating the heavy treadle while the other took husked grain from the mortar and sifted out the chaff on a woven bamboo tray.

Husking enough rice for the large family was one of the women's unchanging daily tasks. There were many mouths to feed. The diners would be Apoe's father and mother, her sister Apha, Apoe herself, two little sisters and a younger brother, as well as her elder brother's family—his wife and her three children, two of them from her previous marriage. Somewhat unusually, the family's eldest son, who was 21, had married a woman of about 30 whose first husband had been killed, leaving her with six children. According to custom, all the children should have gone to their father's relatives to carry on his family's lineage; but in this case, rather against village approval, the mother had brought a daughter and a son to be her companions in her new home.

Apoe's father was one of the minority of Akha men to have married two wives; but his senior wife had not

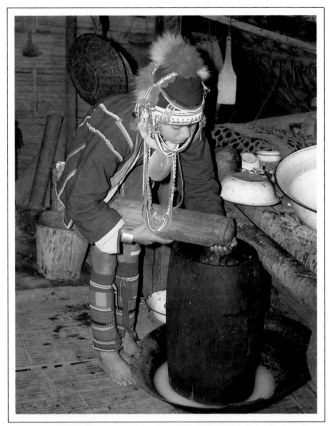

Apoe trickles water from a bamboo container into the rice steamer.

ready to be winnowed. As the daylight became stronger, occasional shotgun blasts rang out from the forest below; the boys of Apoe's age were already out, hunting with their home-made muzzle-loaders.

The sun had been up for half an hour when Apoe, who had husked enough rice for the family's meals for a day, went back into the house to wake her father, who was still fast asleep under his blanket. Abaw Aseh was a man in his mid-fifties—elderly for an Akha, whose average life expectancy is somewhere in the forties—and no longer in good health. Although he went hunting and fishing, he was not strong enough to do any work in the fields. The previous year, he had been obliged to sell the last of the family's silver in order to buy extra rice. Since he could not cut wood and bamboo necessary for building, the house was in poor repair: the floor was shaky rather than springy and the roof badly needed mending. Apoe's mother found her life hard and anxious, and her dour expression often reflected her worries.

Apoe turned to help her mother and elder sister prepare breakfast. Like all women in an Akha household, Apoe was expected to perform a long list of daily chores. Indeed, since her father's ill health left the family short of hands for labour, she had to work harder than most girls of her age—but she did so uncomplainingly.

By nine o'clock, breakfast was ready, and the men—Apoe's father, her married brother and seven-year-old

accepted the newcomer and had left him. She now lived further up the village. His other wife, Apoe's mother, had borne 13 children, of whom eight were still alive. The eldest son, his wife and three children had separate sleeping quarters in a little house within the family's compound, although they had their meals with the main household. The eldest daughter was married and lived about a quarter of a mile higher up in the village. A son of about 17 was living at a Buddhist temple in the town of Mae Suai about 10 miles away, while he attended the town's Thai school. There was a school in the village, but classes were held there only a few days a month. Apoe liked to attend them whenever she could, but she had not managed to learn much Thai because the government-appointed teacher did not speak Akha.

By a quarter to seven, it was light enough to see the surrounding houses. Nearly everybody was up, chatting with their families and neighbours as they went about their chores. Apoe's niece and two nephews crossed the compound from her brother's house and watched as she took her turn at the rice husker. Her mother now helped her, lifting from the mortar batches of grain that were

Her mother scoops up a handful of husked rice from the mortar.

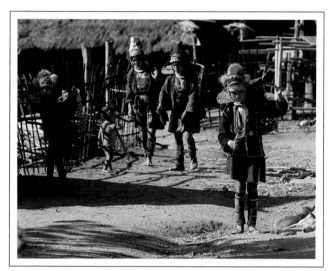

On her way to fetch wood, Apoe plies her thread-making spindle.

As she cuts wood, a pointed hood protects her cherished headdress.

younger brother—had risen. She served them first, at their end of the house. They had pickled greens, cooked greens, hot spiced soy cake—made by Apoe's mother and sister—and the rice that she herself had steamed, all accompanied with wild tea from the forest. When the men had eaten, the remaining food was transferred to the women's side, where Apoe and her mother and sisters finished it up. The women got their fair share of the staple rice, but the three other dishes had been disproportionately depleted by the men.

Today, Apoe had planned to go out to the fields with her elder brother, to cut imperata grass for thatching—a task performed once a year after the rainy season, when the rice harvest is in and there is more time to spare. But her brother decided instead to look for the family's one horse; it had been missing since the day before and, while it might have simply strayed, the family feared that it had been stolen by an outsider.

Apoe's grass-cutting expedition was therefore postponed, and instead she set off with seven other girls and boys on a wood-gathering trip in the forest. It was almost 10 o'clock when they left. Apoe and five of the children carried machetes and back-baskets; the other two, too small to cut wood or bring back loads of it, came along just for the fun of the outing.

As the children entered the forest, each of the older girls pulled a small wooden spindle and a fluffy roll of prepared cotton from the little basketwork container

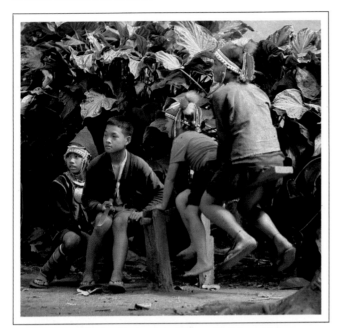

A seesaw provides fun for Apoe and three of her companions.

she wore strapped to her waist and began to spin thread as she stepped along the path. With her right hand, she briskly rolled the spindle against her thigh to start it twirling; with her left, she fed out strands of cotton from the roll, looping the resulting thread round her to keep it taut as the spindle took it up.

The children climbed up a steep path to a high ridge. The forest that clothed it was secondary growth, full of weeds and bushes, though some of the trees rose as high as 70 feet. As they walked, the girls sang jaunty love songs, interrupting themselves only when they had to cope with a particularly precipitous or slippery ascent. At one point, they stopped to collect flowers to be worn on their headdresses that evening when they would be going to the dancing ground: a level clearing near the upper gate of the village where the young people gathered most evenings to socialize.

Half an hour after leaving the village, the children were on a hilltop that overlooked a magnificent range of dark green hills. They fanned out and with their heavy machetes began chopping down small dead trees to be used for firewood.

For the next couple of hours, the children worked strenuously, felling the trees and then chopping the trunks into sections three or four feet long that could be stuck upright into their back-baskets. They gathered far too much wood to take back on one trip, so they stacked what they could not carry against a tree, to be collected another day. By noon, their industry slackened. One of

the older boys found two enormous scorpions in a rotten log and killed them. After sitting and talking for a few minutes, they picked up their baskets and set off down the slope again towards the village.

On the outskirts of the village, the group of children passed the compound of the small school, built for them by the Thai government some years before. It had not been open for several weeks and had an air of desertion. A wooden seesaw stood in the yard and several of the children turned aside from the path to play on it for a while before returning to the duties their families had waiting for them at home.

Apoe was home again by one o'clock. Her mother had gone to another village to visit some of her husband's relatives, so Apoe and her elder sister prepared lunch for the rest of the family. Usually a small, brief meal of rice and vegetables, the fare today included dog meat—a treat enjoyed only once or twice a fortnight. Apoe cut up the meat and mixed it with chopped vegetables in a large *wok*. To provide liquid for the meat to cook in, she carefully drained the water from some greens that had been soaking during the morning into the *wok*; then she set it to stew gently on the fire.

After the meal had been cooked and eaten, Apoe paid a short visit to her sister-in-law's little house, in order to use her mirror. She usually did this once or twice a day

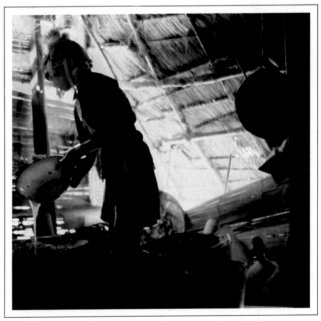

To cook lunch, Apoe uses water flavoured with soaked greens.

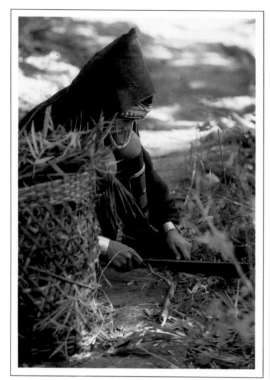 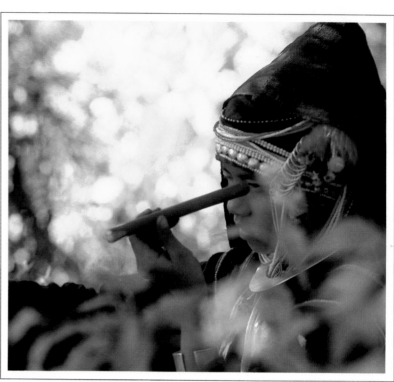

In the forest she cuts a section of bamboo . . . **. . . checks it critically before cutting notches . . .**

if she had the time; she was getting quite conscious of her appearance and there was no mirror in her house. After smoothing and combing her hair, she readjusted her silver headdress and gazed critically at her reflection in the mirror. Unlike some of her girlfriends, who sometimes used face powder and lipstick, and wore patterned Thai skirts—all bought from the markets in the lowland towns—Apoe was particularly attached to the traditional Akha dress.

She stayed, chatting with her sister-in-law, until just after two o'clock, when she returned to her own house to collect her basket for another trip into the forest—this time to fetch fodder for the family's animals. She set off alone, spinning thread on the way as she had done in the morning. By the end of the day, in fact, she had spun a whole spool to be used in the next piece of cloth her mother would weave.

On the fringes of the forest, she encountered some of her girlfriends from the village who were also gathering fodder. She exchanged a few laughing remarks with them. One of the girls, a child of about eight, decided to

accompany Apoe. As they walked along the forest path, they passed two young men carrying bunches of forest flowers as well as their guns; Akha boys, too, often wear flowers behind their ears when they go out to meet the girls in the evenings.

Half a mile farther along the trail, the two girls found a bamboo thicket whose foliage they began picking for animal feed. It did not take them long to fill their baskets. Before the two girls started back to the village, Apoe selected a straight section of a young bamboo pole and with a machete cut off a piece about eight inches long with which to make a flute. She carefully carved several notches at intervals and was soon playing a few tentative, wandering tunes on it.

As the girls neared the village, they met Apoe's married sister coming down another path from the forest. She was carrying her baby slung in a cloth at her side and a full basket of firewood on her back. Apoe had an especially fond relationship with this particular sister and she looked forward to seeing her every day. Now she took the baby in her arms and carried it herself into

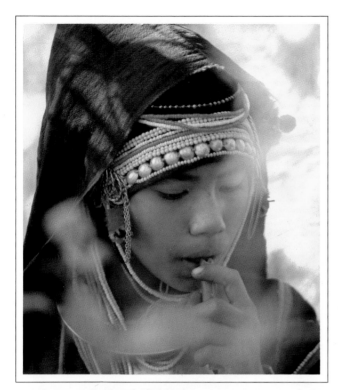

... and tries out the flute she has made.

the village before handing the infant back to its mother.

It was four o'clock when Apoe returned to her house. On the porch she shed the full basket of fodder she had been toting on her back and propped it against a wall, then she went in to make herself some tea. Before starting on her evening tasks, she sat and talked for a while with her parents, brothers and sisters.

Her elder sister soon began again the chore of pounding rice to be soaked overnight, ready for cooking the following day. Apoe had done her share that morning, so she was free to spend some time retying the strings of beads on her headdress, polishing the silver coins that adorned it and fluffing its pompons of gibbon fur.

After putting her headdress back on, she gave her sister a hand by steaming some rice for the puppies of the house to eat. She dished it out for them and, while they gobbled it, stood by to ward off any pigs that threatened to chase the puppies away from their food.

When the dogs had finished their meal, it was time to fetch water from the spring. This time she loaded her back-basket with four empty water gourds. Calling her little sister A-eh to come with her, she handed the child an additional gourd to carry and they walked together

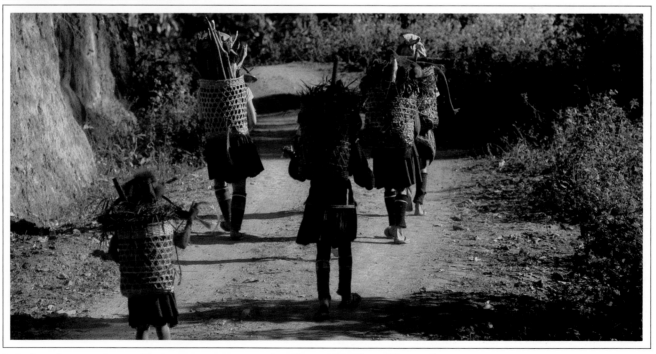

In the late afternoon, Apoe and her young group return to the village with fodder and firewood.

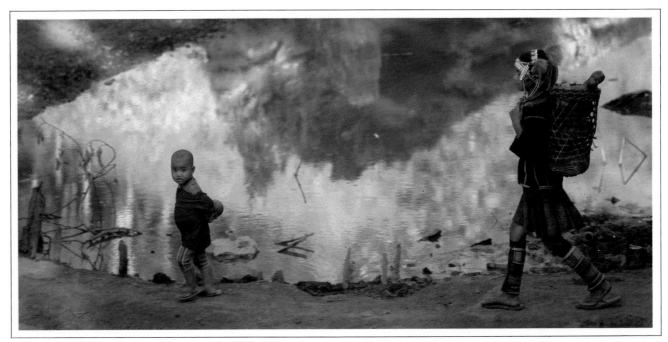

The sisters take their gourds to the spring to be filled with water.

along the side of a pond of standing water that had collected during the recent rains. In five minutes, they had reached the source where water from a spring in the hills came spouting out of a large pipe of bamboo. A-eh took off her clothes and Apoe bathed her under the stream of clear water, then she scrubbed her own feet before filling up all five gourds and piling them into the basket. Back at the house, she lined up the gourds on a shelf reserved for water bottles and made up the fire so that it would be hot enough to cook the evening meal.

Shortly afterwards, Apoe set off for the topmost ridge of the village to visit her married sister—as she did most evenings. Like that of many newly married couples, her sister's house was small; yet almost daily it was full of friends who sat around the men's hearth laughing and telling stories while the shadows lengthened outside. Apoe stayed for about an hour, bouncing the baby on her knee. As she was leaving, her sister gave her a present to take home: a bag of freshly picked greens.

By 6.30 p.m., the sun was sinking at last in a fiery blaze behind the western hills. Apoe strolled down the hill towards her own family's house, exchanging greetings with friends of her own age whom she met along the way. Some were only just returning from the fields, carrying huge bundles of thatching grass that loomed over their heads like giant birds. At home, the rest of the family had already eaten their evening meal and Apoe dined simply, on some rice and a couple of chili peppers

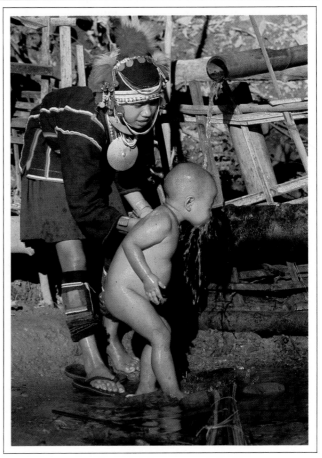

A bamboo conduit delivers water for a thorough bath.

that remained. When she had washed all the dishes and put them away, her work was at last over for the day.

By now, it was quite dark outside and only the three glowing hearths in the house shed faint illumination by which Apoe could prepare herself for her evening out at the village dancing ground. She adorned her headdress with the flowers she had picked in the morning. Then, her silver ornaments flickering in the firelight, she took A-eh on her lap for a goodnight hug before she went out.

By 8.45 p.m., perhaps 50 adolescents and children had gathered near the upper village gate to sing and dance, and to cuddle on three wooden benches placed there. The moon had not risen yet and some of the boys had brought burning branches to use as torches.

Apoe and her girlfriends stood in clusters around the dancing place, singing the love songs they had learned from their mothers and older sisters. The boys, rather more raggedly, replied with songs of their own. In between songs, there were long and noisy interludes of chatter and some girls showed off their dexterity by competing with each other in cotton-spinning contests.

By 10 o'clock, all the torches had gone out and only dark silhouettes could be seen moving against the starry

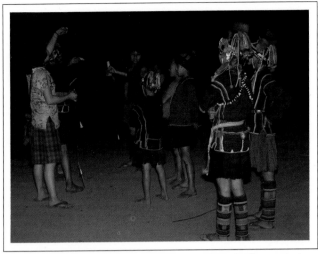

Relaxing at night, Apoe watches an impromptu spinning contest.

sky. One or two of the older girls wandered off into the forest with their boyfriends, but for Apoe—as yet too young for courting and also mindful of another long working day ahead—the evening was over.

She walked down the hill to her house and was soon curled up underneath her blanket next to the women's hearth. The dogs were still barking and the pigs were grunting, but Apoe was oblivious from the moment her head touched her bark-fibre mat. The rest of the family was already sound asleep.

Three | **The Pride of the Craftsman**

The lyrics of an Akha song speak of a blacksmith's forge looking "like a crow's nest"—a perfect description of the main smithy at Napeh. Each of the subsections of the village had its own smith, but the most important was the one who lived in the section near the lower village gate. Located in a sooty bamboo shed behind the blacksmith's house, the forge looked untidy and insignificant when it was not in use—and yet became one of the focal points of village activity as soon as the blacksmith had kindled his charcoal fire. Then, indeed, the sparks began to fly and, because the smith often chose to work far into the night, the pounding of his hammer would ring through the darkened village as late as one or two o'clock in the morning.

Like so many other features of their way of life, the blacksmith's place is celebrated in Akha folklore, and plays its own part in the cultural patterns preserved by the people for centuries. Traditionally, the Akha have always taken particular pride in the skills of their one professional village technician. "Our blacksmiths are better than theirs," insists one of the *dzoema* songs. "Although the Chinese ironmaker is called 'blacksmith' by the Chinese, he cannot even make a nail. Although the Shan ironmaker is called 'blacksmith' by the Shan, he does not know how to hammer a mould. . . . The Akha ironmaker is called 'blacksmith' because he does know how to make things."

The main forge at Napeh was simplicity itself: a rectangular working surface of flat stones on top of earth packed inside a wood frame. An ingenious hand-operated bellows—a wooden piston inside a bamboo cylinder—fed a stream of air as needed to the charcoal fire, which was heaped between two blocks of sandstone set on the forge. It was the customer's duty to work the bellows whenever necessary, but occasionally the smith would pump the piston himself, or sometimes he would delegate the task to one of his small

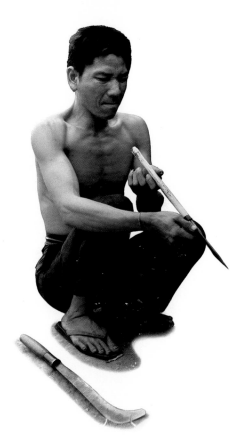

sons or to a bystander. There were always many onlookers when he worked, all of them ready to help out, for the smithy serves as an impromptu male club where men of all ages come for conversation as well as business.

One day I watched the smith make an Akha machete, the most essential and also the most versatile of their tools. It is strong enough to cut down small trees and sharp enough to serve as a butcher's knife.

The smith began by thrusting a four-foot pig-iron bar into the bed of charcoal and heating the metal until it was red-hot. Then he hammered it flat on an anvil sunk in a large log. Behind him, on a table, he kept his entire assortment of tools: three hammers and two pairs of tongs. Whenever the iron cooled off, he would lay it again in the coals and pump the bellows to send more air on to the fire. Sometimes his assistant would beat the blade while the smith steadied it on the anvil. The young men watching at the forge considered it a special privilege to be allowed to wield the heavy hammer. "Where there is a strong blacksmith, strong iron is forged," according to one of the ritual poems—and not without reason: technically, I gather, the more the iron is hammered, the stronger the resulting blade.

To temper the blade after it had been pounded, the smith plunged it into a hollowed-out log partly filled with brackish water. Then, while smoothing out the surface and forming the haft, he sang a little song, half to himself, accompanied by an anvil chorus of taps from his smallest hammer: "A good Akha blade, *bam-bam-bam*; a good Akha blade, *bam-bam*!"

A shower of red-hot sparks filled the small hut whenever the air from the bellows hit the coals, but the smith and his assistants made it a point of honour to work with their shirts off. An Akha smith is always conscious of being the chief actor in a scene that never ceases to hold his audience's fascinated

attention. Even his small son at the bellows would never have dreamed of flinching when the sparks singed his bare shoulders.

When the machete blade was ready to be inserted into its handle, the smith thrust the haft into the fire and waited until it was red-hot. He had already prepared a wooden handle bound with a copper ferrule. Picking up the blade with a wet rag, he pushed the nether end down into the wood; it sizzled and smoked as he hammered it into the handle to obtain a close fit.

As well as machetes, the Napeh blacksmith produced hoes, sickles, knives, spades and narrow-headed axes, and would sometimes repair or even make one of the huge shotguns that the villagers used for hunting and for protection against marauding robbers. Nearly every family in the village owned a gun. The standard model was made by the blacksmith from a piece of steel pipe brought up from the valley. It had an enormously long barrel and was loaded through the muzzle. A charge of black powder was poured in first, followed by a load of pellets and some cotton batting—everything finally tamped down with a ramrod. The charge was detonated, not with a flintlock but with a much simpler device: a paper cap like those used for toy pistols.

The blacksmith had improvised a spring mechanism that was cocked back with the thumb and released by the trigger; it was supposed to snap down on one of the pink paper caps whose explosion, at the touch-hole, would set off the black powder inside the barrel. Nine times out of ten, unless it was raining, the thing actually went off. Although it was difficult to hit anything with an Akha shotgun at a range of more than 50 yards, it was more effective in the field than the crossbows with which the Akha always hunted in the past.

In former times, every metal tool and weapon used in an Akha village was made on the blacksmith's forge—either by the blacksmith himself or by a villager whom he had allowed to borrow his equipment. He is recorded, too, as the maker of the official knife that is the *pima's* symbol of office; he carries it whenever he is called upon to chant the ritual verses. Nor do the smith's functions stop at iron-working; he is also especially skilled in the bamboo technology that is central to Akha life, and serves as the master architect and technical adviser of the village. He is consulted when a house is built or the ceremonial gates are renewed, or any other important structure is planned.

As a result, the blacksmith has traditionally had special influence in the village. He takes his place among the leading figures of the community: the *dzoema, pima, buseh* and—at least in many villages—the *nyipa* or shaman.

Nowadays, although ready-made goods from the lowland markets compete with the blacksmith's own products, his traditional authority is still respected. The present main incumbent in Napeh, in his early thirties, was descended from a long line of smiths and *pimas*. His great-grandfather had been a blacksmith; his grandfather and his father were *pimas.* Yet both of the latter also knew how to forge iron and the present blacksmith grew up with the option of assuming one role or the other. (There is a tendency for Akha village leaders to come from families and clans that have provided functionaries in the past, but Akha society has never developed any real priestly class or "aristocracy".) Eventually the present smith chose to wield his influence

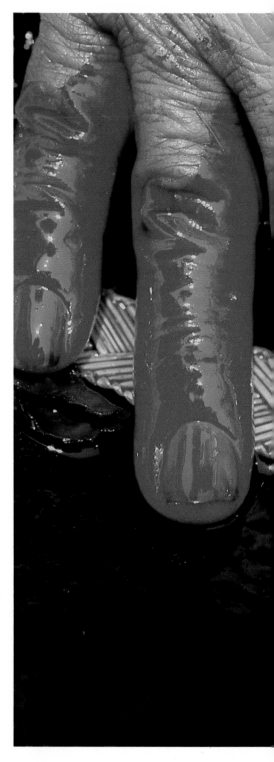

A band of plaited bamboo that will adorn a silver headdress is immersed in red dye derived from the crushed leaves of a tree. Akha women use this deep red to colour small accessory items, as a contrast to the standard indigo cloth used for their apparel.

at the forge, but he evidently inherited something of the gift of tongues, as well as tongs, from his ancestors: whenever he addressed a circle of elders, he spoke with the ease of someone sure of his position.

Like remote peoples everywhere, the Akha are increasingly touched by the all-pervading material culture of the 20th century, which threatens both their adherence to *Akhazang* and their erstwhile self-sufficiency in articles of daily use. Increasingly, plastic jerrycans compete as water carriers with gourds and bamboo sections, and ready-made knives can be bought in the lowland markets, so long as the villagers have the money to pay for them.

But for the Akha, this is only a new—though perhaps more extreme—version of an old experience. Since they have never been sealed off from their neighbours, they have always had to live partly in contact with the mysteries of a cash economy controlled by forces they cannot influence, and partly in the forest world of their own making. They have accepted fragments of the strangers' cultures, yet have managed to keep their separate identity—not only as the result of discrimination against them by the lowlanders, who do not want to admit them to their own more privileged world, but also because of their rejection of the neighbouring civilizations.

Throughout their long history in the mountains, the Akha have regularly exchanged goods with the lowland peoples. At different periods they have grown crops such as cotton, sesame seeds, peppers and tobacco in order to obtain in return necessities such as salt and iron, and other goods such as buttons and silver. But their trade has never been either steady or substantial enough to allow the development of a class of professional merchants or middlemen. Indeed, they take conscious pride in the egalitarian character of their society, in which everyone works his own fields and gives help to his neighbours in exchange for the same kind of support.

One of the *pima's* verses cautions them to remain true to Akha traditions and put mercenary thoughts out of their minds: "The people downstream have silver; don't let your soul wander to their silver. The people upstream have gold; don't let your soul wander to their gold." Instead, the hillside rice fields that provide the only subsistence they can control by their own efforts have come to symbolize to them the survival of their way of life; and to those rice fields they owe an allegiance that is invested with much emotion.

As contact with the lowland culture becomes more difficult to resist, many Akha fear impending oblivion for their way of life and wish they could escape into a new highland forest, as their ancestors did so many times before. The more remote the mountain and the thicker the forest, the more they feel at ease with themselves and their environment. "I feel uncomfortable when the hills around me are not high enough," one of my Akha friends told me. "If we go too far down, we stop being Akha and become something else."

Down below, in the market towns, the villagers are obliged to spend their very limited resources of cash on products that lack the meaning of a long-evolved place in their own system. For most Akha, moving further into the commercial world would mean living a marginal existence in a no-man's-

The brilliant green shells of forest beetles, as well as other decorations, hang from a man's jacket. Included are a variety of strung beads, dyed wool pompons and chicken feathers. Made by the women but worn by both sexes, such ornaments are reserved for courting and for village festivals.

land between their own culture and that of modern Thailand. A Western-style education—the key to that other world—is virtually unobtainable for the Akha, since the only schooling in the villages is given by Thai teachers, who do not know the Akha language and often bring little enthusiasm to their task. Akha children have to pick up Thai as best they can before they can even start their lessons. To find any further education, they must leave their families and their roots to go to a Thai city.

The Akha's self-respect and sense of themselves is thus very much bound up with the continuation of their own skills and crafts. The connection is complicated but not nullified by the appetite of the tourist market for traditional Akha products. In Napeh, at least, I could see that many of the villagers still preferred the output of their own smith to items available in the lowland markets—especially since, as custom demands, Akha blacksmiths do not work for cash but receive payment in the form of labour: three days' work in their fields each year from each household in the village. The exchange of such obligations of time and work is an important link binding together the members of the village. Payment of debts in these terms is scrupulously honoured; most families have no other wealth than the strength and time of their members, which must be budgeted as carefully as capital. So someone who needs a knife or a machete buys some iron from a dealer in the valley—old truck springs are considered especially suitable for making knives—and brings it to the blacksmith, who hammers it into the desired shape.

If a paved road ever reaches the village and the young Akha figure out ways of buying motorbikes, I suspect the smith may well have to turn into a motorcycle mechanic. But I am certain that he will make the transition when the time comes, just as he was able to turn successfully to matchlocks when firearms replaced crossbows in the Akha arsenal.

The women of Napeh were as proud of their skill at weaving as the blacksmith was of his ironwork. The slow, painstaking process by which they converted wisps of hill cotton into sturdy, decorative clothing was a remarkable instance of an ancient craft still serving its original purpose and scarcely capable of improvement. Although the other hill peoples know how to weave, most have given up making their own fabrics. The Lisu, for example, make their colourful dresses from store-bought cloth. But Akha homespun cloth is prized for its strength and beauty even by the lowlanders, and they will pay a premium price for the material.

The Akha's highly evolved cotton technology is the result of periods during several centuries in eastern Burma and southern China when they were among the chief producers of cotton for the lowland markets. In Thailand, however, they have lost contact with the market for cotton and, in any case, not many Akha villagers have enough land for a cotton crop; the villagers of Napeh were hard put to produce enough cotton to satisfy even their own demand for their fine cloth. Just below the village, I was shown a typical cotton field—a small plot of ground on a steep slope where the plants were struggling to stay alive. Most of them succeeded sufficiently to produce a tuft of

Lengths of indigo-dyed cotton cloth and thread are hung to dry in the hot sun (right). To make the blue-black dye, leaves of the indigo bush are soaked in water, then lime, charcoal and ash are mixed in (below) to absorb the colour. For a deep and lasting colour, the cloth must be dipped in the dye and dried daily for about a month.

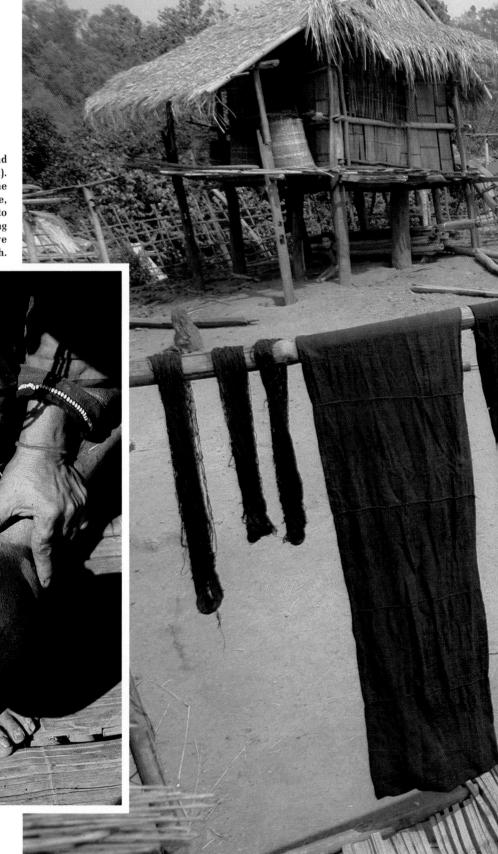

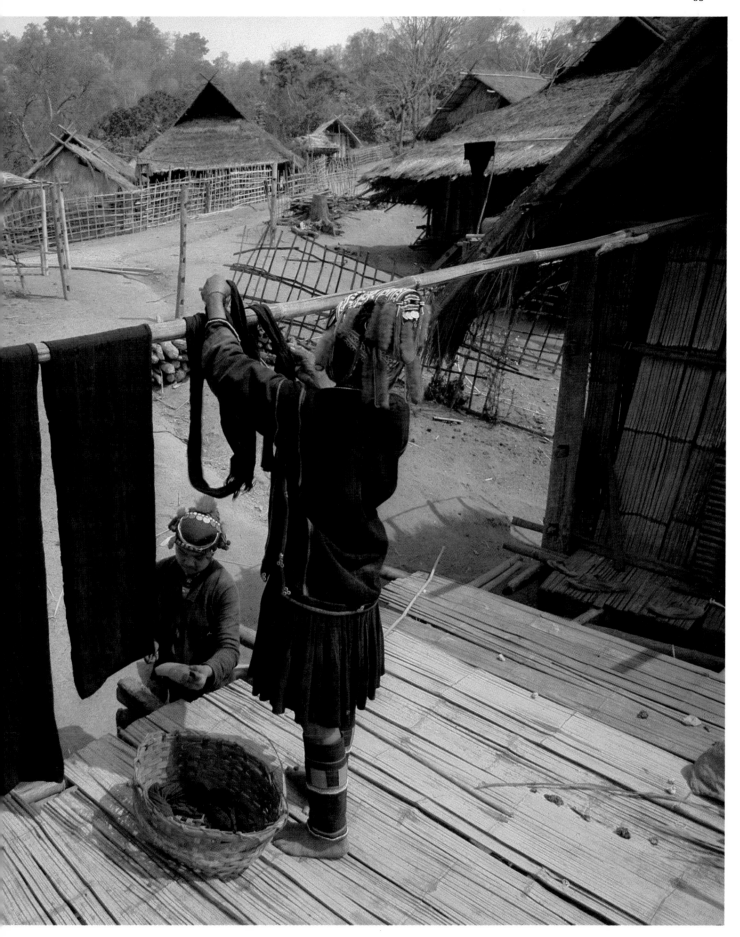

cotton just large enough to plug one's ears against the village noises at night. This crop constituted the basis of the village's textile industry, yielding the raw material for an average of one new outfit per family every year.

Spinning and weaving are exclusively women's work and every girl has mastered the skills by her teens. The spinning goes on continuously all year round; I rarely saw an Akha woman or girl walking along a path, either alone or in company, without a spindle of cotton whirling from her fingers. My next-door neighbour Misaw, who was a very pretty woman and a skilled weaver, was willing to let me watch her during all the stages of the production process, and I found it a fascinating experience.

Like the other women of Napeh, she began by harvesting her own modest crop of cotton and bringing it back to the village in a bamboo basket. First of all, she passed the cotton through an ingenious gin in order to remove the seeds. The next step was to fluff up the fibres by plucking a sort of miniature archer's bow that she had thrust into a heap of cotton. Then, using a wooden cylinder that was no more than six inches long and an inch in diameter, she rolled some of the cotton into sausage-like shapes on a smooth wooden board, flattening the fibres with the palm of her hand.

She always carried a few of these fluffy rolls in a basket at her waist or in her shoulder bag and spun them into thread wherever she went. Pulling out a tuft of cotton from the roll, she would attach it to the spindle. She hitched up her skirt a bit and set the spindle in motion by rolling it quickly along her bare thigh and twirling it out into the air before her. The weight of the whirring spindle would draw the fluffy cotton into thread. The need to give the spindle a running start may account for the fact that Akha women wear miniskirts; it is much easier to start the spindle on smooth bare skin than against a cloth-covered thigh. With her left hand, very deftly, Misaw would feed out the raw fibre, pausing occasionally to restart the spindle with another twirl. Her right hand always did the twirling and her left hand—employing swift and delicate gestures that resembled those of an Indian temple dancer—controlled the thread.

When the spindle was full, its thread was wound into a ball and, by the end of each day, Misaw had a good supply of strong cotton yarn. Though only four feet tall, she took a six-foot bamboo pole with short crosspieces at each end, in the shape of the letter I, which she manipulated like a drum majorette swinging a baton, winding the thread on to it in a figure-of-eight pattern. To strengthen the resulting skeins, she starched them by drenching them in water already used for soaking rice and put them out to dry on a large rotating rack that stood in an open space between two of the houses in her corner of the village. After that, she unwound the thread into a basket, looping it carefully to prevent knots and tangles, and sprinkling it with fine wood ash to absorb any excess starch and moisture, and help prevent it from tangling.

The next day she took the basket to an open area near her house where two rows of three short bamboo stakes had been hammered into the ground. She ran a slalom course around these stakes, paying out the thread from her basket. When she had formed enough loops, she took them off the stakes and

Patterns in Cloth

Appliqué—the technique of cutting out shapes from one fabric and sticking them on to another—is a craft practised by many of the Thai hill peoples, including the Akha, who use it to striking effect on the dark-dyed homespun cloth that provides their dress. Some regional groups have a tradition of simple decorations—perhaps just a contrasting border sewn on to a skirt or jacket. Other groups create designs of dazzling complexity. The example shown here, made by Akha who recently emigrated to Thailand from the Loimi Mountain area in Burma, is among the most elaborate.

Numerous narrow horizontal bands of red, white and yellow cotton cloth are sewn on to the back of a simple indigo jacket to create a rectangular pattern. Thinner strips of contrasting materials are appliquéd over the first layer for a rich, quilted effect; diamond shapes and triangles are then cut out and stitched on with different coloured threads. The jacket's sleeves are banded in a similar fashion, and buttons and tassels sewn on to the mosaic complete the decoration.

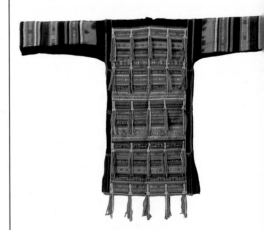

Layer upon layer of appliqué adorns the back of this Akha jacket (above), whose appearance has been further enriched by embroidery (detail at right). Jackets of this type are worn by Akha women in some villages as part of their daily dress.

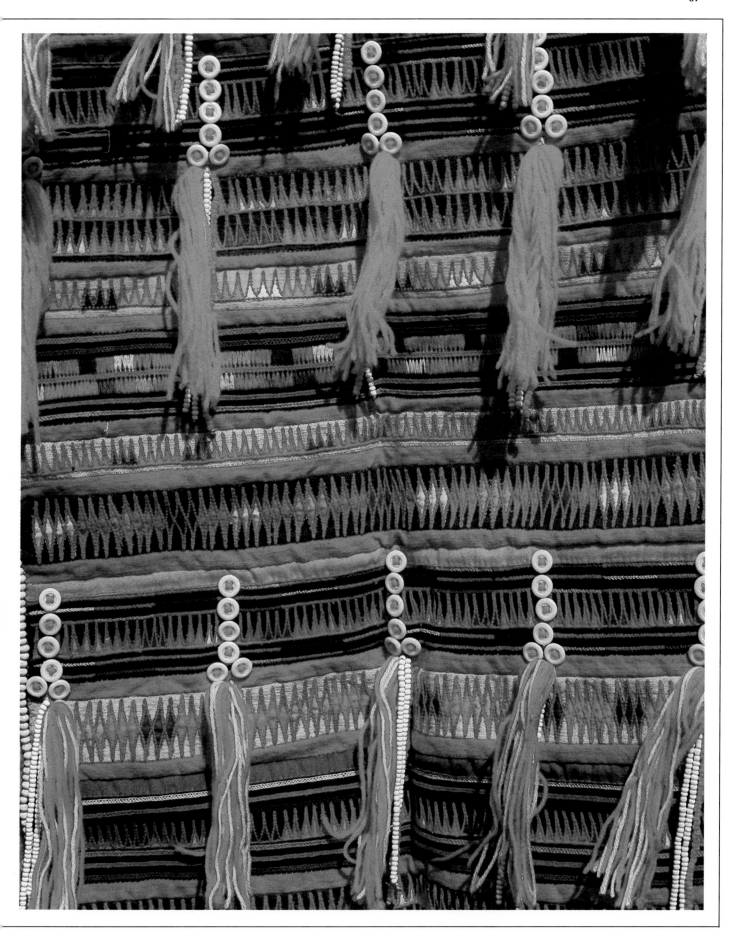

fixed them to two lengths of split bamboo. The result, by some immemorial miracle, formed the warp—the lengthwise yarns—for her weaving loom. The rest of the thread remained in the basket, ready for winding on to a shuttle and forming the woof or cross-yarns.

Like so much else in the village, the loom was of bamboo. Four thick poles about five feet high, set in a rectangle, served as the uprights. A rectangle of slimmer struts was fixed to the top to keep the framework rigid. The loom was assembled in front of Misaw's house—*Akhazang* specifies the right time of year to set it up and start weaving. When she was not actually working at the loom, she did not dismantle the frame, but she kept the moving parts inside her house. These comprised the heddle that is inserted between the warp threads and shifted by two pedals to raise and lower the warp threads during the weaving; and the comb-like reed that both keeps the warp threads evenly spaced and packs the cross threads tightly together.

Weather permitting, she would take these components into the yard with any completed material already attached and fix the roll of finished cloth to the back of the frame. She would then drive a stake into the ground at the other end of the framework so that the warp was stretched taut and hang the heddle from the cross-struts, with the two pedals resting on the ground near her feet. Nothing could be simpler; the whole process of assembling the loom took her no more than five minutes.

Misaw's weaving was only about a hand's span wide, but tight and strong. She stood beside the loom, pressed a pedal with her foot, inserted the shuttle with its thread, pushed it through by hand and combed it back with her fine wooden reed—dark brown and worn smooth with use. She pressed the other pedal and repeated the passage of woof through warp. Sometimes a thread would break; calmly Misaw mended it and went on weaving.

Misaw wove very quickly and for long hours whenever she had the time, but it took her many days to complete a length of about six or seven yards. She sold me some of the cloth I had seen her weave and she measured it the Akha way, between her outstretched arms. Each "stretch" was worth 50 *baht*—about two and a half U.S. dollars. She saved the rest of the material to make it into a new jacket for herself or one of her family.

All the women of Napeh wore jackets, skirts and leggings woven in the village; but most of the men had given up wearing their traditional costume— loose jacket, baggy trousers and a blue-black turban. Many of them would have preferred to keep the old Akha dress, but, as one explained: "It makes us too conspicuous. If we show up in a town like Chiang Rai dressed in the old style, we're sure to be asked whether we really come from Thailand or whether we have just slipped over the border from Burma. Most of us have no identity cards, so they hold us in jail until we can prove we belong here. To avoid this kind of trouble, we change to modern clothes."

Akha women, on the other hand, infrequently leave their village, so they have no need to escape notice among the lowlanders. Perhaps also they sense how much more beautiful they look in their traditional dress than in store-bought clothes. They wore miniskirts centuries before the style first became

fashionable on London's Carnaby Street and they realize that this is a distinctive, not to say extraordinary, garment. One of their folk-tales explains how they happen to come by it.

When A-poe-mi-yeh was distributing to the various peoples the social customs (zang) that each of them was to follow, representatives of every people were present, including the Akha man. But the Akha woman was too bashful to come, since she had no clothes. Only after the others had received their instructions and departed did the Akha woman put in an appearance. When A-poe-mi-yeh asked why she was late, she explained that she had been shy about coming without clothes. So A-poe-mi-yeh took a cloth money bag, cut off the end and threw it to her, saying "Here, wear this!"

The dark indigo-blue cloth is common to Akha groups everywhere, but the style of decoration varies considerably from one region to another. In some Akha villages near the Burmese border, a woman will spend a whole year of her spare time decorating the back of a jacket with an intricate labyrinth of appliquéd and embroidered patterns executed in a blaze of primary colours, and finish the jacket with rows of buttons and fringes. This is the so-called Loimi style, which takes its name from Loimi (Bear) Mountain in eastern Burma. The Akha who lived on the thickly wooded slopes of the mountain developed, during a period of security and prosperity, a distinctive costume, which has also been brought by settlers of the Loimi clans to some villages in the extreme north of Thailand. The women of Napeh, however, prefer a more subdued form of decoration and they leave large areas of their jackets unembroidered. But they, too, have an enormous repertoire of traditional patterns with which to ornament jackets, leggings and headdresses. Many of their designs have names; one of them, in which a line runs back and forth like a mountain trail, is known, appropriately enough, as "The Path".

Women do not invariably wear the typical dark-blue skirt, but a change from it always has special significance. On the day of her wedding, for example, an Akha bride exchanges her blue miniskirt for a white one, returning to her blue skirts after the marriage. Most women will never wear a white skirt again, but some, after they have finished raising their children, undergo an initiation ceremony that entitles them to carry out various important rituals. Having been through the ceremony, they will be entitled for the rest of their lives to wear a white skirt on special occasions, as a sign of their status.

The most conspicuous feature of an Akha woman's costume is, of course, the covering for her head. Like their patterned jackets, the decoration of the women's headdresses reflects various local differences of style (the Loimi type being the most elaborate). Akha women adopt the ornate and extremely becoming bamboo-and-silver headdresses, called u coe or "pointed hats", only as they approach the age for marriage. Before that, a girl wears a simple hat—a blue cotton bonnet, decorated at first only with a few coins or cowrie shells, but progressively embellished throughout her childhood with more ornaments. The additions that a girl makes to the decorations are part of a series of changes she makes to her clothing as she grows up—putting on a bodice, then a belt, and finally replacing her bonnet with a pointed hat. These

changes may be made on two days of the year only, at the celebrations held to mark the New Year in December and at a big festival in August.

The form and decoration of a woman's headdress can indicate other things besides her place of origin. The bamboo covering, for example, is open at the back if a woman is single, but closed if she is married; at marriage, she places tassels at each side of her hat, without which—according to the intricacies of *Akhazang*—it would not be proper for her to cook the rice for her family.

In normal circumstances, however, an Akha woman always wears a head-covering, except when washing or arranging her hair. And while young girls take off their simple headgear at night, custom requires that women keep on the *u coe* even while sleeping. Consequently, as I learned from one villager, the sight of a girl's hair used to be considered a great erotic moment for Akha men. Times have changed though, since the lowland girls are always bare-headed, and the fascination has worn off even for young Akha boys.

The Akha women's ornate and flashing silver adornments, both on their headdresses and in the form of brooches, bracelets, torques and jacket buckles, have traditionally served the purpose of storing and surplus cash a family may have changed to accumulate. The Chinese, Burmese and Laotian coins attached to some headdresses can tell a tale of savings made many decades ago. There are customary forms of silver jewellery for men as well: magnificent bracelets and buckles, which are owned particularly by *pimas* and *dzoemas*. The traditional bracelets worn until recently by *dzoemas* and *pimas* are among the rarest and most valuable treasures of the hills. Made of solid or hollow silver, the ends of the bracelets are embossed in the shape of a dragon's head and designed to rattle when the *pima* moves his arms. If they are solid, the bracelets have tiny balls concealed in the dragon's mouth; if they are hollow, they contain pellets of birdshot.

Some pieces have been handed down, like the ritual poems, through generations of *pimas*. "I brought these with me from Burma," explained an old man who owned a superb pair of dragon bracelets. "They are very old and I will never sell them. Whoever wears them is protected from fire and no harm can come to him." They were solid silver, but someone long ago had added touches of enamel in auspicious colours: blue, yellow and green. Had they been made by an Akha silversmith? "Our silversmiths have always learned from our neighbours. When we lived among the Chinese, they made silver that was like that of the Chinese; and when we were neighbours of the Shan, our silver resembled that of the Shan." His could have come from a Chinese silversmith or an Akha who had learned from the Chinese.

Silversmithing, at any rate, became one of the great traditional crafts among the Akha, although it is not mentioned in the ritual texts that are older than 100 years. Generally it was the blacksmiths who acquired mastery of the silver arts. In some villages the silversmiths learned the elaborate casting techniques of the Chinese or the Shan; elsewhere they reproduced superb pieces of silver by hammering: buckles incised with abstract representations of birds, fish, butterflies, dragons, flowers, and sun or moon motifs. Their

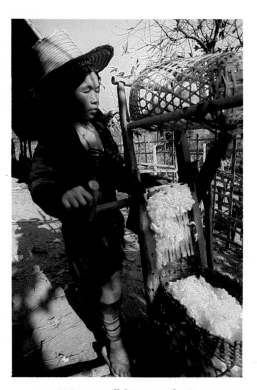

Using a small, home-made gin, a woman removes the seeds from raw cotton (above). The seeds are caught in a container at the back as the cotton passes between two rollers into a basket. After the seeded cotton has been spun into thread, it is woven into lengths of cloth on a bamboo loom that is worked by two foot pedals (right).

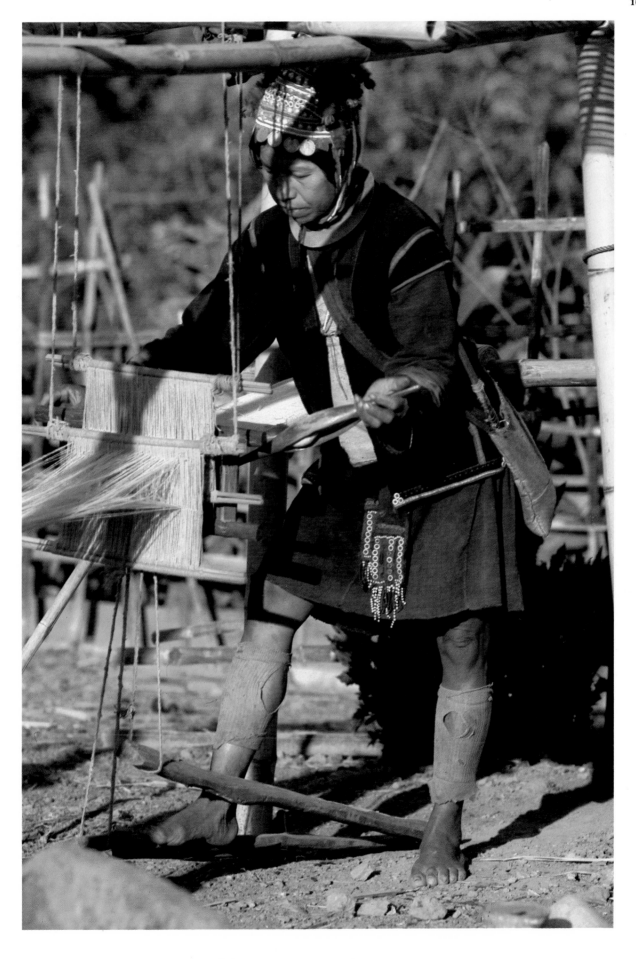

animal, bird and flower designs are intriguing in the elegant simplicity of form. It strikes me that even Picasso would have admired these silversmiths' way of reducing what they saw in nature to a few essential lines, engraved with a chisel on silver hammered out from an Indian rupee.

The superb bracelets, along with circlets and neck rings of flat, round or twisted silver, are the relics of an Akha past in southern China and eastern Burma, where their silversmiths produced thousands of such pieces. Today in Thailand, only a few villages boast a silversmith. "My great-grandfather," said the blacksmith of Napeh, "could do beautiful things in silver." Yet he himself created adornments only in iron. He made iron neck hoops, copied from silver heirlooms, which he and his friends wore on formal occasions.

Paradoxically, silversmithing has declined partly because the price of silver has shot up, to the point where it has become dangerous for the Akha women to walk through the forest to the fields wearing their family's entire fortune on their heads, arms and necks. When local bandits began systematically robbing Akha women of their headdresses in the 1970s, many of them sold or buried their silver and replaced it with aluminium substitutes, perhaps keeping a few pieces of silver to wear in the privacy of the village. In Napeh, this circumstance led to tragedy, with the murder of the *dzoema* Abaw Ayeh a year before our expedition arrived. Akha jewellery had become so valuable that robberies were an everyday occurrence; and since there was no practical way of safeguarding his family's small hoard of silver, the *dzoema* had decided to sell it and hide the money.

At the time, two Thai merchants were making the rounds of the hill villages on a silver-buying expedition, and the *dzoema* arranged to see them at a settlement about half an hour's walk from his own. He sold them 10,000 *bahts'* worth of jewellery, but the transaction was witnessed by two bandits, who later followed him home. Shortly before the *dzoema* reached Napeh, they attacked him and tried to take the money. When he resisted, the bandits stabbed him. He was close enough to the village for his cries to be heard and people rushed to his aid, but he was already dying when they reached him.

Normally a violent death is seen by the Akha as a sign that an unlucky fate accompanied the victim and that the village should avoid being linked with him if possible. Had it been anyone else, the villagers would have buried the body in the forest where it lay, rather than risk bringing the corpse and its ill-fortune back within the village gates. But since Abaw Ayeh had been the *dzoema* of the village and a man of exemplary life, his body was brought home and given a proper funeral, complete with a buffalo sacrifice—though with the precaution of a special recitation by the *pima* to guide his abused spirit. Following the *dzoema's* death, almost everyone in Napeh immediately stopped wearing silver. But even so, I saw several of the old men of the village who refused to relinquish the long silver, or silver-mounted, pipes which they carried with them everywhere, lit or unlit.

The Akha's ability to produce from their limited resources objects that are both useful and beautiful is abundantly proved by their textiles and metal-

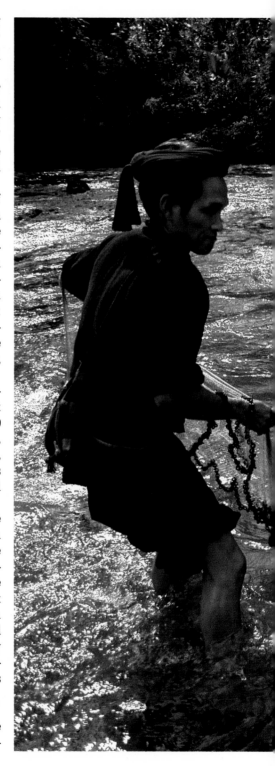

An Akha fisherman prepares to cast his net into a shallow reach of the fast-flowing Mae Suai river. The net is weighted with lead sinkers and attached to a cord, which the man holds in his left hand while casting with his right. With such nets, the Akha catch trout and other medium-sized fish. They also use a variety of traps and—for minnows and shellfish—hand nets.

working. But it seemed to me that their creative skill was just as impressive in the use they made of the simplest and cheapest material that is available to them: bamboo. It is an intrinsically beautiful plant and they transform it into any number of beautiful objects.

Not only do they extend its use to almost everything they need in the way of furniture and kitchenware, they make from it also a whole range of instruments with which to express their constant delight in music. Every child, for instance, knows how to space the notches that transform a one-foot length of bamboo into a recorder-like pipe. The Akha mouth-harp is an even more remarkable instrument: nothing more than a thin bamboo section that is sliced almost in three lengthwise; the central sliver remains attached to the outer framework at one end, while the other end is free to vibrate. The instrument makes splendid noises when one end is clamped between the lips and the other twanged with the thumb. The sound swells like an organ stop as one increases the pressure on the lips, and takes on very subtle shades according to whether one inhales or exhales. One of the young Akha musicians' favourite tricks is to "talk" to the girls in mouth-harp music, twanging monosyllables that mimic the texts of the best-known Akha love songs.

Another modest but astonishing Akha instrument is the bagless bagpipe, cut from an even thinner section of bamboo. The one-third of the instrument that forms the mouthpiece—a tiny slice of bamboo that serves as a single "beating reed"—is popped into the player's mouth; a three-inch cylinder with three sound-holes protrudes beyond the lips. By puffing out her cheeks and fingering the three holes, any little girl of nine or ten can produce high-pitched sounds similar to those of a bagpipe or a Sardinian *zampogna* as she goes trudging through the forest to collect firewood.

But perhaps the most impressive demonstration of Akha craftsmanship with bamboo is the architectural miracle that occurs each time they put up a new house. It is a virtuoso performance by any standards, yet nothing is put on paper—no plans, no dimensions, no construction sequences.

The accumulated experience of the smith, in his capacity as construction consultant, is called into play to ensure that everything is done efficiently; and the spectacular speed with which the house goes up, once the chosen day for its erection finally arrives, conceals much highly organized labour that has gone before. The men of the family who will live in the house begin by cutting the beams and bamboo poles in the forest, measuring their sizes in ways that are no less effective for being informal, like the "armstretch" measure Misaw used for the length of cotton cloth she sold me. Cubits (elbow-to-fingertip), handbreadths and fingers all ensure that the separate components will fit as intended when they come together.

The women help with collecting the bamboo, but their main task is providing the 300 or more grass shingles for the roof thatch—cutting the imperata grass that has sprung up in fallow fields and tying it into enormous bundles, which they haul up to the village either on their own backs or those of pack-horses. For days on end, I would see them at dusk, trudging into the village with 10-foot bundles of grass sprouting from their backs. The bundles are

heavy and some of the smaller women staggered under the weight, yet I never heard a word of complaint either during the fetching and carrying or afterwards when the grass was being looped over sticks to form the shingles. Women work terribly hard in this society and the Akha are proud of the fact. Indeed, I have never seen children work as hard as Akha girls in their early teens, who seem to be kept busy from morning to night.

Finally, when the preparations are complete, 15 or 20 of the family's kinsmen come together on an auspicious day to raise the beams and fit all the components together. The result is a superb tensile structure—a perfect example of the Akha's ability to create works of great beauty and utility from the most basic of raw materials.

As in every practical undertaking, the traditional way of doing things—*Akhazang*—determines each step in the procedure. The cheery co-operation and sense of occasion that mark a house-building mask the serious commitment that underlies the event. The materials may be free in the forest, but a house-building is an expensive undertaking nonetheless. House-building would be impossible without observing the proper formalities towards the family's ancestors and towards the "spirit owners" of the land on which the house is to stand. Formal meals that must be provided, partly as offerings and partly as food for the helpers, usually involve the family in the outlay of at least one dog and usually a pig—enough to make the undertaking really difficult for poorer families.

And although a family's relatives contribute their labour, that help must be returned. One of the houses I saw built during my stay at Napeh took the work of 15 helpers for two days, involving the family in the obligation to give two days' help to each of those other families over the next few years—a substantial commitment in a world where constant work is needed simply to provide enough to eat. Yet these commitments, understood and accepted by all the Akha, are the kind of ties that bind the Akha community together and have preserved its character for so long.

Skilful Manipulations of Bamboo

Fashioned readily into houses and bridges, fences and conduits, flutes and clogs, bamboo is the hill people's universal material. This giant grass springs up in clumps wherever there is ground space. Fast-growing and abundant, it is easy to cut and light to transport.

Bamboo grows in a vast range of sizes, from pencil-thin wands to stiff and woody stems a foot in diameter, and it has a strength-to-weight ratio even greater than that of steel. The hill people found out long ago how to use each type to the best advantage. The larger poles—rigid, dead straight and up to 120 feet long—are ideal for constructing buildings. Hollow and

The sides of an open-weave basket used to store firewood are woven from split bamboo. The bamboo's rich brown colour is achieved by storing it in the

watertight, they also make excellent containers: a section of a wide stem, with the solid node that separates one section from the next providing a ready-made base, serves as a rice steamer or a storage jar. When halved lengthwise, large bamboo sections also make aqueducts to carry water long distances from a spring to a convenient spot in or near the village. Slimmer, more flexible stalks can be curved to make furniture, or sliced into strips and woven into matting or baskets. Dampened for flexibility, bamboo split thin also serves as twine. Shoots of the very finest grade are left whole and used for pipe stems or carved into small wind instruments.

rafters above a hearth, where woodsmoke slowly penetrates it. The curing process also protects the basket from insects that would otherwise devour it.

108

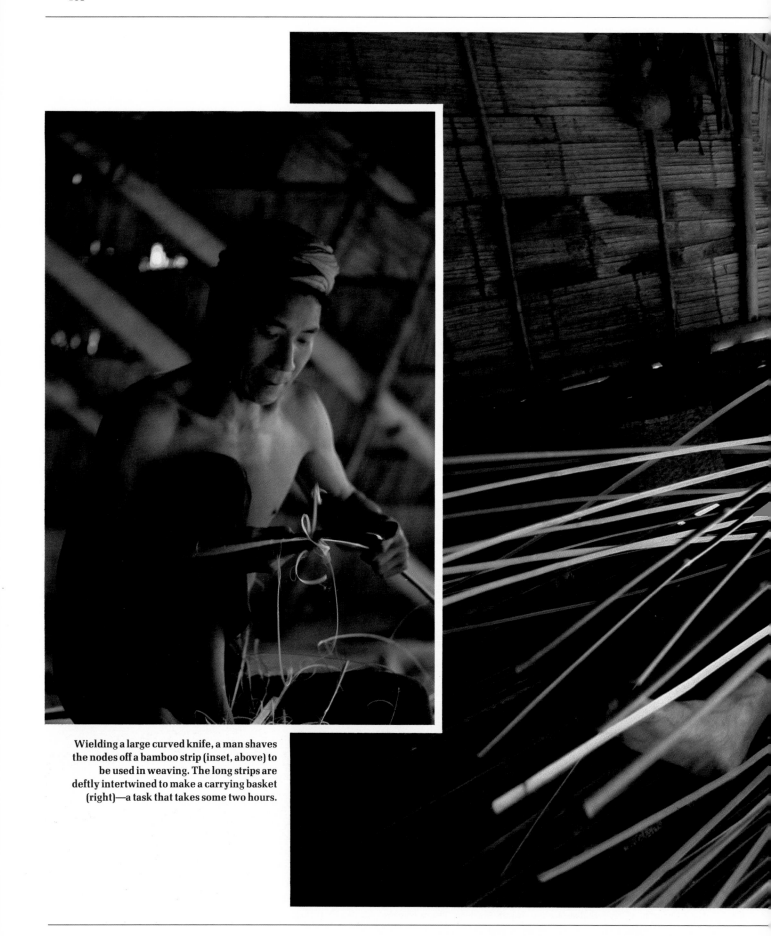

Wielding a large curved knife, a man shaves
the nodes off a bamboo strip (inset, above) to
be used in weaving. The long strips are
deftly intertwined to make a carrying basket
(right)—a task that takes some two hours.

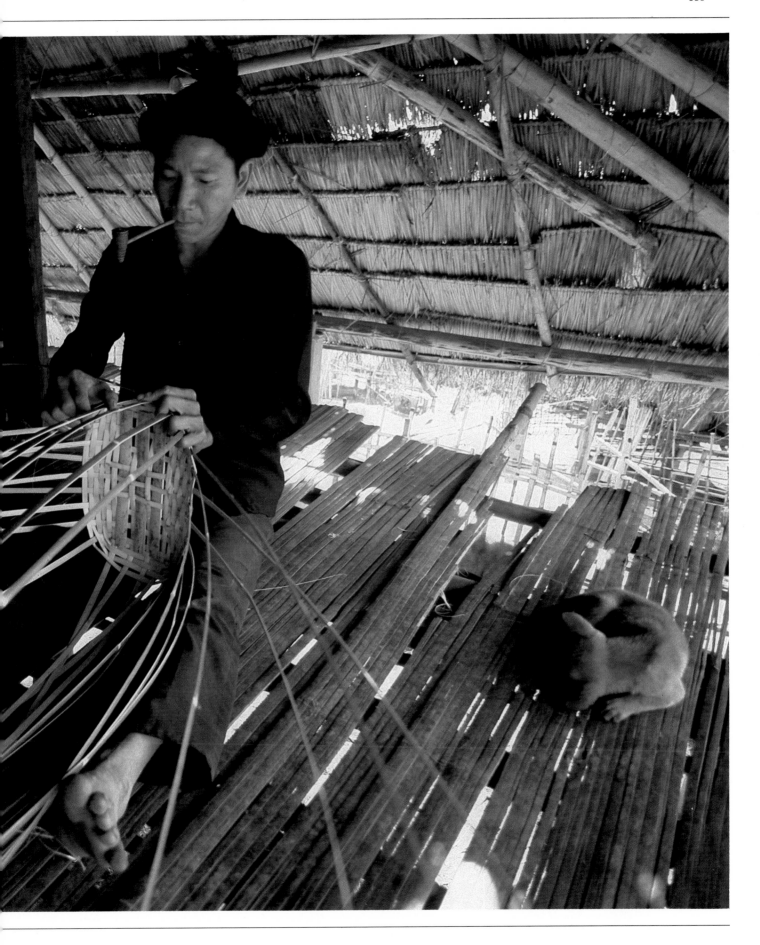

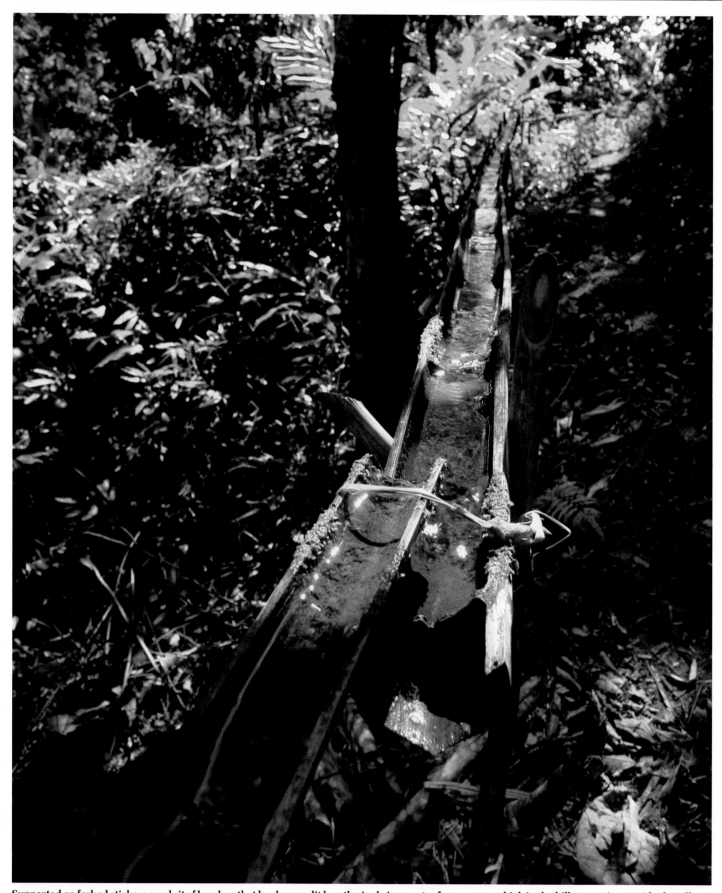

Supported on forked sticks, a conduit of bamboo that has been split lengthwise brings water from a source high in the hills to a point outside the village.

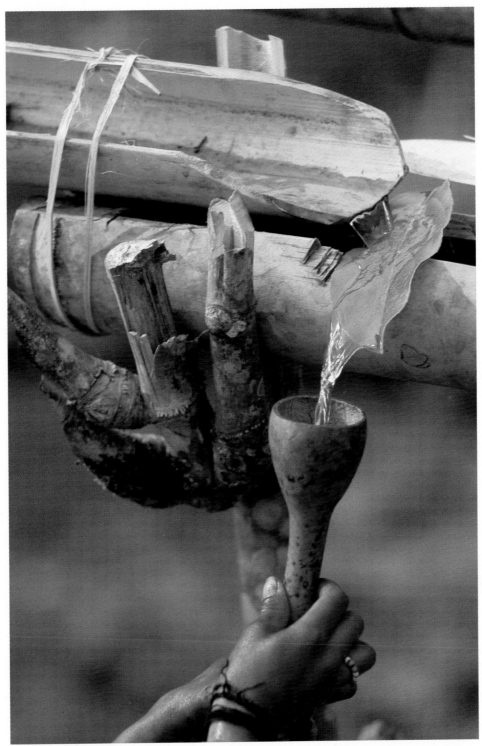

A leaf, temporarily placed at a joint in the pipeline, diverts water through a gourd funnel into a jar.

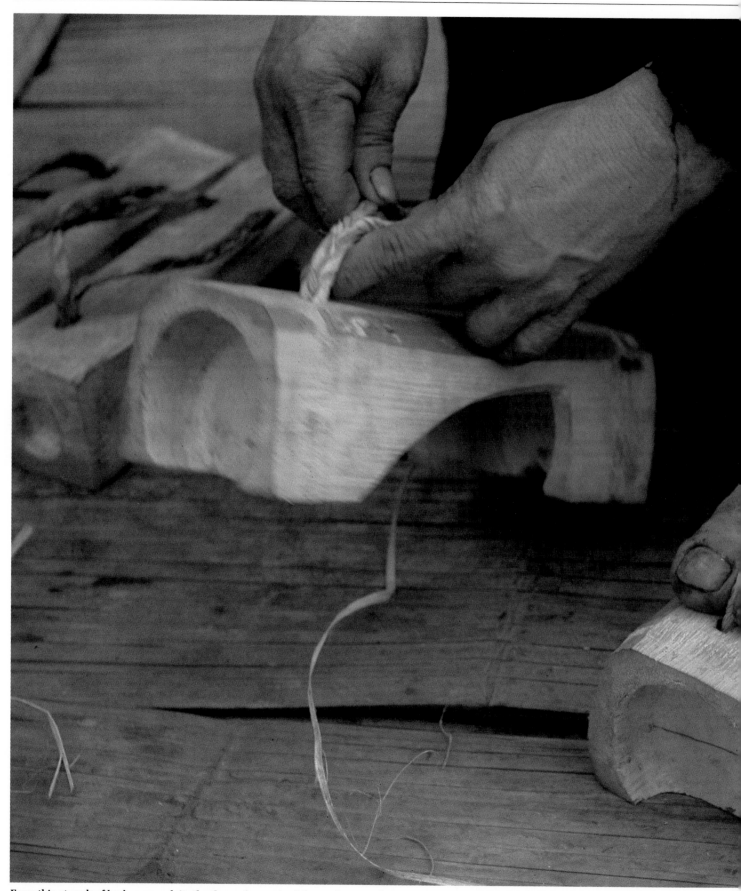

From thin strands of bark, a man plaits the thongs for a pair of clogs to be worn during the rainy season. Such footwear, carved from bamboo sections,

helps to provide traction on steep hill paths that become slippery with mud. Only men wear clogs; women traditionally go barefoot in all weathers.

A bird trap baited with a grub (left) is held under tension by a taut string leading from a delicately poised trigger to a pivoted bamboo hoop. When a bird puts its head through the hoop to snatch the grub, the trigger is released and the pole springs back, pulling the resulting noose upwards so that the prey is instantly choked (below).

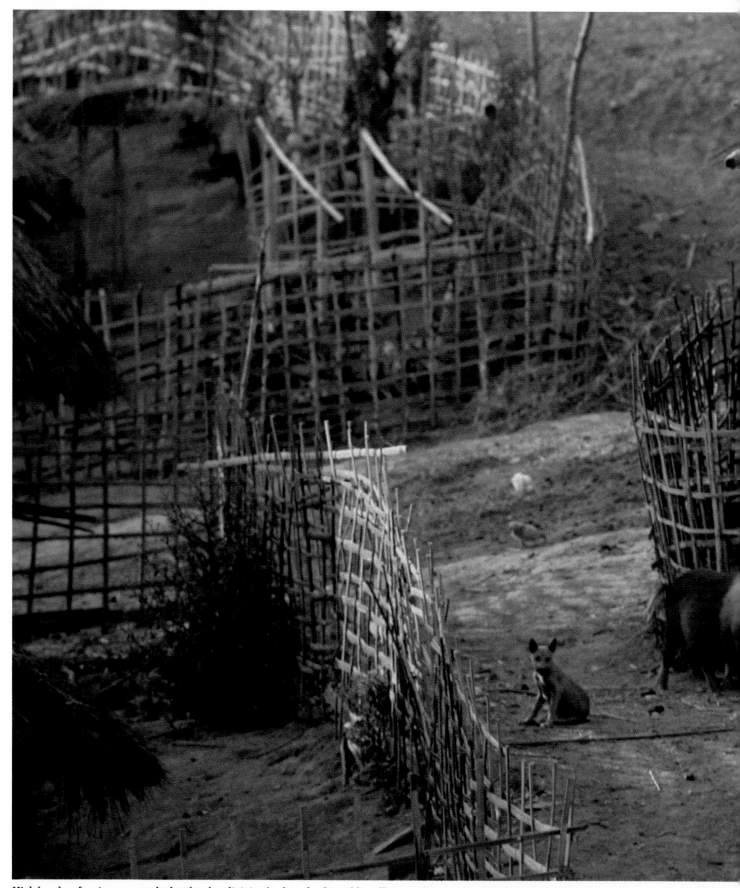

High bamboo fencing surrounds the closely adjoining backyards of an Akha village. A sliding gate (right), constructed by slotting long bamboo poles

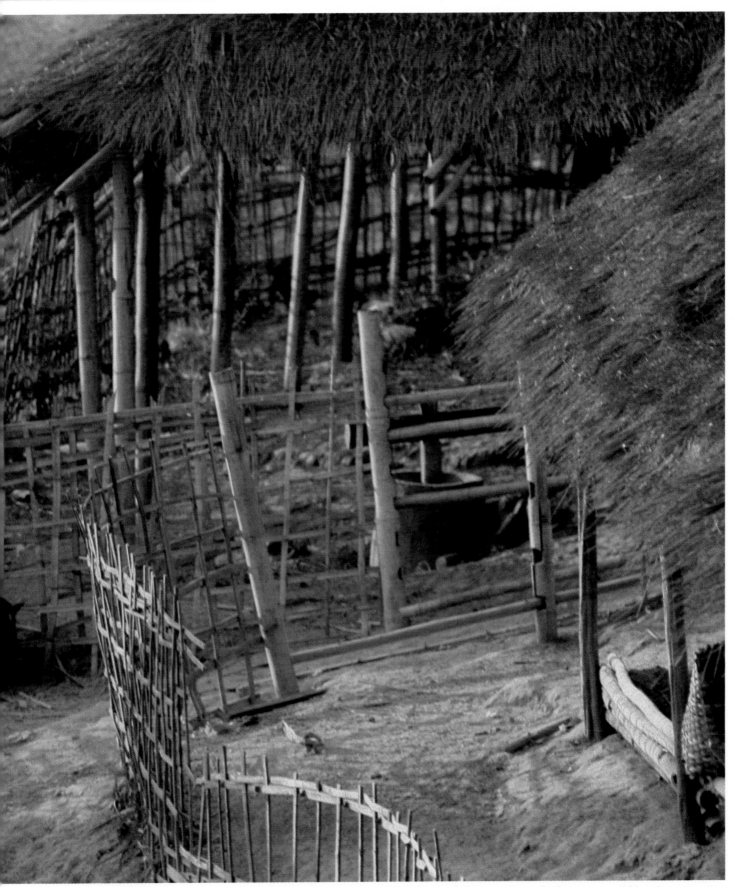

through thick vertical posts, can be completely or partially closed to prevent family livestock from straying and to keep out a neighbour's rooting pigs.

Thick bamboo poles, securely lashed together, provide the platform (inset, above) of a footbridge over the Mae Suai river. Supports to carry the 25-foot

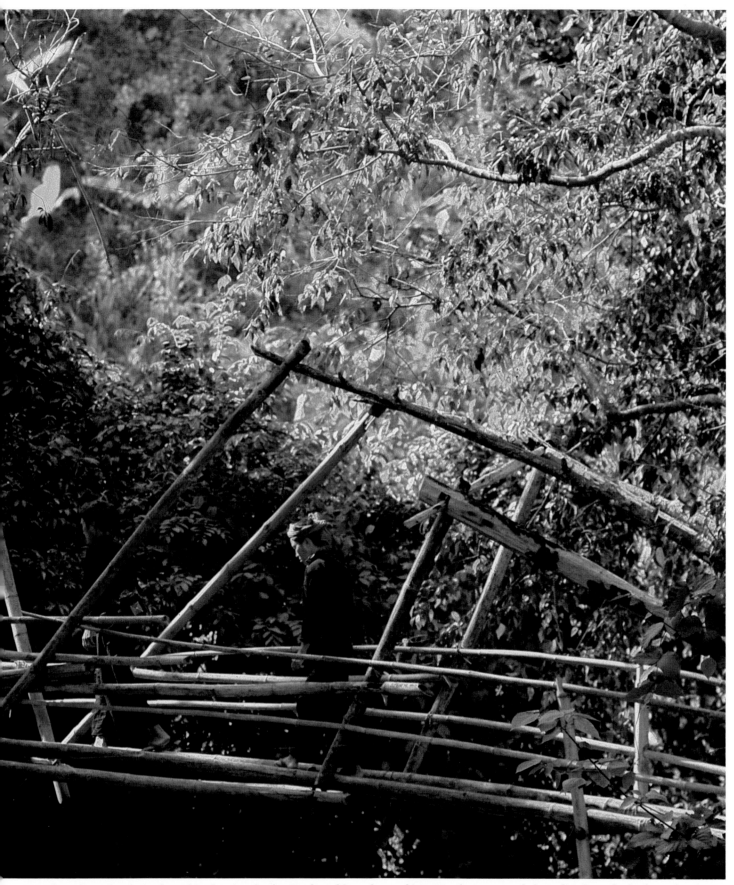

span have been deeply implanted in the river banks. Hardwood branches arching over the structure help to distribute the load evenly (above).

Four | **A Journey to the Border Villages**

After living for a few weeks with the villagers of Napeh, I became curious to see the area in which they had made their previous home—the mountainous region close to the Thai border with Burma. Napeh villagers sometimes walk the 40-odd miles to the border villages to visit their friends or relatives and I resolved to make the journey myself. One January morning, I departed with Liphi, an English-speaking Akha who earned a living as a guide for "jungle treks". He had been born in Burma, knew the border area well and was delighted to be setting off on the five-day trip in the north, where he could expect to meet many of his old friends.

We drove as far as the dirt road would take us, passing through an area where I could see from the truck that the hill villages were extremely poor and deprived. They had become impoverished by land shortages, their swiddened areas merging into each other, the protection afforded by forest belts lost. With the Thai authorities discouraging the villagers from moving on again, their future—and indeed their present—looked bleak. Further north, where we were heading, villagers were not so desperately short of land, although they had the political disturbances of the border to contend with.

From the small provincial settlement where the track ended, we then set off on foot along the mountain trail laden with our gear—knapsacks stuffed with sleeping bags, a change of clothes, emergency rations and medicines. The narrow trail would follow a mountain ridge for three or four miles, dip down to the stream-bed in a fold between two hills and ascend again to the next ridge. On steep slopes the path wound back and forth: sometimes we encountered steps that had been cut in the earth by the hill people to make the going easier. Labouring up and over ridges, bent under the weight of my knapsack, I scarcely had the energy to look around, and by the first nightfall I was totally exhausted. Liphi found us shelter with the *buseh* in a small Akha

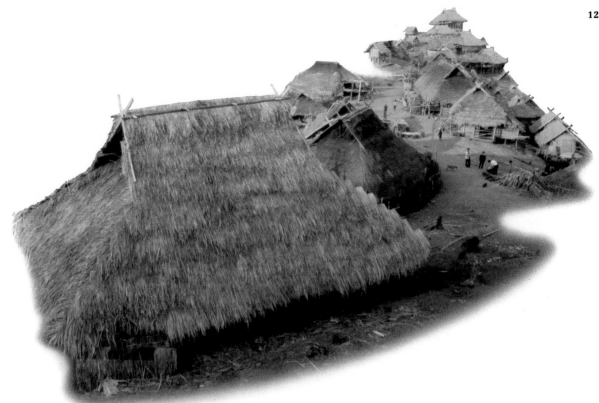

village about 10 miles from the border. I passed the evening there in a state of numbed relaxation induced by the welcome meal of rice and vegetables, washed down with several cups of rice liquor. Waking up on the covered porch the next morning, the rice mortars pounding in my ears, I was seized by a sudden inspiration: get a horse!

In many Akha villages, a few families who can afford them own a pack-horse or two, which they use to carry the sacks of rice or vegetables from the fields back to the village and to collect firewood or thatching grass. I had seen them at dawn in Napeh, up to a dozen tethered daily on the central esplanade, all of them saddled and ready for early departure. Sometimes the horses make longer journeys, to distant villages or to the lowland markets, but since they are rarely ridden they travel no farther in a day than a man can walk. Along the trail we had often seen convoys of half a dozen horses, with one or two men walking ahead and a few others bringing up the rear. The horses were not roped together but ambled at their own pace, picking their way along the rutted tracks and keeping their heads bent firmly forward.

The *buseh* told us that his horses were otherwise occupied. He had a brother, however, with an unemployed horse. A child fetched the brother, Agoh, and we settled down to discuss the matter at leisure over several cups of rice liquor. Agoh seemed reserved at first and not nearly so convinced as we were that it would be practical to continue the journey. He knew the area; he did not think it advisable to take this foreigner into it. Much of the region, he said, was controlled by Kuomingtang soldiers, remnants of the Chinese nationalist armies defeated by the Communists in the 1940s, who fled first into Burma and then into northern Thailand. The Thai government allowed them to settle there in order to strengthen the inadequate border patrol that guarded against armed groups operating on the other side. Since World War

II, the Kuomingtang, who replenish their ranks with their sons, have established a highly profitable system of opium production, persuading many of the hill people to grow poppies on the high ridges, where conditions are most favourable for cultivation. The illegal crop has brought wealth to the area, but it put the hill people at the mercy of the Kuomingtang, as well as others who control the trade. And the region had also become infested with bandits, who rob the hill people of their opium and travellers of all their valuables.

I had been told before I left Napeh about these hazards, but they seemed exaggerated. In any case, I now encouraged Liphi to insist that we proceed, and Agoh finally relented. After some long silences and more rice liquor, he mentioned an astronomical fee that was to include not only the use of the horse but also himself, suitably armed to protect us against bandits. Liphi saw my surprise and reminded me that hiring a horse in the Thai hills is not comparable to renting one from a livery stable. The owner stands a good chance of having his beast stolen any time he strays too far from home, and there is neither a police squad in the hills to help him recover it nor any insurance to reimburse him. Agoh's enormous bill—the day rate was over 10 times the Akha day-labourer's earnings—thus came to sound reasonable enough, especially since he proposed to defend our lives with a genuine U.S. Army M-16 rifle—presumably war-surplus.

After we had struck the bargain, Agoh brought out an ancient wooden pack saddle and strapped our gear to it very firmly and carefully, placing the same amount of weight on each side: for the horse's sake, a pack saddle used in the hills has to be better balanced than a national budget. We set off, then, with nothing to carry except a small over-the-shoulder bag. I was cheerfully lightfooted after the previous day's toil, but the horse, it turned out, was a plodder. He took every opportunity to nip bamboo sprouts from the edge of the trail and then stand there, ruminating over his good fortune.

It did not greatly matter, since the hills of Thailand are not a terrain one can race through. We were headed for a long, high massif that ran parallel to the Burmese border, and the trail wound up and down along the outer ridge of this range. In several places the forest was luxuriant and the path led us through groves, complete with lofty trees, trailing vines and fragrant bushes. Even isolated pockets of this kind can give one a sense of what a Garden of Eden these forests must have been a few hundred years ago. But the landscape soon turned back into scrub forest and swiddened fields, interspersed with groves of wild banana trees and giant bamboo.

Around noon we decided to take a short cut down a long-unused trail that Agoh remembered discovering 10 years before. We turned off the main path and found ourselves following the horse through unkempt scrub that impeded our progress at every step. It was heavy going, but Agoh assured us that we would save a lot of time by taking this route. At one point we had to fight our way across a field of head-high imperata grass. The insidious stalks made way for the horse but then slapped back, frequently hitting me squarely in the face. One sharp-edged sliver of grass embedded itself like a dart in the cornea of my right eye. I had to pull it out before my eyelid would close

Weathered wooden figures lean against a fence at the entrance to an Akha village on the north-western fringe of Thailand. Each Akha community has developed its own style of carving these village guardians. The casual aspect of this couple is reinforced by the pipe lodged in the mouth of the male.

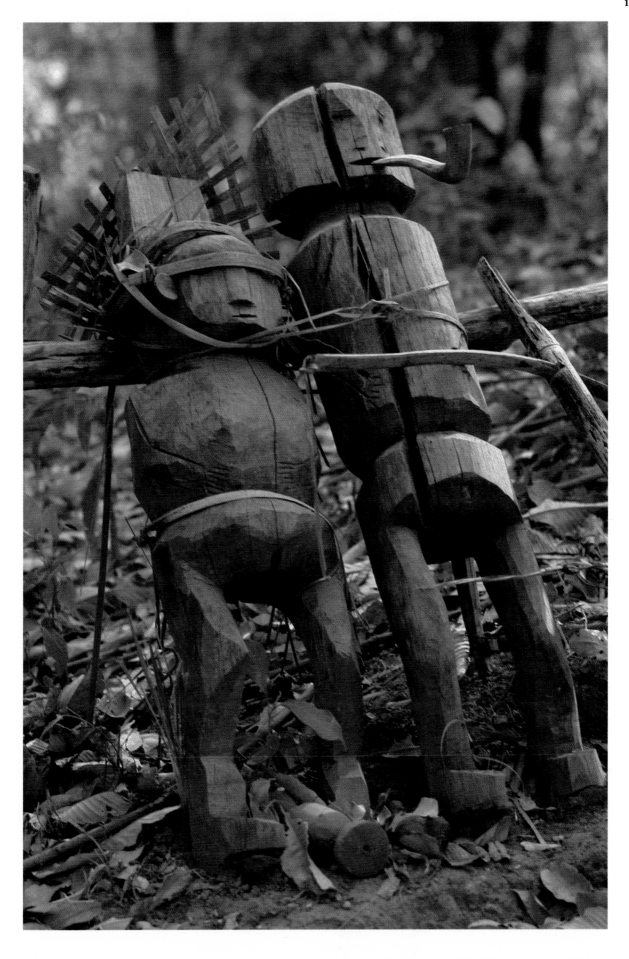

again and for the next two days I could hardly see out of that eye. From then on I kept my bush hat firmly on my head and my eyes turned downwards whenever we got into really dense underbrush.

After several hours in the bush, we were suddenly back on a broad, well-worn trail. It was as steep as a ski slope, and deeply rutted by horse traffic and the torrents of water that pour down these hills during the monsoon. Below us we could hear a stream rushing through the forest, but we had almost reached the water before we could see it. The horse drank his fill as he splashed across the swift but narrow stream. We, on the other hand, used a foot-bridge—a tall tree on the high bank that had been felled so as to span the river. Once on the far bank, Agoh and Liphi unsaddled the horse to give him a rest. He immediately found a bamboo thicket in which to forage.

The neighbouring hills were dotted with the villages of several different peoples—Akha, Lisu, Lahu and Yao—and travellers in a variety of costumes were going to and from them with their horses. A Lisu family in rainbow-coloured clothes and black turbans had reached the ford ahead of us and sat resting their horses. A boy, aged about nine, was risking a ducking by tiptoe-ing back and forth across the bridge. Suddenly we heard a commotion ahead of us. A dozen men with as many horses picked their way down a trail even steeper than the one we had just descended. They wore a strange assortment of homespun shirts and war-surplus army gear, carried rifles, and had tucked long machetes in their belts. Their horses seemed very lightly loaded.

"Who are they?" I asked Liphi. He said they were Shan, the most powerful group in Burma's Kengtung State, who had been in revolt against the central government since the 1950s and had succeeded in establishing a tentative autonomy in eastern Burma. These Shan, Liphi guessed, were on their way from the highlands of Kengtung to one of the Thai market towns where one can trade raw opium for, among other material delights, digital watches and transistor radios. The Shan swept past us without a word, splashed across the ford and disappeared in the direction from which we had come.

We took this as our cue to saddle up and begin the long climb to the next ridge. After about two hours, we reached the first of several Akha villages that lay along the trail. But we pushed on, bypassing the guardian gates, because we wanted to put more miles behind us before we stopped again.

The top of the mountain was still heavily wooded, but the slopes below the trail had been swiddened. In the middle of each field stood a thatched bamboo hut where the owner's family could take shelter during sudden downpours and at noon in the hottest months, when the sun pursues its scorched earth policy across the slopes. Had we not been pressed for time we might have taken a siesta in one of the huts; the Akha have no compunction about using someone else's field hut as a wayside resting place.

We passed several springs along the way, each one carefully tapped with open bamboo pipes supported by forked sticks. Next to the mouth of each pipe there was usually a bamboo cup up-ended on a stick, so that all who passed could have a drink. The inhabitants of the nearest village provide this amenity for travellers simply because the custom redounds to the benefit of

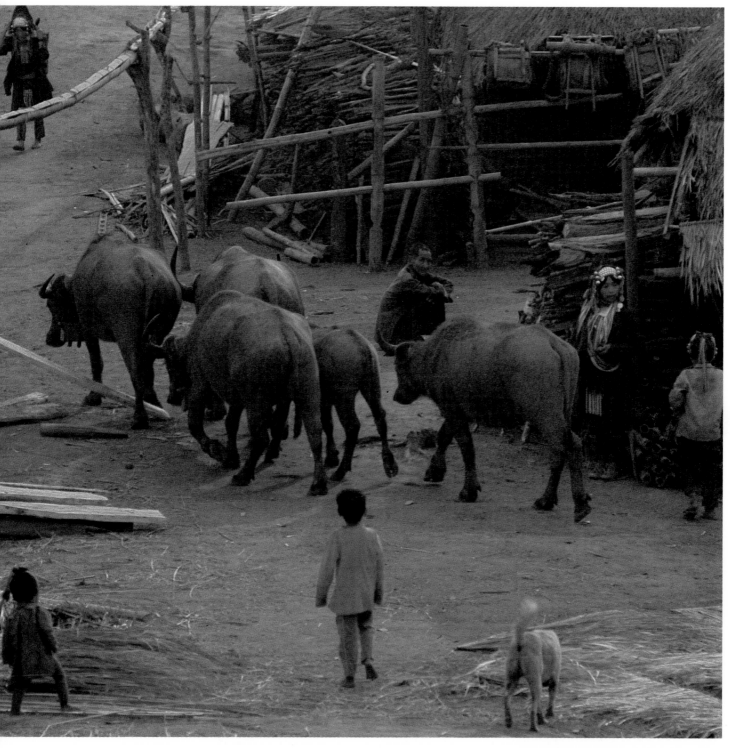

Sleek buffalo amble through an Akha village in the mountains near Burma. Overhead, an aqueduct brings in water. Well-fed livestock and a central water supply are signs of the relative wealth that opium cultivation has brought to some villages in this region.

all. Water is a precious asset in the hills, to be treated with great respect, especially in the dry season. The traditional locations of the Akha people—half way up mountain slopes, with stronger communities above as well as below—mean that providing a good, safe water supply is not easy; hence they consider it a priority to make spring-water available to everybody.

The trail took us through Kuomingtang settlements, but nowhere did I catch a glimpse of lives enriched by ill-gotten gain. These Chinese villagers were mountain people living among their pigs and chickens, and scratching as hard as the rest for a living. The families had bamboo houses not very different from those of the Akha, but each village was grouped around several open-fronted bamboo shops stocking a small but useful assortment of goods, including flashlight batteries, Chinese noodles, soy sauce, rice liquor, rubber sandals, soap, two brands of Thai cigarettes and matches.

At the top of the ridge we came to a settlement of no more than half a dozen houses overlooking the border. The inhabitants were Haw Chinese—the traditional middlemen of the mountains whose ancestors, like the Akha, have lived in Yunnan for centuries. Even this tiny place boasted a solitary emporium run by a beautiful pregnant woman holding a squalling infant. She, too, sold flashlight batteries, noodles, soy sauce, two brands of cigarettes. . . It occurred to me that her meagre shop was the northernmost outpost of capitalism in this part of the world: from there to the North Pole everything was, at least nominally, socialist. The horses in the adjoining compound were half as high again as those of the Akha and able to bear much heavier loads. They were used to haul the noodles and cigarettes up the mountain.

Our path continued to run almost exactly parallel to the border. In the next village we actually saw some Kuomingtang soldiers who were in control of this part of the frontier: three or four young men in unmarked fatigue uniforms and an older man who must have been an officer. They stood on a hillock overlooking the trail, inspecting us with dark looks. We passed muster, evidently, or Liphi's cheerful greeting may have served as the password. He was clearly enjoying every minute of the journey. We pressed forward again and, as the afternoon wore on, we fell in with two Akha women who were walking from one village to the next. It turned out that one of them had attended the same mission school in Burma as Liphi had. They had not seen each other for 12 years, so they dropped back and talked together excitedly about things that had happened to them in the meantime: their spouses, the dangers they had experienced. Agoh and I walked ahead with the horse.

Our next brief halt was at an Akha village perched on the knoll of a hill and surrounded by tangled underbrush. We entered by way of the lower gate and paid a courtesy visit to the *dzoema*. We saw that things were not going well: the children were ragged, the houses dilapidated, the adults hostile or indifferent. These were Akha trapped by poverty and losing their faith in the future. One could sense their unhappiness and I began to understand that the villagers of Napeh were indeed among the luckier few of their people.

We pushed on to another small Akha village perched on the shoulder of a mountain that dropped off sharply towards a swift-running stream. Here at

last we were in an area where there was less pressure for land, and so the village looked better kept than any of those that we had seen *en route*. We marched ceremoniously through the upper gate, which was guarded by several carved figures and, as additional protection, by the desiccated, eyeless head of a black dog mounted on the crossbar. "You see that," Liphi said, as we passed beneath the head with its ghastly grinning teeth. "There has been some sort of illness in the village." We found out later that their pigs were dying of swine flu. A dog's head at the gate is an old Akha symbol, designed to ward off the invisible forces that cause epidemics.

Undeterred, we made our way to the dwelling of the *buseh* at the centre of the village—a new and spacious house decorated with dagger-like wooden sculptures that were pegged on to the gables. Liphi introduced me and the *buseh*—Yehju, by name—greeted us warmly, inviting us to stay the night. We presented him with a bottle of the powerful rice liquor; he countered by asking us to dine with him and some of the elders. Tall and aristocratic, with delicate bone structure and a rather distant look in his eyes, he had the bearing of a Tibetan shaman or an American Indian chief.

Both Yehju and his wife were in their early sixties. She was a handsome woman wearing a magnificent headdress that was ornamented with heavy silver balls and coins in the so-called Loimi fashion that developed in Burma. Yehju had only one son; but the son had two wives and nine children; a matter of great pride to the grandparents and the first thing they told me, since it meant equally that the family was honouring and perpetuating the ancestors, and that the ancestors were protecting and guiding the family.

Shortly after nightfall we men sat down to a festive dinner of chicken, pickled forest plants and hill rice. Yehju apologized that there was no pork, because all his pigs had caught the flu. Then, over innumerable cups of forest tea, he proceeded to tell us his story.

Yehju had led a very productive and, in many ways, exceptional life, yet he provided a typical case history of what many Akha have endured in recent times. He was born in Burma at Yalgoh, a mountain village two days' walk from Kengtung town, the capital of the state of Kengtung. Although the village was untouched by World War II, civil disturbances in Burma following the war led him and his family to move farther south. They walked for 10 days to reach an Akha village in a remote part of Burma, where they stayed for two years and Yehju became the *buseh*. Then hostilities caught up with them. Kuomingtang soldiers who were retreating from Chinese Communist forces levied a "tax" of 1,500 rupees—about 150 dollars—on the village. When the money could not be collected, Yehju was taken to the Chinese camp and savagely beaten. "I was almost dead," Yehju said, "but I took jungle herbs for seven days and recovered enough strength to escape."

Yehju made his way back to the village, but he was afraid that the same thing might happen again. He and his entire village moved south, still within Burma, and settled once more. With his family, he remained on the new site for eight years and grew prosperous. But the area became the scene of bitter

fighting between the Burmese central government and a group of Lahu—a hill people who tend to be more militant than the Akha. Lahu partisan units had been fighting for their independence for several years. Burmese planes, Yehju continued, had bombed Akha villages along with those of the Lahu. Burmese government troops had also entered Yehju's village to conscript all the able-bodied men for service as unpaid porters and ammunition carriers. The partisans disappeared into the jungle, but as soon as the government troops had moved on, the Lahu came back and forced the remaining Akha to pay taxes, which were all the more difficult for them to raise because the young men of their village did not return from forced labour for several months. All the Akha villages were suffering similarly. It was a situation that had recurred many times in the centuries of Akha history: stronger neighbours had always seen them as a pool of labour to be impressed at will.

The Lahu guerrillas made the Akha's lives so intolerable that Yehju and several relatives decided to escape with their families. "Our situation was little better than slavery," Yehju said. "We worked the fields, and they waited and took our crops." Since armed Lahu were guarding the village, Yehju's followers surreptitiously sent out two scouts to reconnoitre an escape route and find a new settlement location. The scouts walked as far as Thailand, worked out a safe route across the border and then returned to report to the others. Led by the scouts, five families, including Yehju's, began the exodus.

To avoid arousing suspicion, they had to leave at home all their livestock and belongings except the silver ornaments they wore every day, some raw opium and whatever they could carry in their back-baskets. The five families—12 adults and 11 children—walked out of the village past the guards, pretending to be on their way to the fields for a day's work. Instead, they walked as far south as they could, all that day and all the following night, and then hid in the forest. "The mothers took their small children on their backs. We had a new-born infant with us, and one dog. The dog warned us whenever the Lahu were near; then we would hide in the forest. The baby cried once; fortunately, no one heard us in our hiding place. But we had to leave behind the old people who were too frail to make the journey." I asked what had happened to those elderly relatives and to the others who had remained. Yehju evaded my question; evidently the topic pained him. If he knew their fate, he was not saying. Even if the other villagers had survived the treatment of the Lahu partisans, they could not have had an easy time, deprived of the most active members of their community.

As soon as Yehju and his companions were sure that the Lahu troops were not pursuing them, they walked by day and spent their nights, whenever possible, in Akha villages. They carried only enough food for one day at a time and depended on friends or sympathetic hill people for help. After 13 days of walking, their scouts told them they had reached the Thai border. They crossed the frontier on a forest trail, bypassing the official border crossing—the bridge at Mae Sai.

They had neither relatives nor acquaintances in Thailand, but as luck would have it, in the first Chinese village on the Thai side, they ran into a

A silversmith transforms a Thai coin into one of the hollow balls used to decorate the women's headdresses. Holding the coin with tongs (top), he pounds it to a fraction of its original thickness. Then, steadying a horn mould with his feet (above), he uses a screw-shaped pestle to beat the coin into a hemisphere. Two such forms are heated and fused together to complete the ornament.

Haw cattle-trader with whom Yehju had done business years ago in Burma. He advised them to settle in the immediate area. "If you travel farther south," he told them, "you will have difficulties with the Thai authorities. Stay here and we'll look after you." I asked Yehju whether they had regarded the Chinese as their friends. "We weren't sure whether they were good friends. But we didn't know how to speak Thai and we did know Chinese. Since other fleeing Akha we encountered were also strangers to Thailand, we thought it best to settle near people who at least knew something about the country and could speak the language."

Yehju and his group found a site in the forest and built their village there, although the ground sloped more steeply than they would have liked. None of the settlers was sufficiently well versed in the laws and rituals of *Akhazang* to qualify as a *dzoema* but among the Akha refugees streaming across the border they did find an experienced old man, Ja Cheh, who agreed to become their *dzoema*. He and the two families with him were not from the same clan as Yehju's group but nobody considered that an impediment; most Akha villages are made up of people belonging to several different clans. Indeed, unless members of at least three clans join in creating a new village, it is not possible for the full range of relationships in *Akhazang* to be established. It was Ja Cheh who, just three years before my visit, had performed the founding ceremonies for the new community, dropping an egg to locate the site of his house. In accordance with custom, everyone pitched in to build Ja Cheh's home, if possible in a single day (the *dzoema's* roof, at the very least, must be finished on commencement day). Next, they laid out the dancing ground. Other Akha refugees from Burma joined them in due course; at the time of my visit, the village consisted of 37 families, of whom about half belonged to the *buseh's* clan, and the rest to various other clans.

As soon as the building of the houses was well under way, they began clearing and burning nearby hillsides on which to grow the next year's rice crop. Since they had no reserves of rice to fall back on, they sold the 30 pounds of raw opium that they had managed to bring with them. It was the only thing of value, besides their silver, that they owned. The Chinese opium traders paid them only 150 dollars for each *joi* (three and a half pounds)— about a quarter of the going rate at the time. "We sold one *joi* every month and the money enabled us to buy rice for the village during our first eight months in Thailand. But then the opium ran out and our best workers had to hire themselves out for a pittance as field hands to the Chinese."

Three years later, the village was self-sufficient, although the villagers were still repaying debts they owed the Chinese. "We have our own fields, and this year for the first time we harvested enough rice to feed everyone in the village. We grow vegetables, too, and a little opium. We wouldn't work for anyone else, however much they paid us." But they had one insoluble problem in Thailand: "There is not enough land. In Burma we allowed most of the land to lie fallow for long periods. That way, our ancestors could stay on the same spot for a hundred years or longer. Each family cultivated two or three fields at a time and only one of these was used for rice; we rotated crops

A Decorative Asset

The Akha live among a number of other peoples renowned for their exquisite silver ornaments. Over the years, they have acquired many fine pieces by trade; and, never reluctant to learn from their neighbours, they have in the past century acquired their own mastery of the silversmith's craft. Although their productions do not rival the most ambitious creations of the Chinese, the Shan of Burma or the Hmong—another hill people—Akha jewellery and headdress decorations have a restraint and elegance that give their wearers much pleasure.

The most skilful smiths use a wide range of techniques to produce different effects. They may incise a design on the metal with a sharp chisel, beat out a relief design from the reverse side of a sheet of silver, or set a tiny fragment of enamel in the metal. Less adept smiths confine themselves to simpler tasks, such as twisting silver wire to embellish a ring or hammering silver coins into spheres to dangle from headdresses.

Nowadays, the high cost of silver and the danger of robbery by bandits make the Akha reluctant to commission such showy objects of wealth, and few silversmiths continue to practise their calling. But some families still own substantial creations of past craftsmen. They often keep them hidden away, making do with aluminium ornaments for daily wear; but on festive occasions, the beautiful old workmanship comes out on view.

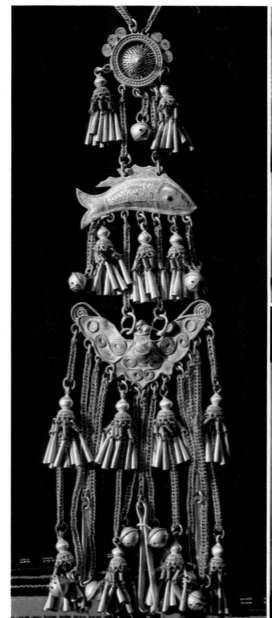

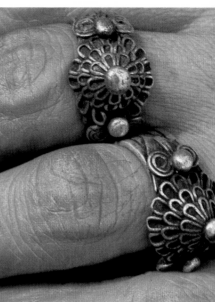

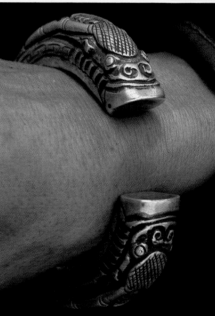

A range of jewellery illustrates the tastes of the Akha. This page, clockwise from top left: an Akha necklace with a fish motif, Akha rings patterned with silver wire, a heavy Akha bracelet etched with stylized dragon's heads, and four Chinese dragon's-head bracelets. Opposite page, from top left: a Hmong bracelet of twisted silver wire, an Akha woman's bodice, embellished with keys, and a heavy Akha neck torque.

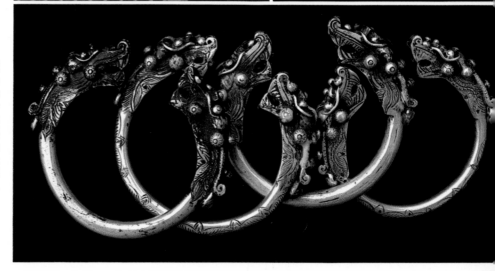

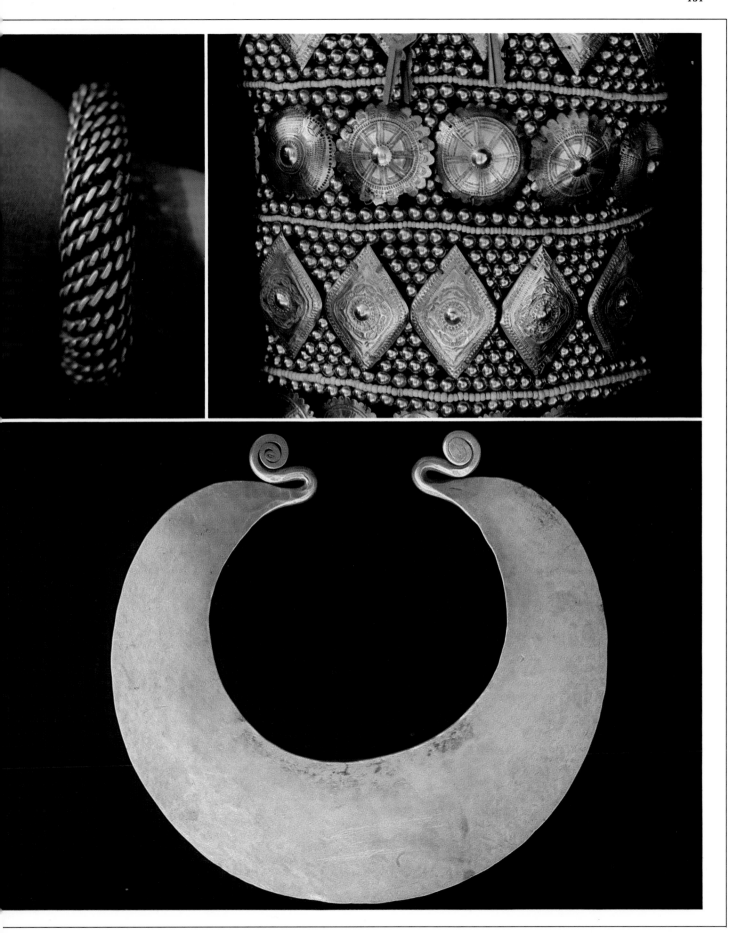

as well as fields. But here it is impossible for every family to have two or three fields; there is just not enough land within walking distance of the village and people would have to go farther and farther to reach their fields."

In spite of such problems, the villagers were happy to be living where they were. "The difference is that here we have peace," Yehju said. "No planes come over to drop bombs on us. The war-makers leave us alone. In Burma if you heard a dog barking at night you had to be ready to run and hide. Here you can fall asleep even if your dog happens to bark. And we can work our fields knowing we will keep our crops. Everything we earn is for ourselves." The Kuomingtang soldiers protected his villagers from thieves and dacoits. For the moment at least, the *buseh* was confident of being able to maintain their new-found prosperity. But it is a fragile security at best. Nobody who cultivates opium can ever be sure of his safety and any action that offends the Kuomingtang can lead to retaliation.

The opium poppy is not a traditional crop for the Akha; their texts make no reference to its cultivation to compare with the detailed instructions given for cotton-growing, for example. But Shan or Chinese traders will pay between 350 and 750 dollars per *joi* of raw opium, a strong cash incentive for any hill community. Their poppies bloom between November and February, depending on the variety; then the petals fall away, leaving an egg-shaped pod containing the milky opium sap. The women score the pods with a sharp knife. A day later the men scrape off the resin, dark with oxidation, that oozes from the pod, before packing it into banana-leaf parcels. The silver-crowned Akha girls working in the poppy fields look colourful and charming, and the men handle their sticky black cakes of resin with almost the same indifference as a lady selling poppy-seed buns in a Manhattan bakery.

The Akha regard opium primarily as an effective though risky medicine for—among other things—malaria, dysentery, rheumatism, diarrhoea and excessive hunger pangs. But in addition, in some villages, several adult male Akha smoke at least occasionally. Many are casual users who can take it or leave it alone, but there are some who are more or less addicted. A seasoned addict may not do much work in the fields, thus putting an extra burden of labour on his wife and family. Yet some of them manage to function fairly well, in spite of their problem, as members of their community.

It is chiefly the Akha men who smoke opium, although occasionally an unhappy or sick elderly woman may join the smokers. In general the women are radically opposed to opium, because of the great hardship the habit can impose on the family. I noticed that the smokers tended to be among the most intelligent members of the community—those who have the most reason to be despondent because of their insight into the acute problems their people face. Paradoxically, the inhabitants of the opium-growing villages are less likely than Akha elsewhere to become addicted, possibly because their relative prosperity gives them some grounds for a more sanguine outlook.

The escapist emphasis among the Akha of the opium pipe was brought home to me a few nights after we left Yehju's hospitality, when we stayed

with the *buseh* of a border village on the eve of his brother's wedding. There was to be a great feast at the *buseh's* house when the brother brought back his bride from another village. The whole household bustled with excitement as they prepared for the three-day ceremony. But the eldest daughter, a statuesque woman who wore one of the most elaborate headdresses I had ever seen, sat in a corner moping. I soon learned why. According to tradition, if her uncle was to be married in her father's house, no one else in the household should get married for the rest of the year. But she was already 25, a spinsterish age for an Akha, since most girls are married by the time they are 20. At her father's behest, she had already postponed her own marriage several times; each time there had been some similar technical hitch, but I got the feeling that her father simply did not want to be without her. This time, she was determined not to accede to his wishes. That very evening, therefore, literally at the eleventh hour, she ran away with her husband-to-be.

Elopement—serious flight as opposed to the mock-elopement that is a prenuptial Akha ritual—is a fairly common occurrence among the Akha, especially when a marriage is thwarted by the couple's parents. It can be a source of embarrassment for the households concerned, but normally both sets of parents know that the elopement will be followed by a prescribed ceremony at which everybody's feelings will be duly placated. In this case, however, the deprived father proved to be almost inconsolable. Not only had he lost his favourite daughter, but his brother's wedding would be held under a cloud and he would lose face in the community.

He first discovered the elopement about midnight, when his daughter failed to return from the dancing ground. His reaction was one of outraged disbelief, then of despair. Eventually the friends at his fireside succeeded in calming him down and he went off to bed. We had been invited to sleep inside the house that night, since it was damp and chilly outdoors, and I stretched out in my sleeping bag, listening to the snores of the *buseh* and his two sons, who had also gone to bed. But after an hour or so, when the fire had died down and it was pitch-black both inside and out, I heard the *buseh* rise from his bed and begin fumbling for something on his shelves.

He was looking for matches. They were not where they should have been and he could not find them in the dark. He became more and more agitated, cursing under his breath while opening one container after another with a desperate perseverance. It was evident that the man was in agony. Finally he coaxed a flame out of the embers in the hearth and ignited a sliver of bamboo, with which he lit the wick of his pig's-grease lamp.

I could now see him dimly by the light of the yellow flame, stretched out on his bed roll, and I realized that he had taken a roll of raw opium about the size of his little finger and was pinching off a small bead to smoke. He stuck the bead to the end of a metal probe and twirled it over the lamp flame, rolling it between his fingers occasionally as it softened.

Lying on his side, propped up on one elbow and holding the pipe sideways against the flame, the *buseh* at last took deep, satisfied puffs without removing his lips from the end of the stem. His pipe made wet inhaling noises, like

someone sipping the last of a drink through a straw, and the opium frizzled as it burned. He used the probe to push every precious particle down into the bowl. It had taken seven or eight minutes to prepare the pipe; it took him no more than a minute to consume it. By the light of the lamp I could see that his face had relaxed at last. Then he set about preparing another pipeful. During the next hour and a half, he repeated the entire procedure no less than seven times. Finally he dropped off to sleep, his anguish assuaged.

This troubled soul was one of those "occasional" smokers who can remain functioning members of their village community. Opium does not prevent some *pimas*, for instance, from remembering their 10,000 lines. Indeed, it helps them overcome the exhaustion brought about by the hours of reciting, but their sense of reality is gradually impaired if they become addicted and in time they become incapable of undertaking anything that will separate them from their desperately needed pipe.

Most Akha leaders recognize the insidiousness of opium and are actively opposed to its use. They would like the Thai authorities to forbid the Chinese middlemen from entering their villages and promoting opium trade. In one village near the border, the *buseh* told me he had done everything possible to keep his people from using the product. "They are under strict injunctions to leave it alone," he explained. "We had four addicts in the village; I worked for years to get them to take the cure. They went to the detoxification centre in Chiang Mai, but always returned to the pipe." Finally he paid them to leave the village. "It was the only way I could prevent them from contaminating the young people. We paid all their expenses and helped them set up new houses further south. But still their wives came back to me to beg for rice."

The last village we visited on our tour of the borderlands was a fairly large settlement of 70 to 80 houses in three distinct clusters beneath the crest of a hill. The *buseh* received us with great courtesy, invited us to stay and seemed all the more delighted to have us when we proposed buying a pig and some bottles of rice liquor so that we could invite him and the principal elders to a dinner party the following evening.

This village, too, had been settled by refugees from the Loimi district of Burma. I wanted to hear the story of their exodus, but I had already learned that such things could not be hurried. When the elders came to dinner the next night, the conversation turned this way and that for many hours.

Three or four of the elders were already in their seventies and proud of having reached that age. In many Akha villages, there may be hardly anyone older than 50. They joked about the increasing infirmities that prevented them from climbing hills as quickly as they once had. One of them conceded that he was now slightly lame; all the same, he had made up his mind to live another 20 years—though of course he knew that he would not be able to reach the Akha goal of 100 years.

"Yes," one of the others agreed. "It is not given to us to be 100. Long ago the first Akha wanted life, a very long life. So they went to the Great Ancestor A-poe-mi-yeh and asked for life and the right to stay on earth for a 100 years.

A farmer checks if any of his poppies are ready to be tapped for raw opium. When the petals fall, he scores the seed pod to release the resin. His valuable crop exposes him to a possible attack by bandits; he keeps a loaded carbine at the side of the field (inset).

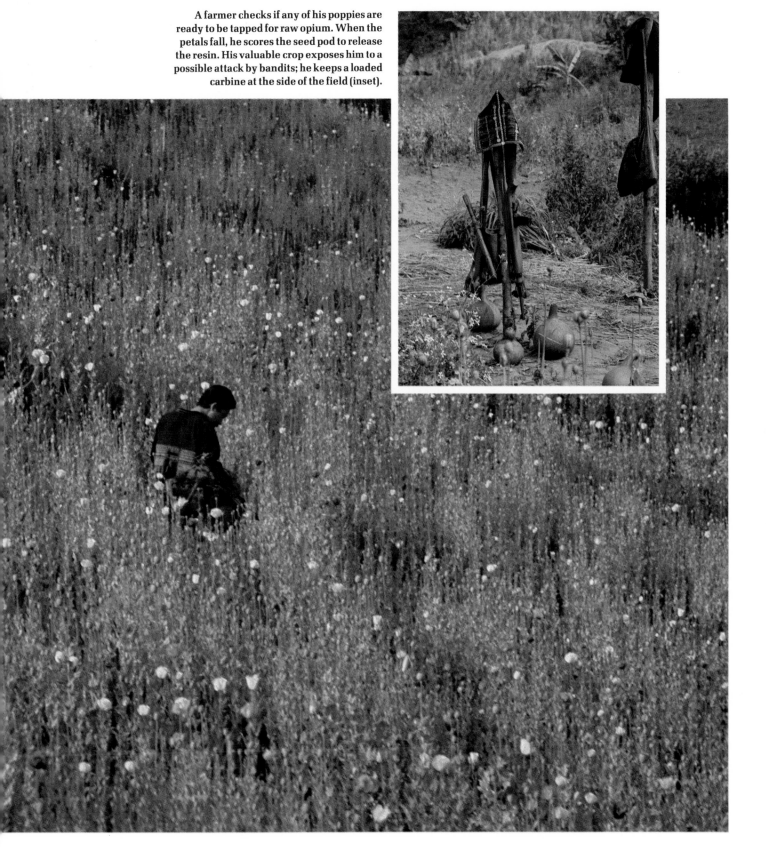

But they received no answer. So they went a second time and asked for life, and for a life of 100 years; and still they received no reply. So they went a third time with the same request. They wanted the right to stay on earth for 100 years and not die so quickly. Then A-poe-mi-yeh told them, 'Oh, you've come to make trouble for me so many times. So I will give you life, but also death. Under no circumstances will you live for 100 years.' Because A-poe-mi-yeh was angry, no one can live to be 100."

The story was typically Akha, for there was no trace of fear in its telling: A-poe-mi-yeh was like a provoked mother who finally says "Enough!" to her complaining children, not a vengeful god who punishes their weakness. There is no hell in Akha mythology; the afterlife takes place in the ancestor world that mirrors a village in the hills—but with the one provision that the dead are spared the constant oppression by more powerful neighbours that had been their lot on earth.

The elders of the village had good reason to be proud of having lived their 70 years. They had survived a devastating series of wars and revolutions, in the course of which, no matter who was fighting whom, the Akha had always been the losers. They remembered the smallest details of their experiences, but had only the vaguest notions of who had fought the wars, or why. Theirs was a casualty's view of history—and realizing this gave me a strange insight into why it is so vitally important for the Akha to preserve consciously their history and traditions: it is the only means they have of keeping their identity during the centuries they have lived as if under perpetual siege.

These old men could remember Burma as a province of British India before World War II, when the British had hired them as labourers to work on the roads. Then came the war and the Akha were forced to serve first the invading Japanese army, then a Thai puppet army. "They killed our animals and ate free. We were forced to carry their supplies for long distances, from here to there—and always without any pay."

When the Burmese rose against the intruders, war-planes came over and dropped bombs on villages near Kengtung town. Were they Japanese or Thai? "We don't know who dropped the bombs." Later, Chinese armies harassed them; again, the elders had no idea whether they had been Nationalist or Communist. "We were always caught up in one war or another. That's why we had to escape. In my village there are 87 families; all of them have escaped from Burma. We don't have so many problems with the government here. They leave us in peace and we can work for ourselves."

One of the elders added that the people of his generation were happier now than at any time since the beginning of World War II. This was a relatively prosperous village—most people had an opium field higher on the ridge—and no one presented an immediate threat to their security. All the elders agreed with this view, but then the *buseh* spoke up. He had kept silent throughout the evening, but now voiced some misgivings. He was a thoughtful man in his sixties who spoke very slowly and deliberately between puffs on his silver-mounted tobacco pipe: "When we were young, we wore only Akha clothes made of Akha material. Girls wore no store-bought shoes, they

went barefoot rather than be seen wearing them. Now things are changing. Now they want to buy from the towns." He was afraid that there was more to these changes than met the eye. "Children don't listen. They want the wrong things. At this rate, they will not continue to uphold the Akha traditions."

But the turn the conversation took next suggested that Akha traditions are not going to vanish overnight. The *buseh* wanted me to know that he was not against change as such; he realized that the modern world had much to offer that would be of benefit to the Akha. At this moment, for instance, they were planning to supply the village with water from a distant spring by means of pipes and aqueducts. Such a decision had to be reached by consensus in the village assembly, and most of the elders felt that a new water supply system might save countless women-hours of labour, hauling water up the trails. But it was going to cost money; everyone would have to pay a special assessment. The elders were currently engaged in long discussions with the heads of all the households, many of whom claimed that they could not afford the luxury of such an expensive system. I suggested, rashly, that in addition to consulting the men they might ask the opinion of the women, who had to do 90 per cent of the fetching and carrying.

Everyone was highly amused at this idea. Naturally, as in communities all round the world, Akha women take their part in the decisions that affect their families. But their influence is exercised mostly in informal ways and behind the scenes. According to the precepts of *Akhazang*, women follow the men's lead, and they have always done so.

The next day my suggestion was repeated round the village and never failed to produce a laugh, even among the women. Yes. . . they could see my point; and probably such things did happen among foreigners. Nevertheless, it was not the way of the ancestors.

Liphi saw to it that the story was recounted at every stop on our journey back to Napeh. In no time at all, I became known among the Akha as "the-man-who-proposed-that-the-women-be-consulted-on-the-water-question."

The Hunter's Forest Skills

A generation ago, when the northern Thai forests were more extensive, the Akha matched their prowess with the crossbow against dangerous large animals such as tiger and bear. Nowadays, the challenges of the hunt are fewer and the rewards slimmer. The forests that nourished the prey have been reduced by the Thai, who haphazardly cut down trees for timber, and by the hill peoples when they clear fields to plant rice. Also, many of the hunters now use locally made shotguns, which have further depleted the big game. Except for summer expeditions for boar or deer, the Akha now pursue mainly birds and rodents. Since they can afford domesticated meat

Grasping a crested bulbul he has just brought down, an Akha hunter touches the wound in its neck with the muzzle of his gun. Next, he will brush the

only once a week or so, even such small additions are welcome. And the skills to bag them are esteemed as highly as ever.

A hunter moves softly among the trees, alert for the slightest sound or the briefest movement. When he has located his quarry, he takes aim and fires—with amazing accuracy, considering the crudity of his gun. After he has made a kill, the hunter will touch the different parts of his weapon against the dead animal. Originally, the gesture was probably meant to appease the angry spirit owner of the quarry he had slain; but for the present-day Akha, the ritual is simply a formality.

bird's body with the barrel and its tail with the stock. Addressed to the soul of the dead bird, this action is part of the unchanging etiquette of hunting.

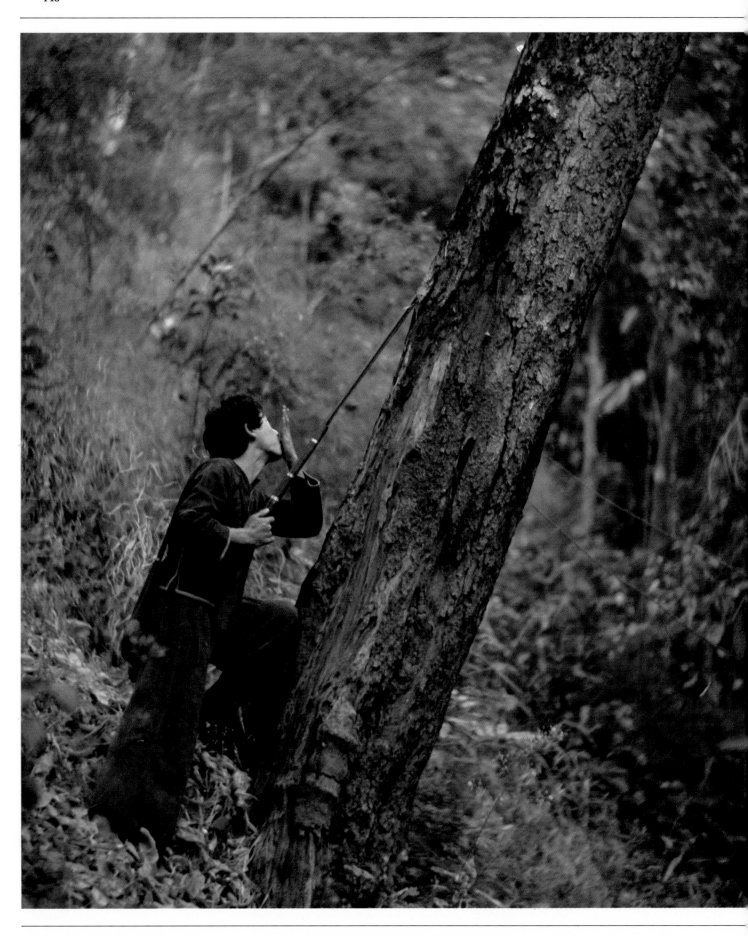

Catching the cry of birds perched within a steep-sided forest valley (left), a young Akha carrying a long-barrelled shotgun puts his hand to his mouth and imitates their call. Then (below), the hunter intently awaits an answering call that may pinpoint a branch where one of the birds is perched.

Advancing along a fallen trunk past the giant leaves of a banana tree, the hunter moves towards his prey. The flighty catch is likely to be a species no more than four inches long, so he moves quietly and quickly.

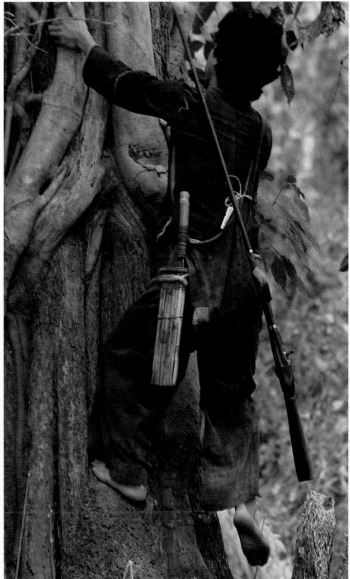

Hoping to get a better fix on his target, the hunter climbs barefoot up the massive vines that twist round the trunk of a tall tree. The equipment on his back includes his shotgun, machete and hunting bag.

A puff of gunsmoke wafts down through the branches as the hunter fires at a bird from his own perch high in the tree. Because the weapon has no sights, he holds it with arms extended in front of him and aims along the barrel. During a vigil lasting half an hour, he killed two birds from this vantage point.

The hunter-turned-cook fashions a plate from a banana stalk while the two birds— already roasted over a fire—are kept warm on a cleft stick above the embers. The birds will add variety to the rice, peppers and onions in the banana-leaf wrapper that the hunter has brought with him. The pile of firewood has been stacked at the site by an Akha wood-gathering party.

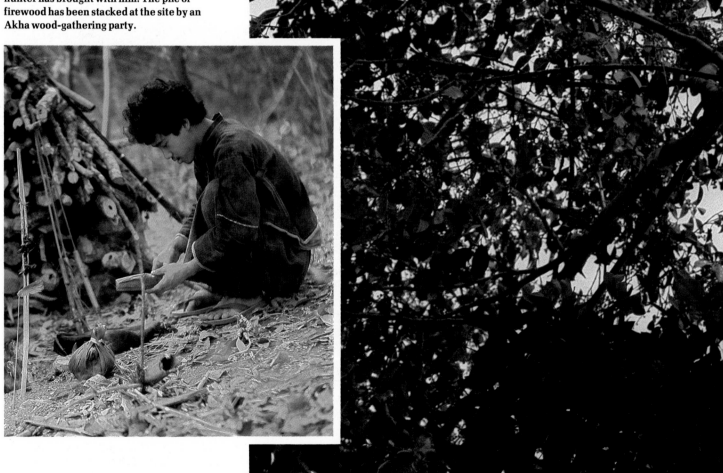

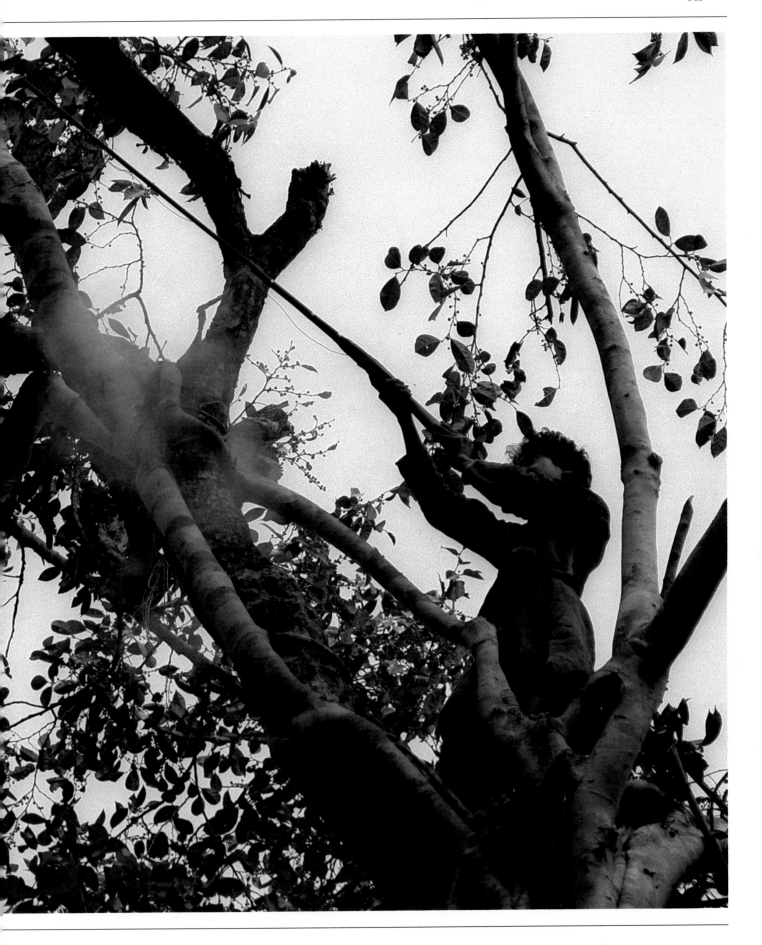

Five | **Heirs to an Epic Tradition**

Across the valley from Napeh, a whole hillside was burning. The mountains behind were obscured by the thick white smoke given off by crackling underbrush and imperata grass. Beneath the smoke, a thin red line of flame crept along the ground, leaving behind a field of bare, blackened earth. Looking down the steep slope from my vantage point at the edge of the village, I could see several Akha men and boys at the windward edge of the fire. They seemed to have it all under control. While lighting this blaze, they sang a traditional song, urging the wind to blow in the right direction and the flames to consume the scrub and not the village. Originally the Akha used small quantities of lard and beeswax to start the fires, and the song instructs the grass and brush to "burst into flames like lard and melt away like wax."

Sometimes, in spite of injunctions to the contrary, the fire burns too well or the wind refuses to obey orders, and people may even be killed as the flames race across the land. Although it does not often happen, such a disaster is unfortunately a more common occurrence now than it used to be, because the shortage of land means that fields are often prepared not in the heart of thick forest among heavy trees that are slow to burn, but on ground covered only by imperata grass and bamboo, which are dry and highly combustible in hot weather. But usually—since the villagers choose the day with practical wisdom and experience—the fire and wind are co-operative, and the clearing and fertilizing process comes off without a hitch.

Everyone breathes a sigh of relief when the last field has been burnt over. But, of course, many months of back-breaking physical labour are still to come, for the main period of activity in hill agriculture is between March and November, when rain waters the crops. In January, brush and any trees in the area selected for cultivation have already been cut down and allowed to dry out. Towards the end of March comes the burning. Afterwards, the debris must be raked up and any remaining wood burnt again. The soil has to be cultivated by hand, since the ground is mostly too steep for animal traction, and the water buffaloes that could pull simple ploughs on the gentler slopes are in any case an investment that most Akha families cannot afford. The

spring planting, the summer weeding and the autumn reaping represent demanding toil but the Akha do not begrudge it, because rice—by far the principal crop—is their staff of life.

It would be difficult to exaggerate the importance of rice in the Akha scheme of things. A well-filled granary means economic independence from the world of the lowlanders; hence the grain has acquired symbolic importance that transcends even its practical value. In the yearly round, rice farming ceremonies therefore play a very important part. These, like other Akha ceremonies, deal with the forces with which the rice farmers must contend: the influence of the soil, of the seasons—especially the regular return of the rains—and of various kinds of political and economic pressures. The ceremonies are intended to help maintain the harmony between the people, their land and the rhythms of the universe, by ensuring that everything is done in the right way and at the right time, as the ancestors have taught.

The ways of the ancestors are formulated in the texts memorized by the *pima* and the *dzoema*, and in traditional songs. These passages are chanted at the rituals that mark not just the stages of rice cultivation but every important juncture in the life of the community; they are not prayers addressed to the invisible forces of nature but rather descriptions of actions—both practical and symbolic—that must be taken if things are to turn out well.

Guided past every landmark in their lives by their eloquent yet down-to-earth poetry, the Akha derive an enviable serenity from their assurance that the ways of the ancestors are the right ways. No subject was too vast for the poets of the Akha past: the verses describe movingly the great crises of birth, illness and death. Equally, no subject was too specific. The texts run on easily from the major turning points of the year to the agricultural details of hoeing, weeding and scaring away the birds.

After the fields are burnt, each family builds a hut in the middle of their plot. It is a bamboo-and-thatch structure in which they may rest during the day, or even sleep at night during very busy periods. On the upslope side of the field

hut they build a miniature hut for the Rice Lady—the force or essence of the grain. It will be dismantled again after the rice has been harvested.

Both men and women till the fields; if it is a virgin field, they use a mattock to turn over the soil and break up the clods. After burning the accumulated piles of rubbish, they start the rice-planting activities. First, in the evening, each household makes an offering to its ancestors, and the *dzoema* announces that the next day is a day of abstinence. In the morning, the *dzoema* and the village elders go to the water-source in the forest belt, where they symbolically purify the water, and cleanse the rice seed for a ritual first planting by the *dzoema* later in the day. Then they kill a hen and a cock, and "read" the state of the birds' bones and gizzards to determine whether the signs augur well for the coming harvest, as well as for the year's hunting.

Next day, individual households are free to do their own first planting ceremony, which is the responsibility of the family's white-skirt woman, if it has one; otherwise, it is the duty of the man who is head of the household. When all the planting has been done—the men dig the holes with dibble sticks and the women drop in the seeds—the village must observe a day of inactivity; no one goes to the fields or hunts or even gathers firewood. The prescribed restraint is so complete that husbands and wives are forbidden to make love—although no one minds if sweethearts wander off together.

In June or July, once the rice begins to grow, a hen is offered at the Rice Lady's hut. If there is a white-skirt woman in the family, she must offer a pig as well as a chicken. A small portion of each animal is offered to the growing crop and the family eats the rest. The field has to be looked after carefully, for unless it is paid proper respect, the crops will not flourish. For example, a couple are not allowed to make love in the field while the rice is growing.

Weeding has to be done two or three times during the growing season, until the rice plants are tall enough to overshadow the weeds. It is a sweaty and unpoetic business in which whole households join hands; the correct tool for the task is a small, narrow-bladed Akha hoe. The owner looks on with satisfaction when the weeds have been banished to the edge of the field and the rice begins to ripen—"When the wind blows, the rice seems to be walking," as one of the *pima's* verses expresses it. Whenever necessary, the children go out with clappers like castanets to scare away the sparrows and parakeets that descend in swarms on the ripening grain, but often this is not enough and sometimes even the Akha shotguns fail to halt their depredations. The best scarecrow, I was told, is a dead falcon suspended by its legs. As for wild boars, which although diminished in number still come to eat and trample down the ripening rice, the village mounts a hunt from time to time before the harvest. Some 10 to 20 men go for a day-long chase, and if it is successful they return in the evening in formation, drumming on bamboo sections.

November brings the rice harvest, with reaping, stacking, threshing and winnowing, each activity preceded by an appropriate ceremony. The first reaping is an enterprise of great pith and moment, which is carried out symbolically on a small scale as an introduction to the real harvest. Three stalks of rice are brought home by the head of the household or the white-skirt

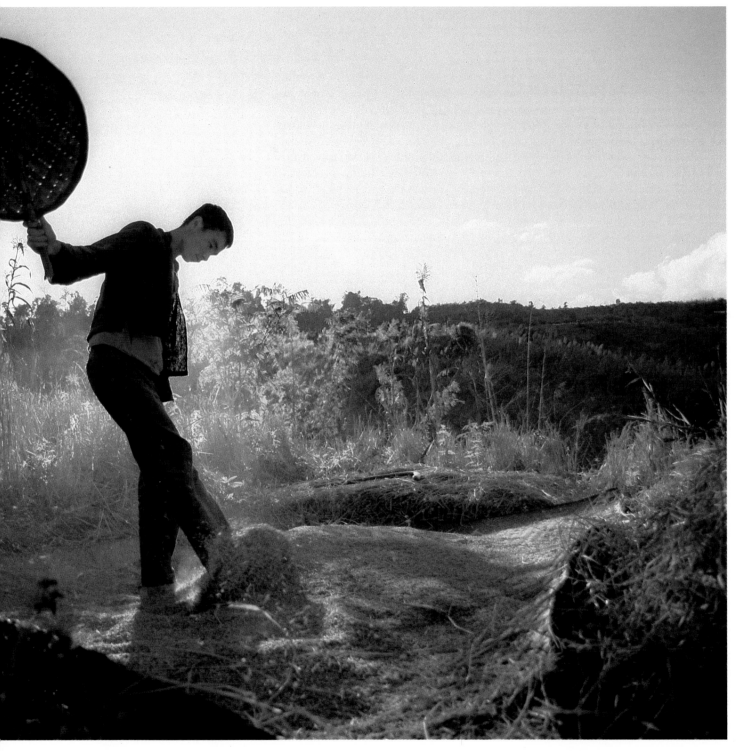

Waving a large fan of woven bamboo, a man
standing on a mat winnows threshed rice.
In one continuous, graceful movement,
he kicks up the rice and sweeps the fan
down to catch it. As the rice is tossed in the
air, the breeze blows the chaff on to the mat.

woman, and put in the foot-long bamboo section dedicated to the ancestors that, together with the woven ancestor basket, occupies an unchanging place on the women's side of the house. Some loose rice is brought too, and cooked to be eaten at a special meal that the ancestors are ceremonially invited to share. Then the real harvest can start. In the same way, three stalks of rice are symbolically trodden before the real threshing starts.

The flails that the Akha use for threshing rice look like hockey sticks designed by Brancusi: a hardwood branch slightly knobby at the business end, and worn mirror-smooth with use—an object of splendid heft to the hand and delight to the eye. The men whip the flail down on the rice straw and at the same time give it a flick with the wrist: up-down, up-down; a thousand, ten thousand times. Meanwhile the rice is encouraged to give a good yield by means of occasional cries of *Jeu! Jeu!* (Increase! Increase!) Threshing is followed by a long period of drudgery devoted to carrying the grain back to the village—by packhorses for the well-to-do, in bags or back-baskets for the less fortunate. This chore, too, is described in the Akha songs:

> *If you are strong, let ten baskets be full,*
> *Going to and from the fields ten times in a day*
> *With a full basket on your back,*
> *Carrying the youngest child in front;*
> *Carrying a basket, pointing to heaven on your back.*

The rice is taken to each household's granary and the Rice Lady's little hut in the field is replaced by one built on stilts beside each family's granary, where she can protect the stored rice. In the hut are deposited in a ceremony three special stalks of rice that grew from the ceremonial first planting; they are to be used in turn for next year's first planting. When the grain has been stored, families start making the new rice liquor and sharing it with the ancestors.

About a month later, towards the time of the full moon in the 12th month, the Akha year comes to an end, and it is time to celebrate the New Year. New Year is one of the nine important occasions when the ancestors receive offerings from their families, and the festivities symbolize the link between past, present and future that the Akha invest with such importance.

The four-day festival is a benchmark in time as well as an occasion for resolution and renewal, for with the start of the new year, everyone is considered a year older, regardless of their birthdate. Like their neighbours all over Thailand, the Akha use a variation of the Chinese calendar, with 12 days in a week. The days have names of animals, such as sheep, monkey, chicken, dog, pig, rat, buffalo, tiger, and so on. The New Year celebration must start on a buffalo day, and may not take place less than 12 days after anyone in the village has died. The names of the years follow the same sequence and are repeated when the cycle is completed. The New Year festival that I attended took place as usual in mid-December on our calendar: they were celebrating the end of the monkey year and the beginning of the chicken year.

It is a time for dancing, eating, drinking, the refurbishing of headdresses and putting on new clothes—one of the two occasions in the year when girls

A woman places a freshly picked tomato on a tray that holds other produce from her fields: mauve and green aubergines, ginger root and roselle, an edible type of hibiscus flower. The flower and some vegetables will be carried home and cooked; the rest will provide a picnic lunch for the woman's family as they work on their plots. On the left is a blackened bamboo salt container.

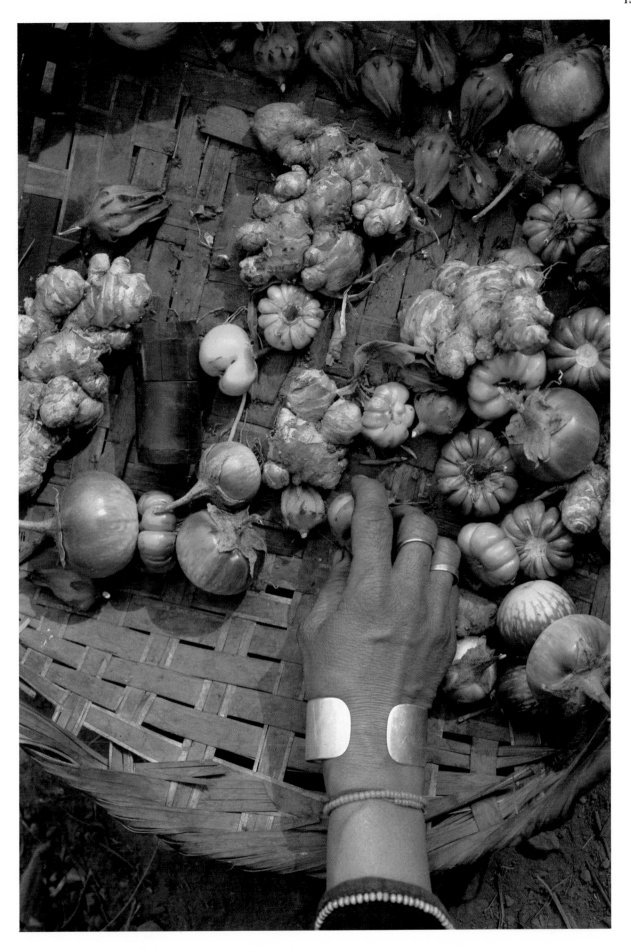

can make formal changes in their clothing as they grow up. This is also the one time when tops may be spun. According to *Akhazang*, their wooden tops may be used only during the last three days of the festival, after which they should be thrown away. Indeed, during my succeeding weeks in Napeh I saw not a soul playing with a top. It seems that the stress laid by Akha tradition on doing everything "at the right time" is enough to banish the desire.

The spinning itself is a snappy and rather aggressive affair. One boy flings his spinning top as far and as fast as his whip-string will allow it to go; then his opponent tosses his own so as to knock the first out of its orbit if he can. It seemed such an innocent pursuit, however, that I asked the *pima* why this game was restricted to just three days. He asked me to accept the rule on faith: "The ancestors said that you have to spin them for the New Year."

"Were they never used at any other time?"

"Actually they can be used symbolically at other special times. A woman who wants children but cannot have them may ask the *pima* to carry out a ceremony to aid her fertility. He will carve a miniature top, which she then fixes as an ornament to her headdress."

I had expected the first day of the occasion to produce a certain amount of merry-making, but there was no obvious excitement at Napeh. It was the day for the ancestor offerings and the observances were largely a family affair carried out indoors. I was grateful therefore that the *buseh* Abaw Baw Soe had invited me to spend the New Year with him and his family, and to participate in one of the most intimate and solemn of Akha ceremonies.

First of all, traditional rice cakes were prepared by Abaw Baw Soe's mother, a handsome and capable white-skirt woman of 70-odd years. She took a small amount of glutinous rice—a special, sticky variety—which she had already steamed, and pounded it with a heavy pestle in a mortar placed beside the open deck on the men's side of the house. After 10 minutes or so, the *buseh* took her place and finished the pounding. Although rice preparation usually belongs to the women's domain, the pounding of the sticky rice is a heavy task with which the men will often help.

When the rice had reached the consistency of pizza dough, the old lady shaped and patted it into round cakes and placed them in a bamboo basket to keep them safe from animals (and children). She then slaughtered a chicken in front of the bamboo ancestor basket that stood in its customary place against the rear wall of the women's section. It contained several small objects, including one or two items that had belonged to deceased members of the family, and miniature implements—a whisk and a wooden scoop—to be used in serving food to the ancestors. The Akha customarily use their ancestor basket also as a safe place for their most valued possessions such as their silver jewellery because, they assume, no one would risk incurring the wrath of the ancestors by stealing from it. Tied to one of the rafters above the basket was the other important container: the bamboo section in which were placed each year, over several generations, the symbolic stalks of rice.

A short time later the house filled with acrid smoke as the old lady burnt away the pin feathers of the chicken over a fire in the women's hearth. When

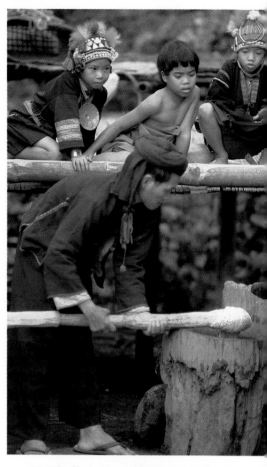

Watched by curious children perched on the porch above, a man wields a giant pestle that he is using to pound steamed glutinous rice. When the rice has been reduced to a sticky paste, it will be presented to ancestors of the Akha during a New Year ceremony. The villagers of Napeh grow this special type of rice themselves, but they rarely use it except on such ritual occasions.

there were no more feathers, she gave the bird to her son, who singed it for a few moments, then chopped it on a thick carving board. It took him about 10 minutes to complete the task, slicing most of the bird into tiny pieces, but setting aside a portion of the breast, one drumstick and the liver as special delicacies for the ancestors. The pieces went into a cooking pot, together with rice, salt and sliced ginger root, and a little water was added to boil it up.

When the meat was ready, the *buseh's* mother sat on a low stool in front of a wickerwork table and filled five small porcelain bowls. The first bowl contained some chicken meat and rice; the second, a mixture of ginger and tea; the third, a special sort of rice liquor; the fourth, rice cooked in water specially fetched from the spring for the ancestor offering; the fifth, cakes of sticky rice, well salted and rolled in toasted sesame seeds.

The *buseh's* mother placed the table in front of the ancestor basket and presented the cups towards it. She turned around, waiting silently for a minute or two to give the ancestors time to accept her offering. Then she herself ate a little of everything, and gave small amounts from the five bowls to the other members of the family who were present. Now it was my turn to taste from each bowl, aware that I was being signally honoured.

It was early afternoon, but it was dark in the women's half of the house. Light filtered in through the openings in the roof gables and through the cracks in the bamboo walls, but if it had not been for a flickering oil lamp I could not have seen what they were doing. Behind us, two grandchildren sat in the shadows and a baby played on a mat. One of the *buseh's* daughters came in and out, but his son, who had had to pay a visit to another village, was not present. I was informed that, as long as the people who were at home attended to the ancestors, it was not necessary for everyone to participate.

When we had finished eating the rice cakes, which were delicious, the old lady stood up and struck a small Chinese gong, six times and again six times, and six times more. The ceremony had come to an end, after less than an hour. The following days were devoted to making and spinning the tops; slaughtering and sharing out a pig; and continuous drum-beating. In the evenings the whole village and many visiting guests gathered at a dancing ground where the boys and girls frolicked in their best clothes.

On the third day, another riotous observance took place, which served the purpose of a village "truth-telling session". It is the day for settling all outstanding debts and the heads of all the households assemble at the house of the *dzoema*, who is the custodian of the village money. Each man brings with him a bottle of rice liquor, and Dr. von Geusau explained to me that, during the session, the Akha could settle all accounts and resolve the differences of the preceding year; with their inhibitions erased by liberal consumption of the liquor, they were free to speak out about anything and everything. "It's fantastic therapeutic stuff," he added. Half jokingly, half in earnest, the male elders among whom we were sitting—women rarely drink—were getting off their chests everything that had been bothering them for months.

I can recall few details of the rest of that day, having been caught up in the prevailing camaraderie of the rice liquor, but I do have fleeting images of a

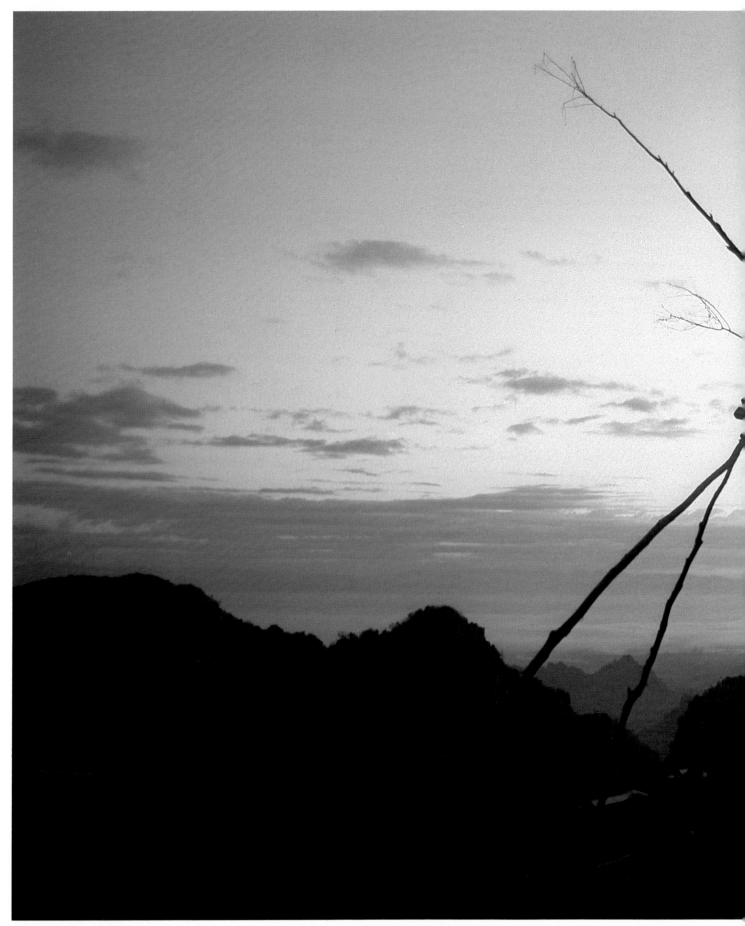

At the edge of the village stands a framework of four strong saplings, rebuilt each year for use during an important midsummer festival. As part of their

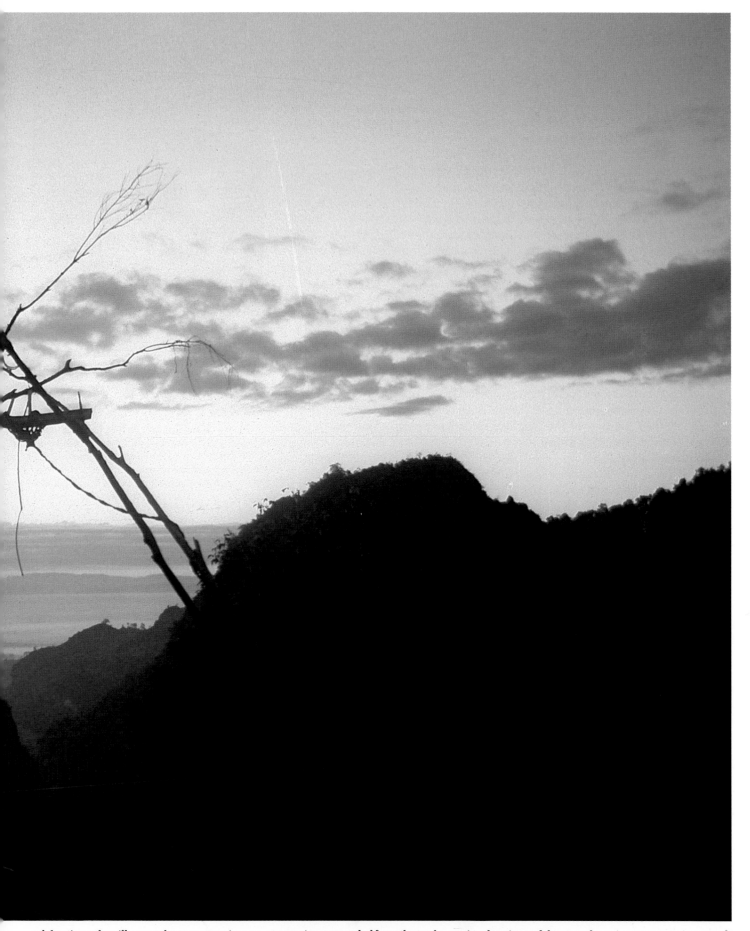

celebrations, the villagers take turns to swing on a strong vine suspended from the top beam. At other times of the year, the swing must remain unused.

gathering in the evening attended by girls who had just renewed their head-dresses. They wore their most beautiful beads and most alluring feathers; despite my semi-stupor I was smitten all over again with their loveliness.

Other festivals are scattered throughout the year, all of them, in the Akha view, helping to connect human activities with cosmic cycles such as the turning of the year: it is their constant preoccupation that such links be maintained. The new guardian gates are built in April, when the wet season is soon to begin. At that time of year, there is a special risk from the hostile spirits who once shared the world with humans, until they retired to their own spirit regions. Loving the rain, they may return during the wet season and bring disease; the gates are a protection to keep such dangerous forces outside the village. These alien forces will be expelled again in September, before the harvest, in a spirit-chasing ceremony during which the boys rush from house to house with much hubbub, brandishing weapons made of painted wood. In the evening they stick the painted weapons into the path outside the village, and fire off real guns.

At the height of the growing season—usually near the end of August—occurs one of the most joyful of the festivals: the swinging ceremony. On the first day, there is food as usual for the ancestors and for the living. On the second, they put up near the dancing ground a high rig of four interlocking poles to which a strong vine is attached, suspended from the apex. The mid-summer festival celebrates good health and the swing is meant to give kinetic expression to the villagers' joy and satisfaction at being alive. It is above all an occasion for the women, but once the *dzoema* has inaugurated proceedings by taking a ride on the swing, nearly everyone who wants to can follow suit to signal his or her good fortune that day. This is the second of the two times during the year when girls can make changes to their dress.

During my weeks with the Akha I came to see that the harmony with unseen forces that they constantly strive for is no mere abstraction for them: its implications are real and practical. A bad harvest is one possible result of disharmony that could spell disaster; sickness is another. Poor health may be caused by disturbances in the cosmic order or by the patient's soul or life-force "going astray"; epidemics may be due to hostile spirits, and sudden twinges might be caused by an ill-wisher practising a spell. Most of the curative ceremonies held by the *pima* are designed to discover where the life-force of the patient has gone. If the cause of the disease is obscure to the *pima*, a shaman may be called in to help furnish a diagnosis through a dream or a trance, so that the *pima* may carry out an appropriate ceremony.

But the Akha do not necessarily resort to such measures; they possess a remarkable repertoire of practical cures. They treat cuts and fevers with a variety of forest remedies, and for breaks and sprains, massage and manipulation are practised with great skill. Most grown women have acquired a general knowledge of at least 30 different effective herbs, roots and bark, and in many villages there are a few people with more specialized skills in

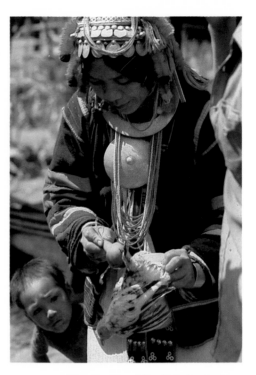

Wearing the white skirt of maturity, a woman prepares to sacrifice a hen (above) to ensure a plentiful rice crop. Nine hen's feathers and some rice from the last harvest will be placed in the Rice Lady's house, a tiny structure that stands in the family compound. At the end of the ceremony that day, the woman removes the offerings (right) and stores the rice seeds in her house ready for the ritual first planting.

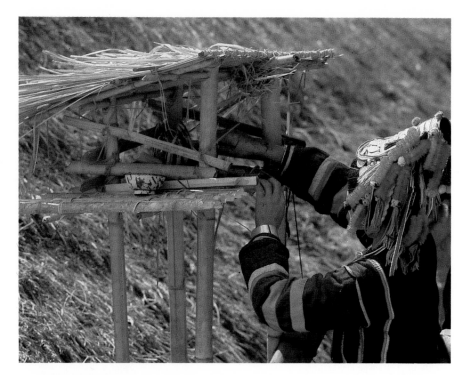

herbal medicine. The Napeh blacksmith, for example, was so widely famed as a practitioner that he was often consulted by people from other villages.

On our trek north, Liphi and I had encountered a traveller who had the reputation of knowing a great deal about forest medicine. When he visited a village, people flocked to him for advice. He always carried a small stock of herbal remedies and would dispense these in exchange for a little opium. We travelled together for a time, and when I asked about his medical skills, he led me on forays into the bush to show me his pharmacopoeia, plucking leaves and pulling up plants whenever he saw something interesting.

The forest, it seemed, was a well-stocked pharmacy. "Take this root, boil it and sip the liquid, and it will soothe a cough," he said, showing us a sort of milkweed. The root and stems of a flowering pepper were good for stomach-aches if boiled, and promoted healing if applied in powdered form to cuts. The leaves of a species of lobelia cured boils if applied as a poultice. A dandelion-like plant reduced swellings, and the fragrant bark of the *boeni* tree was used to disguise the stench from a coffin. "We grind the bark into a powder and make a paint from it, and when someone dies and his relatives come back from the forest with wood for his coffin, they treat the wood with it."

The forest held many other remedies, for circulatory and skin diseases, wounds, parasites and mental illness; one only had to know what to look for. The herb doctor had picked up his medical lore not from any one teacher but from a number of experts, including several from the other hill peoples.

Before he left us, this pharmacist gave me a piece of cinnamon bark the size of his fist. It was to prove very useful during the day, for the inner side of the bark has a tangy, aromatic flavour and works as a pick-me-up. I gnawed on it gratefully as we tramped along. The Akha use it both as a stimulant on the trail and to brew a tea that cures colic and various stomach complaints.

Earlier during my stay in Napeh, I saw a rare kind of medical therapy applied to a problematic case that turned out to have non-medical aspects as

well. A woman had complained of sudden pains in her body and was afraid they had been caused on purpose by someone who had recently accused her of the theft of some money. She asked the *pima* to discover whether this was really the cause of her symptoms. The *pima* performed a divination with rice grains provided by her family and he decided that her illness was indeed caused by someone who had cast a spell over the woman by using a traditional technique common to the mountain peoples and the lowlanders alike: chanting over pieces of metal in a cup, to make the pieces fly through the air and enter the victim's body. The woman's illness, therefore, was diagnosed as being caused by tiny fragments of metal embedded in her body. The *pima* decided to perform a healing ritual to repudiate the spell. I learnt later that the suspicions of the man who had lost the money were generally considered to be justified, but in the absence of any proof he had engaged a local non-Akha "diviner" to cast the spell in order to try and force the woman—unsuccessfully, as it turned out—to confess and return the money.

Pima Asoh agreed to perform the ceremony the next day. After a ritual during the morning in the woman's house, they held the rest of the proceedings outside the village. Before going to the forest beyond the village gates, the *pima* and an assistant prepared a group of ceremonial objects to be used in the ritual. From a piece of tin, they cut models of a hoe and a machete, which they placed on a basketwork tray covered with pieces of banana leaf. They then cut nine small pieces off a sort of vine and put them into a bowl together with nine pieces of iron, nine cowry shells and a 10-baht note, wrapping the bowl in a cloth that had been folded nine times.

The assistant had brought some clay and with it he modelled a tiny man, a horse and a buffalo, as well as a crude egg cup. The male figure represented the malefactor who was thought to have cast the spell: he was to be given a horse to ride away on, and the buffalo was intended as a bribe to persuade him to abandon his sorcery. To these models they added a star-shaped emblem woven of split bamboo, a sign recognized by all the hill peoples as a warning not to approach while a ceremony is in progress.

We set off for the jungle with all this equipment and a young live chicken that the *pima* carried head-down. The ceremony could not be performed in the village, he explained, because the spell, instead of being cast out for good, might ricochet and afflict someone else in the community. When the *pima* had found a likely spot—a fairly steep slope covered with underbrush—he sat down and began a long series of incantations, delivered monotonously on a note that rose and fell with liturgical regularity. He went on for 40 minutes or so, humming, mumbling and singing until his voice grew perceptibly weaker. The chicken, still dangling upside-down from the *pima's* hand, suddenly fluttered and stirred uneasily; it was time for the *coup de grâce*.

When the incantations ceased, the assistant took the chicken and cut its throat, though not all the way through, while the *pima* held its neck outstretched. After the bird had bled for a minute or so it was released, fluttered downhill for a few feet, twitched and lay still. The *pima* rose and went to examine its final position. The head was not facing the *pima* (or the patient

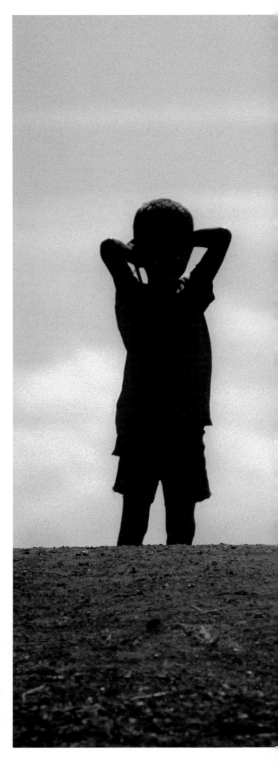

With a flick of his twine whip, a boy sends
his wooden top whirling across the ground
during a New Year spinning contest. Carved
especially for the celebration, tops are
spun in the course of the last three days
of the festival and then discarded.

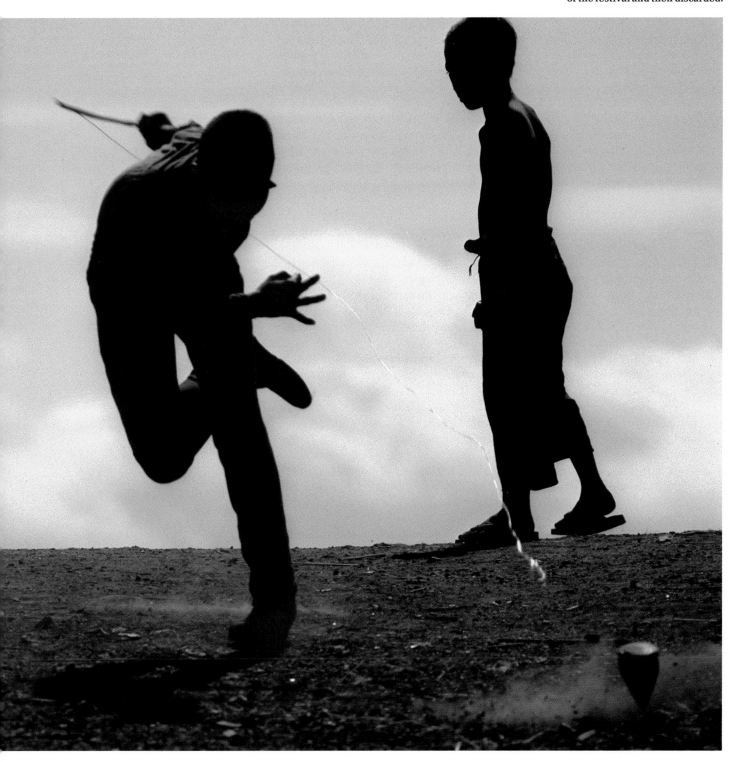

waiting back in the village) but lay downslope away from the village—a sign he interpreted as extremely auspicious. Now he intoned a final chant, interrupted by a few terrifying shouts. He ended the ceremony by shaving a few bits of metal from a five-baht piece, a practice surviving from the days when such pieces were made of silver and not today's cheap alloy. Then we retraced our steps to the village, confident that everything that could be done had been done for the patient. The pains did indeed disappear after a few days, but I never learnt if the money found its way back to its original owner.

The *pima's* treatments are not the only ritual means for dealing with illness. If the *pima* were unable to produce a satisfactory diagnosis, the patient might consult a *nyipa* who—like the *pima*—employs traditional texts in his work. But the shaman uses his chanting to help him (or her: in Burma most shamans are women) to achieve a state of trance, in which he travels into the upper world. He returns with the necessary information about the origin of the disease, so that the patient's family can have the correct ceremonies done by the *pima*, who will, by means of his chanting, go to the spirit world to look for the straying life-force and bring it home to the sick person.

Not long after New Year, I went to another Akha village near Napeh to watch a shaman treat a woman who wanted sons but seemed incapable of having them. She had come from a village many miles further north, in order to receive the shaman's attention. When we arrived, the sun had already set and the shaman had begun a seance that would last well into the night. He was chanting an ancient song of the journey on which, by degrees, he would himself arrive at the village inhabited by the earliest ancestors. In his mind's eye—and in the belief of his audience—he was already travelling swiftly into time-space on a winged horse. Upon reaching his destination he would beg the forces responsible for creating children to help his patient. He sang about his vision as it passed before him, his voice low and melodious.

For the seance the shaman had installed himself in the women's side of the house. In the men's section, three men lay on mats smoking opium, their feet propped up on the partition. Outside there was bright moonlight but none of it penetrated into the house, which was illuminated only by small fires in the two hearths and a single oil lamp. The shaman, who was middle-aged, sat hunched on a low Akha stool with his back turned towards the watchers. It was so dark that I could barely discern what he was doing.

Before him, he had a rice basket with gift offerings for his journey: an egg, money and tobacco, tied inside a banana leaf with string made by the patient. There was also rice liquor, though it was left untouched during the seance. In each hand he held a bamboo and a bark-paper fan, one white, the other red, with which he made occasional gestures or passes through the air.

His right foot kept up a steady drumming rhythm as he chanted—the sound of a horse's hooves, amplified by the vibration of the bamboo floor. As he mimicked a ride to the land of the ancestors he jived his shoulders as if on horseback, and shifted his buttocks on the stool in time to the hoofbeats.

His audience consisted mainly of married women, with a sprinkling of young girls, one or two young men and an assortment of babies, some of

The body of a baby who died during a measles epidemic is carried to the burial ground in the forest in a shaped wooden coffin strapped to a bamboo pole. A child's funeral is marked by a day of abstinence and rest; all villagers stay at home except the men who carry the coffin to the grave.

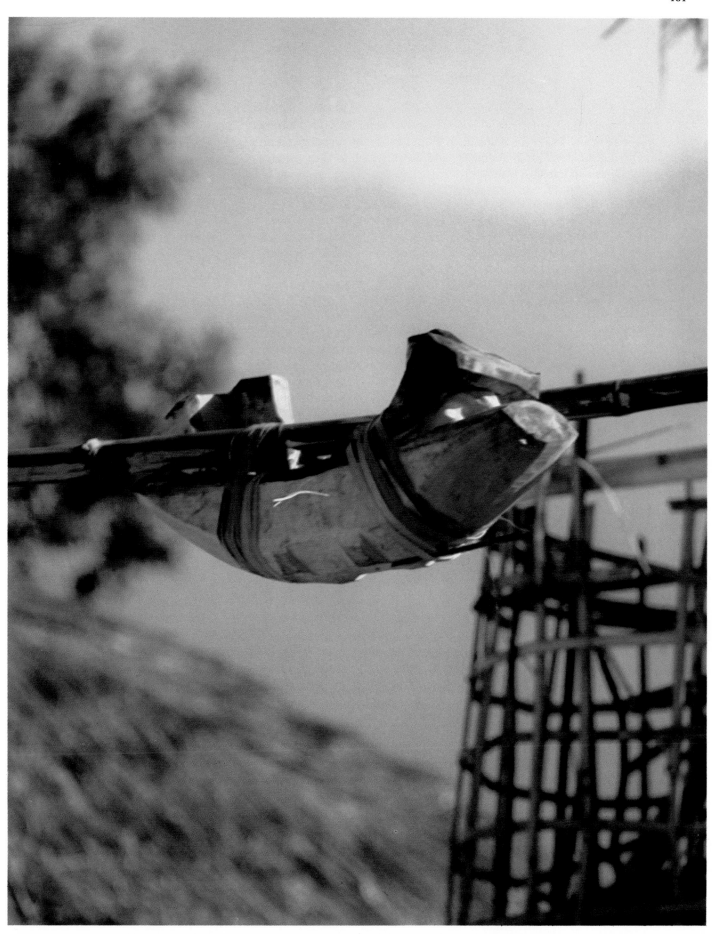

them slung on their mothers' backs, others curled up against a sack or a basket. The women talked, laughed and shouted encouragement at the shaman, who seemed to be oblivious of everything. With the flames flickering at her feet and the light playing on her silver headdress, the patient resembled an impassive Olmec sculpture, chiselled from granite. It was impossible to tell whether she was pleased or dismayed by the shaman's endless chanting and the hubbub going on behind his back.

The shaman had a chant of his own that was very different from the *pima's* incantations, though melodically it was no less repetitious. Every section, or strophe, began with a hearty *Hey-yoh!* sung fortissimo on a descending minor third. Then the rest of the chant would follow, syncopated and in time to the horse rhythm. One opinion I heard later maintained that the *Hey-yoh!* gives the shaman a moment to prepare what his next line is going to be. He sang about where he was going and whom he saw there—once he burst into tears as he encountered his dead cousin, a former *nyipa* of great wisdom. It was clear that all those present believed implicitly in his journey. I gathered that he had arrived finally at his destination, however, when he suddenly rose to his feet and jumped up for his next *Hey-yoh!* For a while he waved his fans in extravagantly sweeping gestures; then he sat down again and resumed his original *Hey-yoh!* in the previous manner. I went outside to catch a breath of fresh air and I could hear each shout, sounding like a peremptory challenge to the spirits, ringing through the entire village.

After five hours the shaman brought his chanting to an end. He went into the men's section, carrying the boiled egg that had been in his rice basket. He shelled it and told the patient to eat it, which she did. He untied the string that had been used to wrap up the gift offerings, and tied it to her wrist as a sign of blessing. She then rose and brought a bottle of rice liquor from the women's section and poured everyone a cup while the shaman expounded what he had seen, and assured the woman that after his intercession with the child-giving forces, she would probably have a son.

The five hours of chanting that I had listened to did not compose an unusual performance by an Akha officiant. Some of their oral poetry goes on for 10 hours at a stretch over each of three consecutive nights. Yet the words are remembered so accurately that two *pimas* chanting the same 10,000-line poem can sing almost identical texts. The poems themselves constantly remind them to "think clearly and make no mistakes in the recitations". They have to learn their art the hard way, by rote, from a master working with a small group of pupils. The master sings the texts for them, line by line, and they must repeat each one. Some of the ceremonies even include verses about the professional fees they are supposed to receive: "Meat to pay for the *pima's* lack of sleep while reciting all night; meat to pay for the *pima's* missing work in daytime...." It is almost as if a priest were to chant the scale of funeral fees along with the Requiem. I found the Akha texts refreshing in their candour.

For centuries, the continuity of Akha tradition has depended upon this slender thread of memory that ties each generation to the next, describing

the everyday life of the Akha in all its colour and passion. At a funeral the *pima* recites thousands of lines describing the joys and sorrows of an Akha woman from birth to death. According to one opinion that I heard, they use the woman's life as a paradigm, on the grounds that nothing of real importance happens in a man's life—because he doesn't bear children. For what is crucial to all the Akha is the link between one generation and the next—a link made possible only by women bearing children.

The Akha may have been driven into the forest against their will, but they have made the experience into something positive. To my mind, no people anywhere has a more eloquent way of articulating its relationship to the world—both concrete and invisible—than the Akha. Their texts are not empty rote but often contain poetry full of striking realism and haunting images. It is impossible not to be moved when they invoke the power of the "lords and rulers of land and water" or when they describe the season of renewal as a time when "seeds that were not alive come to life... rain falls in showers, like seeds. Where good people settle, sons are born; where good animals stay, the fence points towards heaven."

It is impossible not to be impressed by the fact that their common traditions are preserved by every soul in the community, not only by the knowledgeable elders like the *dzoema* and *pima*. Even the songs that the villagers break into so readily are part of the shared storehouse of their identity.

A particular day soon after my arrival in Napeh brings vividly back to me the way that the traditional songs of their past play a constant part in their present life. I was walking with three young Akha men through the fields in the broiling sun, and four or five women were busy there cutting bundles of grass for repairing the thatched roofs of their houses. As they worked, their movements kept time to the folk-song that one of them was singing.

The men, who were accompanying me to a nearby village, shouted something to the women and took up the refrain. Then, as we walked on, Indian-file, one man began another song, in the same melodic vein. He would sing a bantering phrase followed by a single note held for several beats, then jump up a fourth, while one of his companions supplied a falsetto octave above it. The effect was of a constantly repeated recitative and fanfare. His subject was love, and the lyrics changed with each turning of the trail.

> *Say do you know that living by myself like this I get lonely, lonely,*
> *Hey-eeh! Even though I were to gaze into the faces of ten people,*
> *they wouldn't seem as beautiful to me as your single one, Hey-eeh!*

While we were still within earshot of the women in the field, we could hear their answering calls resounding from the hillside. My companions were reaching for their high notes in a yodel-like falsetto, but the replies came in a clear, resonant soprano with a steadiness of pitch and a controlled vibrato that an opera singer might have envied. And, although it might have been only a simple love-song, the singer had learnt its meaning at her grandmother's knee and she rendered it with ardour and conviction.

> *I want to hear the sound of your voice. It is very lovely.*
> *Please bring it with you again, Hey-eeh!*

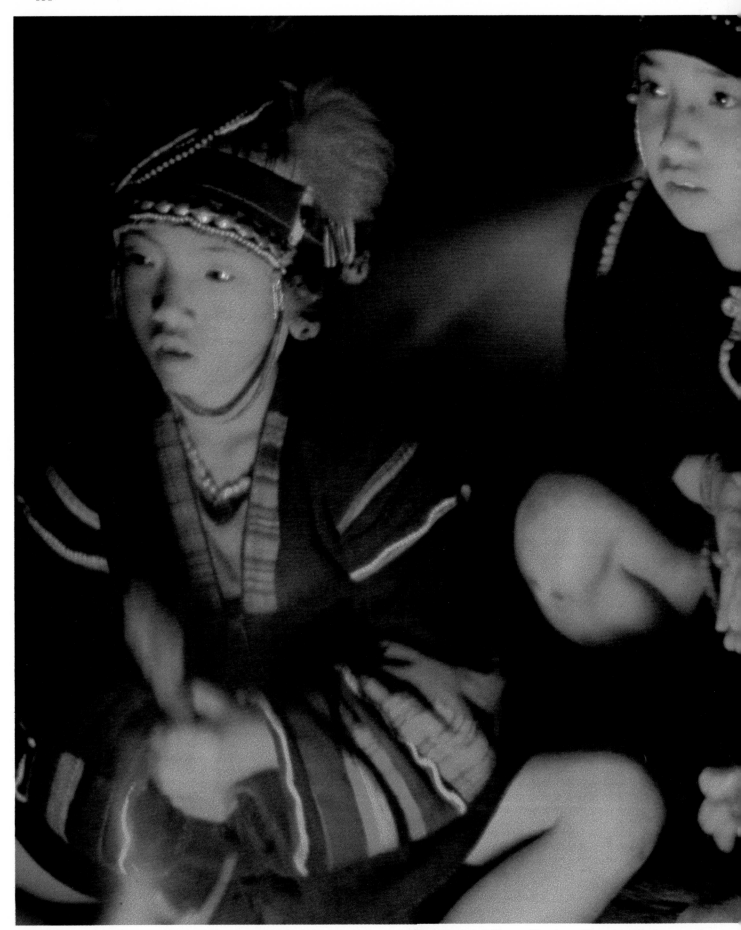

Gathered round their fireside at the end of the day, children listen enthralled to a courting song chanted by an elder sister. Since the Akha language has

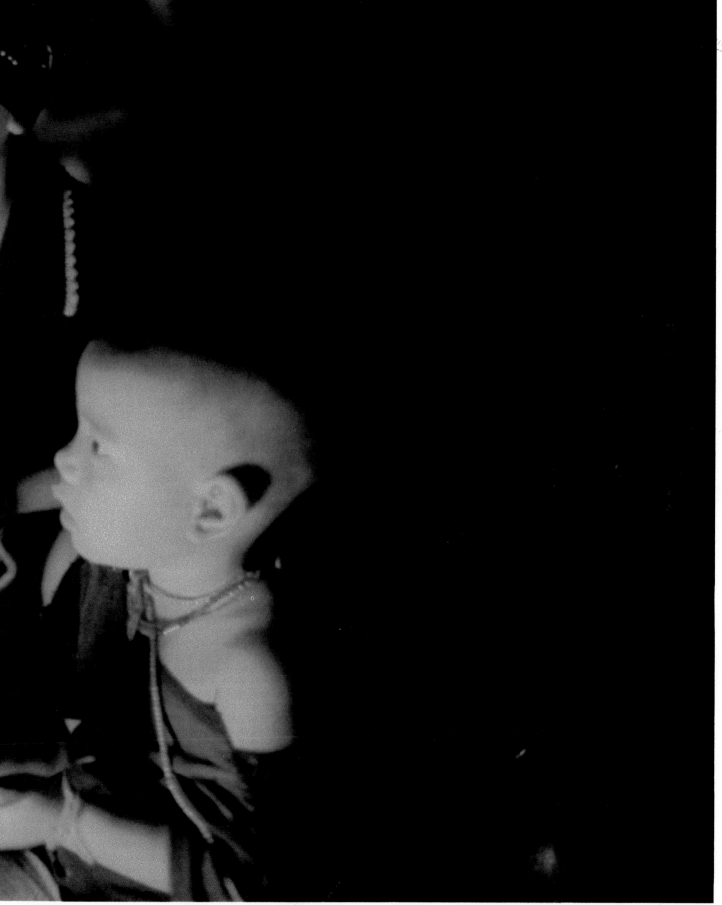

no traditional written form, Akha children learn their history and their customs—Akhazang—through the oral poetry memorized by each generation.

Bibliography

Alting von Geusau, Leo, "Dialectics of Akhazang; the interiorisations of a minority group", in *The Highlanders of Thailand*, editors, W. Bruksasri and J. McKinnon, Oxford University Press, Kuala Lumpur, 1981.

Alting von Geusau, Leo, "The Akha Misunderstood". *Bangkok Post*, November 30th, 1979.

Bernatzik, Hugo Adolf, *Akha und Meau*. Wagnerische Universitätsbuchdrucke, Innsbruck, 1947.

Dessaint, Alain Y., *Minority Peoples of Southwestern China*. Human Relations Area Files, New Haven, 1980.

Dobby, E. H. G., *Monsoon Asia*. University of London Press, 1961.

Hanks, Lucien M., *Rice and Man*. AHM Publishing Corp., Arlington Heights, 1972.

Hansson, Inga-Lill, "The Akha Funeral Ceremony", in *The Highlanders of Thailand*, editors, W. Bruksasri and J. McKinnon, Oxford University Press, Kuala Lumpur, 1981.

Hearn, Robert, *Thai Government Programs in Refugee Relocation and Resettlement in Northern Thailand*. Thailand Books, Auburn, N.Y., 1974.

Kacha-ananda, Chob, "The Akha Swinging Ceremony", in *Journal of the Siam Society*, Vol. 59, Part I, 1971.

Keyes, Charles F., *The Golden Peninsula: Culture and Adaptation in Mainland Southeast Asia*. McMillan, New York, 1977.

Kickert, Robert W., "Akha Village Structure", in *Tribesmen and Peasants in North Thailand*, editor, P. Hinton, Tribal Research Center, Chiang Mai, 1969.

Kunstadter, Peter (editor), *Southeast Asian Tribes, Minorities and Nations*. 2 vols., Princeton University Press, 1969.

Lewis, Paul, *Akha-English Dictionary*. Linguistic Series III, Data paper No. 70, Cornell University Department of Asian Studies, Ithaca, 1968.

Lewis, Paul, *Ethnographic Notes on the Akhas of Burma*. 4 vols., Human Relations Area Files, New Haven, 1968/1970.

Lewis, Paul, "The Role and Function of the Akha Village Priest", in *Behavior Science Notes*, III, No. 4, 1968.

McCoy, Alfred W., *The Politics of Heroin in Southeast Asia*. Harper & Row, New York, 1973.

Suwanbubpa, Aran, *Hill Tribe Development and Welfare Programmes in North Thailand*. Regional Institute of Higher Education and Development, Marupa Publishing, Singapore, 1976.

Telford, J. H., "Animism in Kengtung State", in *Journal of the Burma Research Society*, No. 27, 1937.

Walker, Anthony R. (editor), *Farmers in the Hills: ethnographic notes on the upland peoples of North Thailand*. Penerbit Universiti Sains Malaysia, 1975.

Walker, Anthony R., *Highlanders and Government in North Thailand*. Folk, vols. 21-22, Copenhagen, 1979/1980.

Acknowledgements and Picture Credits

The author, photographer and editors of this book wish to thank the following: Victoria Butler; Inson Charoeporn, also known as "Liphi"; Neyla Freeman; Johannes Gwildis; Inga-Lill Hansson; Mark Le Fanu; Elaine Lewis; Library of the Museum of Mankind, London; Nattaya Puttangkul; Simon Rigge; Royal Botanic Gardens, Kew, Richmond, Surrey; Friedhelm Schölz; Library of the School of Oriental and African Studies, University of London; Supen Singkaraj; Ianya Sugunnasil; Boontham Tehpawan; Vichaicolor Lab, Chiang Mai.

The sources for the pictures in this book are listed on the right. Credits for each of the photographers and illustrators are listed by page number in sequence; where necessary, the locations of pictures within pages are also indicated—separated from page numbers by dashes.

All photographs by Michael Freeman except: Neyla Freeman, 4—middle; Sylvia Lebrun, 4—top; Frederic Grunfeld, 31, 96, 130—bottom, 131—top left and bottom, 134-135. Illustrations (alphabetically): Maps by Terry Allen and Nicholas Skelton for Creative Cartography Ltd., 20-21, 22. Front end-paper map by Engineering Surveys Reproduction Ltd. Cut-away of Akha house by Grundy and Northedge Designers, based on a Michael Freeman illustration, 58-59.

Index

Colour separations by Scan Studios Ltd.—Dublin, Ireland.
Typesetting by G. Beard & Son, Ltd.—Brighton, England.
Printed and bound by Brepols S.A.—Turnhout, Belgium.